Destiny
Denied

Destiny
Denied

Dr. Barbara Boone Wooten

Christians for Biblical Equality
122 W Franklin Ave Ste 218
Minneapolis MN 55404-2451
P: 612-872-6898 F: 612-872-6891
E: cbe@cbeinternational.org
W: cbeinternational.org

CREATION
HOUSE
A STRANG COMPANY

Cover design by Terry Clifton

Library of Congress Control Number: 2007924901
International Standard Book Number: 978-1-59979-193-7

First Edition

08 09 10 11 12 — 9 8 7 6 5 4 3 2 1
Printed in the United States of America

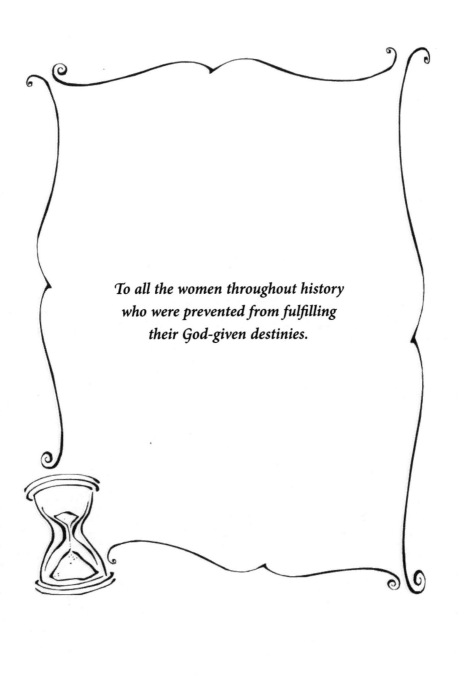

*To all the women throughout history
who were prevented from fulfilling
their God-given destinies.*

CONTENTS

Part 4: What's Happening Now?

PREFACE

THIS BOOK SPEAKS to issues that define women as image-bearers of God with rights as God's ambassadors here on Earth.

> In the last days, God says, I will pour our Spirit on all people. Your sons *and daughters* will prophesy, your young men will see visions, your old men will dream dreams. Even on my servants, both men *and women*, I will pour out my Spirit in those days, and they will prophesy.
>
> —Acts 2:17–18, NIV, emphasis added

With these verses, Peter quoted the Old Testament prophet Joel as he addressed the crowd at Pentecost. Even Peter, anointed by the Holy Spirit at that time, may not have fully understood the ramification of that prophecy. Today, not only are believers being filled with the Holy Spirit, but both sons *and daughters* are also being anointed to prophesy!

God is not interested in man-made hierarchies that are part of the Fall. It is surprising that "a woman's place" in the kingdom of God is still an issue in the twenty-first century. Unless people place their beliefs on the altar, along with those of people with whom they disagree, they cannot gain God's truth on the destiny of women in the kingdom of God. It is only by lying prostrate and spiritually naked before the almighty God that anyone can possibly receive His heart on

this matter. I do not believe anyone should dare to seek to even interpret God's Word or proclaim His truths without stripping themselves before God, knowing that only God's will and purposes are important and that neither man nor woman is of any priority in this. Not only that, but also it is God who chooses to use people.

Women must be released from the shackles and chains of man-made doctrines that have bound them for centuries. These chains have not only enslaved women, but have also caused some to even buy into the notion that they are ineligible to enter boldly into the throne room. These women continue to believe that they must come in through the back door simply because they are female. All vestiges of bondage must be removed from women, and their destinies must no longer be denied!

INTRODUCTION

The church has not always understood true biblical equality, nor acted upon it. Christian leaders have tolerated slavery and racism.... They have taught the inferiority of women and promoted sexism in the name of God. These are terrible sins, which are not yet fully overcome.[1]

—ALAN PADGETT, THEOLOGIAN

I FELT LIED TO, betrayed. Broken."[2] Christy LaFrance–Williamson was devastated by the rejection of her ministry gifts in her Christian denomination. Both Christy and her husband Marcus were raised in traditional churches. She recounts their journey toward true freedom in Christ:

I am not sure how to put my journey into words...As I grew spiritually, I felt a strong calling toward ministry. I entered a Southern Baptist college to major in religion. For the first time, I was told directly that as a woman, I had limits in ministry.

I met Marcus, my husband, in college. We didn't know about the idea of mutual submission early in our marriage, but we did know that male and female "roles" did not make sense to us. We did what needed to be done, made decisions together, and worked as equal

partners. However, our pre-marital counseling, home churches, and Bible studies all told us differently.

Soon after we married, I interviewed to be youth and children's minister at a local church. When I implemented real discipleship programs for the kids, I went from youth *minister* to youth *leader*. I wasn't allowed to speak in worship and had to beg for announcement time. Though the youth programs grew by leaps and bounds, I had to justify my position to the deacon board every few months.

In the four-year church plan, the elders announced that the youth position would change to *Pastor* of Family Ministries and "his" responsibilities would be...I knew my presence offended some, but this affected more than just me: my husband, families that supported my ministry, and the teenagers who saw gender discrimination, perhaps for the first time.

We left the church and the denomination to which we belonged our whole lives. Marcus and I were again on a journey. About a year ago, our new church motivated me to re-read the scriptures I had always questioned...My anger turned to tears...I had to experience inequity before I could appreciate true freedom in Christ.[3]

Christy's words speak to the essence of what this book intends to convey. They also speak to the dilemma women are experiencing in traditional churches today. One of the well-known "secrets" within some conservative and traditional circles is that many people within their ranks find unsettling the restrictive doctrines and sermons espoused by their church leaders on male and female relationships in marriage and women in ministry. Most of these people remain in these churches, however, because these are their home places

of worship; sometimes they are the only churches they have ever known. Often, if there is no traumatic personal encounter, most remain in those churches, even though they do not speak to their personal lives.

Women in these traditional denominations wear a veil, albeit an invisible one. In antiquity women's second-class citizenry was manifested outwardly, an outer covering masking the face and visibly symbolizing their subordination. "The veiled faces in antiquity prevented the 'evil' desires, seen as present in every woman, from attracting the lustful thoughts of other men, who had no right to what was not their property, that is, another man's wife or concubine."[4] Today's invisible veil masks external restrictions, limits, and controls placed on women. Creational subordination is used to camouflage the inequities by proclaiming that women were destined to assist men in fulfilling their dominion mandate. It is, the traditionalists say, God's creative order.

Gender traditionalists, such as Harold Martin, maintain that God directed a hierarchical order. "The woman who follows Jesus Christ and seeks to obey Him rejoices because she is liberated from the responsibility of lots of final decision-making."[5] According to Martin, a woman should feel liberated when a man makes decisions for her. John Piper agrees, asserting that boundaries and restrictions placed upon women are freeing dispositions of mature femininity.[6] This "freeing disposition of mature femininity" is the very indoctrination that has sealed a woman's subordinate state in religious circles—specifically, Roman Catholicism and many Protestant denominations—for centuries. Some gender traditionalists have gone so far as to say that women should never have direct leadership roles, even in the secular realm. Piper

3

asserts that women should not have direct authority over men on their jobs.[7]

These views leave no place for a woman's God-given talents and gifts beyond the boundaries designated by traditional doctrine. Women who see the invisible veil and try to remove it commit, in traditional circles, what is tantamount to sacrilege, and this often results in tragic consequences because they have stepped out of their place. J. Lee Grady deplores this denigration:

> We insult women when we spiritualize condescension by suggesting that God created Eve in order to provide Adam with a maid, cook, and laundress.... She was not created for servitude; she was fashioned to be a co-laborer with Adam so they could rule together over creation, as they were commissioned to do in Genesis 1:28.[8]

The infallible Word of God needs to be revisited; the church is a fallible institution. The church has made mistakes in its doctrinal beliefs, its interpretation of Scripture, and its perpetuation of gender-based hierarchical structures, which have been chronicled in its history. The traditional church, with its flawed interpretations of Scripture, is not God's ultimate authority on a woman's place. His ultimate authority is the Bible, guided by the Holy Spirit.

A woman fulfilling her God-given destiny in no way demeans or hinders men or the family, and yet this has been the disguised argument used by some in the church to limit women's full participation. It is Satan who has targeted the family today, and it is also Satan who has been attacking women for centuries! He gladly attempts to spread the confusion that the family is being destroyed because women are not fully submitting to men. This is his smokescreen,

a smokescreen that has bred destruction and division. It is also a smokescreen that nurtures male pride, which has bred inequality between the sexes for centuries.

This book discusses the ramifications of subordination and its impact on women. It debunks the argument that the lack of female submission has been the demon in dysfunctional marriages. Female submission has never been the problem; nor has submission been considered a dirty word, as some traditionalists like to proclaim. The problem has been the lack of mutual submission within marriages between both husbands and wives. Men are also to submit through self-sacrificed lives to their wives. (See Ephesians 5:21.) As noted in chapter 9 of this book, the husband is called to give his life selflessly to loving his wife "just as Christ loved the church" (Eph. 5:25, NIV). A husband loving his wife unconditionally was unheard of in the Roman Empire as well as the Jewish culture of Jesus' time. Ephesians 5 does not speak to an authoritative rule by a husband over his wife. The Way, as Christianity was called, had to rely on subterfuge to convey the gospel, especially in portraying something so radical as men loving their wives and respecting them as mutual and equal beings. This is what was reflected in the controversial scriptures.

The early church adhered to certain restrictive practices within the existing society because they needed a foothold into the cultural and religious milieu of that time. That is the context in which Paul wrote his controversial scriptures—he was trying not to offend the governmental structure of the existing Roman and Jewish cultures. Paul did not want to cause trouble for Christianity; the Roman government found the new sect threatening. They considered all sects subversive and intent on undermining the social structure of their

society. Without the compromise, the Roman government would have stamped out the new religion swiftly.

Paul's stance concerning winning the lost to Christ was understandable. This was discussed in 1 Corinthians, where he speaks of becoming all things to all that some might be saved. He wanted the church to pay attention to the culture so as not to bring offense when representing the gospel. Ironically, the ones who would argue that allowing women participation within leadership functions and mutuality within marriage as the bowing to cultural influences rather than the adhering to Scripture are the very ones who have transmitted cultural influences into the church. Those very doctrines that men and women in the traditional ranks espouse concerning restrictions on women are the actual results of bowing to the cultural and religious influences by the early church (that includes Greek and Roman philosophy).

More importantly, many of Paul's epistles were written to correct certain problems within particular churches.[9] The problems in today's Western churches are not the same as the ones that were evident in the early church. There is no need to mandate restrictions on a group today where the problems noted by Paul no longer exist. It is a burdensome yoke—a stifling bondage placed on women or any other group, and the yoke must be removed.

This book highlights the fact that Jesus used women in ministry while He was here on Earth and He wants to use women today in the great harvest field. Jesus' mandate to "go and make disciples of all nations" was not just for His twelve disciples, nor was it just for males. All Christians are to go and make disciples of all nations. (See Matthew 28:18–20.) Therefore there is no legitimate argument in limiting women's

participation in the Great Commission or ministry to those who are lost.

Denouncing the use of women in Christian ministry today can be likened to the Sanhedrin's' efforts to quash Christianity. They had questioned the apostles' vigorous proclamation of Jesus as the Christ, as well as the signs and wonders that had been demonstrated by them in His name. Those who would hinder the destiny of women today should heed the words of the wise Pharisee Gamaliel, who chastised the Jewish rulers:

> Men of Israel, consider carefully what you intend to do to these men.... For if this doctrine or purpose or undertaking or movement is of human origin, it will fail (be overthrown and come to nothing): but if it is from God, you will not be able to stop or overthrow or destroy them; you might even be found fighting against God!
>
> —Act 5:35, 38–39, emphasis added

Just as the Sanhedrin rejected The Way, traditionalists, particularly gender traditionalists, have denounced and rejected women as colaborers with men in taking full dominion here on Earth. If taking the shackles off of women and using them to bring salvation, healing, and deliverance to a dying world is of human origins, then it will fail. But if God has commissioned both men and women to take dominion together—if God has anointed His daughters to go forth in His name—then the gender traditionalists or anyone else who tries to hinder them will not be able to stop, overthrow, or destroy them, and they might even be fighting against the purposes of God!

Women are thoroughly capable of carrying their own load. God also prepared them to take dominion at Creation. As

equal dominion-takers, women would be an enhancement to men because they would no longer have the sole burden of speaking for and carrying the lives of women on their shoulders. Allowing women to reach their potential will help in marriages because both men and women will have a "voice" in their families. Jesus will become the ultimate Authority in the home, the One the one-flesh union of male and female seeks in determining their family's destiny.

As the end times approach and Christ's return becomes more eminent, His body must be unified in all spheres, and that includes the role of women in Christendom. Divisions must cease, whether they are racial, sexual, or doctrinal. Gender division is the final frontier within the church that has to be explored and abolished. This book highlights the need to break down the male hierarchical tradition that has spawned male domination and female subordination. Jesus has already paid the price on Calvary for a woman's true liberation, which bestows upon her the ability to fulfill her gifts, talents, and destiny.

God's daughters must have the freedom to come forth and fulfill God's will for their lives. The Holy Spirit is not discriminatory; He distributes gifts to all so that God's people can fulfill kingdom purposes and build up the church. (See 1 Corinthians 12:7–11.) Christians bicker over doctrinal differences concerning what women can and cannot do. It makes one wonder: is the bickering over a "woman's place" more important to some in the church than using available people—male or female—to embrace the wounded, discarded, and isolated both in the world and in the body of Christ? As Joyner laments, "How many potentially great and effective men and women of God are now lifeless pew warmers because we snuffed out the vision God had planted in them

for ministry?"[10] Both men and women are desperately needed to fulfill God's mandate to take dominion. When there is bondage in the body of Christ, everyone suffers; for where there is the lack of liberty, there is also the lack of abounding grace in establishing kingdom purposes here on Earth. This book is for those, like Christy and her husband, Marcus, who believe there is more for women than what some churches have offered them in the past. It is for people, both men and women, who see women fulfilling their destinies in the body of Christ and bringing the restoration to women that was given to them through Jesus' atoning death and resurrection. It is for people who see their marriages as complete one-flesh unions where both man and woman equally submit, respect, and honor each other, and both husband and wife place their spouses' needs above their own. It is for people who believe that Jesus is the ultimate Authority in marriage and everything that pertains to the body of Christ.

Destiny Denied re-examines the Creation and the Fall—the role that both the man and the woman played in it—as well as Satan's onslaught against women throughout history. Women's plight is traced historically and in Christian tradition as it relates to male authority, Jesus' treatment of women, the interpretation of significant New Testament scriptures, and the subsequent manner in which some Bible verses have been misapplied in the lives of contemporary women. In addition, the works of theologians, biblical scholars, and ministry leaders are used to re-examine interpretations of controversial New Testament scriptures that have been used to justify the subordination of women. This treatise brings to light the manner in which Greek and Roman philosophies have infiltrated the church and its application of theology.

Because of its relevance, women's complicity in their own devaluation is also explored.

This book is not a condemnation of men or women who have a traditionalist belief system; it does, however, provide scriptural answers for those who believe that a woman should not be restricted to a limited role within the church and home. This author acknowledges that some traditionalists who theoretically believed in male authority and female subordination have in actuality practiced equality in their own marriages. These husbands and wives sacrificially serve each other and mutually submit, honor, and respect each other. The author further notes that there are traditional church leaders who allow women to utilize various ministry gifts.

The erroneous argument that having restrictions on women solidify rather than blur the lines of masculinity and femininity will be debated. Men and women who treat each other equally within marriage are the ones who truly abide within a one-flesh union. Women being used in their God-given ministries are fulfilling God's destinies, for "there is neither male nor female: for ye are all one in Christ Jesus" (Gal. 3:28, KJV).

Destiny Denied is divided into four sections. The first, "The Best-Kept Secrets of the Creation and Fall," chronicles the Creation and Fall. It examines the truth and exposes the myths and their consequences on human beings, especially women and their destinies. The second part, "The Jesus Revolution," reveals the roles Jesus and the early church played in the restoration of women. Part 3 explores what happened to women down through the centuries, from the early church fathers to the post-Reformation Period. The final section of this book presents what's happening to women in many of today's traditional churches.

PART 1:

The **BEST-KEPT SECRETS** of the **CREATION** and **FALL**

Chapter 1

WHAT THEY DIDN'T SAY ABOUT CREATION

It is as though the power structure in the church
and ministry is labeled with a big sign: For Men
Only—God Says So! "But is that really what God said?
What does it [the Bible] really say about women?"[1]

—PATRICIA GUNDRY, AUTHOR

THIS STORY MUST truly break the heart of God, but sadly,
how many women actually feel this way?

I Hate God for Making Me a Woman

As Funmi grew into womanhood, she found many inequities within her society as it related to men and women. To her dismay, the equality that she had been taught as a child was not always evident even in her parents' marriage! Her anguish reached its highest point one day as she sat in a college fellowship:

It was her second year in college; Funmi thought of suicide as she helplessly sat in that campus fellowship. The preacher joked about women, noting that, in ancient Israel, men often recited this declaration, which is one of three daily chants, "Thank God I am not a woman." His joke was met with laughter and smirks from others who appeared to agree with him.

Dejected, Funmi wept, hating God for making her a woman. She felt entrapped, imprisoned in a female body with its restrictions. Funmi had grown up in a family that taught her and her siblings (one brother and two sisters), that they could become anything they wanted. As she developed into a young woman, she began to experience the gender inequities in her society.

She had met and fallen in love with Jesus while in college. Her heart's desire was to dedicate her life to teaching and preaching God's Word. It surprised her to find that her relationship with Jesus did not eradicate injustices against women.

Pent up with hurt and anger after the campus fellowship episode, Funmi met Collin, a godly young man who prodded her to reach out to God in the midst of her pain. She began to thank God for creating woman in His own image. God reached down and lifted her from her despair. He also lead her to scriptures, such as John 16:13–15, which states that He would guide her into all truth through the Spirit. God taught Funmi to see beyond the culturally bound spiritual leaders in her society. She began to search the scriptures for herself as the Bereans did. (See Acts 17:10–11.)

Funmi, in the end, discovered that God is calling women with willing hearts to look beyond impossibilities and reach for the stars.[2]

Other women may not meet Christians (as Funmi did) who will encourage them to praise the Lord and allow the Holy Spirit to guide them into all truth. Hopefully, this re-examination of Creation will inspire women (and men) to seek God in fulfilling their destinies.

Creation Revisited

The assumption that God mandated female subordination at Creation is a myth that is perpetuated by segments of the church, particularly gender traditionalists. Genesis 1:26–28 states that God made man—male and female—in His image. He also gave both male and female dominion of the earth (no mention of hierarchy). The term *man* originally referred to human beings, without reference to the male sex specifically.[3] The first chapter of Genesis presents a generalized account of Creation and the mandate from God to take dominion:

> And God said, Let us [the triune God] make man [male and female] in our image, after our likeness: and *let them have dominion* over the fish of the sea, and over the fowl of the air, and over the cattle, and over all the earth, and over every creeping thing that creepeth upon the earth. So God created man [male and female] in his own image, *in the image of God created he him: male and female created he them. And God blessed them and God said unto them, Be fruitful and multiply, and replenish the earth, and subdue it: and have dominion* over the fish of the sea and over the fowl of the air, and over every living thing that moveth upon the earth.
> —Genesis 1:26–28, emphasis added

Both Genesis 1 and 2 are about the creation of the human species. The Septuagint (Greek translation of the

Old Testament) states that the Hebrew *adam* is as the Greek *anthropos*, which means "person" or "human." *Adam* (humankind) was formed from the dust of the ground in Genesis 2:7 and bore the image of God upon *them* (male and female). In Genesis 1–2:22, an interesting play on words produces *ha adam* (earthling) from the Hebrew *ha'adamah*, which means "the earth." *Ha adam* or *adam* is a collective noun that refers to humankind, male and female.[4] Here *adam* is the plural for male and female, not the singular for man; the singular word for man (male) in Hebrew is *ish*; the Greek word for man/male is *andros*.[5] Thus, the Hebrew *ha adam* (earthling) is "humankind" in English, and this is reflected in Genesis 1 to 2:22. The use of *man* as a term that represented all human beings began at that time; it was only within the twentieth century that *man* came to solely refer to the male of the human species. Inferring a male hierarchy in reference to the use of man has no basis.[6]

It was *ha adam* or *adam*, male and female, that God told to bless the earth through multiplication, dominion, and authority. God states this before he molded the female Adam from the substance of the original *adam*, "The LORD God said, 'It is not good that man should be alone; I will make him a helper comparable to him'" (Gen. 2:18, NKJV). According to Spencer, Genesis 2:18 literally reads in the Hebrew: "And the Lord God thought it was not good for *adam* (meaning the earthling) to be by himself; 'I will make for him a helper as if in front of him.'"[7] God then parades the animals before *adam* so that they could be named. (See Genesis 1:28.) God also wanted *adam* (the earthling) to know that it was not good for him to be alone. One person does not make a society. In taking the female Adam from the same earthly being, *adam*, God provided a comparable mate. Thus, *adam* was human-

kind and from the substance of the initial human, God created the female Adam (she was not Eve at that time).

Gender traditionalists' views are substantiated in their actions, writings, and interpretations of Scripture. Ortlund's "Male-Female Equality and Male Headship" provides an example of the gender traditionalists' view of man and woman's creation. Ortlund in his narrative makes woman's relationship to man the central issue, and her relationship to God of less importance. In defense of male authority, Ortlund makes several faulty assertions, which are explored here.

Faulty Assertions about the Creation of Humankind

1. Ortlund states that the equal creation of male and female in God's image is a paradox, a contradiction. He notes that Genesis 2 speaks to male authority. Ortlund argues that God made the male the head and the female the helper or assistant. He calls this a "complexity" because the woman was created to be the man's helper. The inference is that her designation as a helper is not exactly equal to his designation as her authority. That is what Ortlund labels a "complexity" in his narrative.[8]

Contrary to Ortlund's belief, the female Adam was not the male Adam's assistant, nor was she placed on Earth to solely satisfy his needs. The creation story presents a clear picture of the woman's creation as the man's equal— co-image bearer and co-dominion-taker on earth. On the sixth day, God fashioned *adam* (humankind, male and female), his ultimate creation for which all other things were made. The process began with *adam* and ended with the formation of the female Adam. The period between the first creation and second creation did not constitute male

as authority or superior being; it was used to show that one earthling/human being does not alone constitute human-kind. "It is not good for man *(adam)* to be alone" (Gen. 2:18, author's paraphrase). Creation was fully complete after the woman was created from the common material of the original *(adam)* to show the interrelatedness of the human species.[9] The creation of human beings was not good until the manifestation of the female of the species. (See Genesis 2:18, 21–22.)

Ortlund errs when he suggests that the use of the term *male* meant that man (as a sexual being) alone was the designee for the human race, while the female was a subordinate. According to him, she could not represent humanity in its fullness. From the Hebrew text, it is clear that the original *adam* was not intended by God to be the sole (one person) embodiment of the human race. It was only after the woman's formation that God's work was good and complete. The comparable help made it good. (See Genesis 2:18.)

The ancient Hebrew language was an expression of patriarchal culture, thus man encompassed both male and female. One cannot conclude that because the Bible was written under divine inspiration, the languages or the words within the languages in which the Bible was written were themselves created under divine inspiration. These languages were as male-centered as the cultures they reflected and by which they were created. The fact that certain words in a language can be used to refer either to a male human or to humans in general reflects cultural concepts of gender; it does not reflect God's view of gender. It must not be inferred that just because God made use of androcentric (male dominated) language, He concurs with the premise of such language. God's use of a male dominated language does not mean that the male fully

represents humanity and the female is a subset of humanity who does not represent humanity in its fullness.[10]

2. Ortlund supports the belief that woman cannot be man's equal because he was created first and placed in the garden to develop and guard it. Therefore, it is this priority of birth that makes him the woman's authority.[11]

This is another fallacy; priority of birth had nothing to do with authority in the creative process. If this theory—that man was first in creative order, and, therefore, is in the position of authority—is used, one must ask why this theory of priority of birth was not used for those creatures created before man. That would place everything that preceded man in authority over him. Priority of birth had nothing to do with it; "God did his creative work in ascending order of importance and sophistication, beginning with inanimate matter, then the realm of vegetation, next the animal kingdom, and finally human beings."[12] Ascending order would mean that *adam,* male and female, was the last order of importance. Priority of birth does not make sense even for those who believe that the original creation was a male Adam, rather than *ha adam* (the earthling), from the original Hebrew. Thus, there becomes no justification for making him an authority over the woman because one would have to ask, then, why does that sequence of creation not make the animal kingdom in authority over humans because of their priority of birth? Spenser surmises that it is not the sequence of creation that is of value; it is the design for each creative being.[13] Also, the second creation's depiction of woman being taken from *adam* does not make her inferior or subordinate "any more than man's being made out of dust makes him subordinate to the earth, or males'

being born of women make them inferior to and perpetually subordinate to their mothers or to women as a class.[14]

Priority as a theory cannot be legitimized on the basis of man being the ultimate creation. The creation of *adam*, the earthling, was incomplete until the manifestation of the female, the last creative act of God in creation. God's ultimate creation was humankind, male and female. God did create male and female animals separately because there was no intended creative interrelationship or one-flesh union between male and female animals as it was meant between the human species. God demonstrated that male and female were of one substance, and ultimately one flesh.

Thus the argument for male superiority does not wash, nor does the argument for male headship and authority, because of a priority of birth. No hierarchical order was mentioned in the creative account. The practice that the first male should hold the authority—priority of birth (primogeniture)—was a Middle Eastern custom. This cultural thread was used, and continues to be used, as if it were God-ordained. There is an array of biblical examples in which God chose a younger sibling—Jacob over Esau; Ephraim over Manasseh; the tribe of Judah over the tribe of Reuben; and David over his older brothers.[15] The truth of the matter is that God never intended to arbitrarily choose the first-born son. Many times when God was doing the choosing, the choice of the eldest was an exception, not the other way around. Incidentally, Jesus has often been called the second Adam.

The "hint" of male headship that Ortlund refers to is not a biblical mandate for male authority over women as he suggests. There is no headship or hint of male headship mentioned in the creation process. Headship is mentioned in the New Testament. (See 1 Corinthians 11:3; Ephesians

5:23.) The scriptural interpretations of the New Testament verses often provide a preconceived mindset that gender traditionalists have used to refer back to Genesis. Even in the New Testament, headship denotes the source or origin, not authority. *Adam* was the original source (substance) from which God created the woman.[16]

3. Ortlund contends that amid the perfection, after creating the man, God suddenly realized that there was a deficiency in the garden. According to him, God put His finger on the one deficiency in paradise—man should not be alone.[17]

God did not suddenly realize that there was a deficiency in the garden and then decided to make the woman to meet that previously overlooked need of man for an assistant. Woman was not an afterthought; she was also *adam*. God had already established in Genesis 1:26 that His dominion-takers would be male and female and made in His image. He did not say that his dominion-takers would consist of a male and a female assistant. Unlike Ortlund's contention, God knew what He was doing; Eden was perfect and every intricate detail was planned before the foundation of the world.

4. Ortlund infers that because God did not immediately create the woman (he calls her the helper), she was created to satisfy the male Adam's loneliness.[18] The supposition is that she must have been made for the man, rather than made to take dominion with him. Remember, God moved through the actual creative process with purpose because He initially created *adam*, male and female. His ultimate purpose was to show that His creative beings were multiple and yet interrelated, and it was from these beings that society was formed. The animals were named by *adam*. God chose to show *adam* that a society of human beings are unlike the animals. Society was to be formed from beings who were comparable.

It would be a social structure of human beings who would be fruitful and take dominion on Earth. (See Genesis 1:26–28.) Those who would see the male Adam as the sole creation until God decided that He needed an assistant are missing out on the creative process—the shared humanity of the male and female. Evans refutes the hierarchical claim made by gender traditionalists who see men as the authorities and women as their created assistants:

> …(It) is not the difference between male and female, but their relatedness. Descent from one ancestor establishes both absolute unity of humanity, and the identical substance of both male and female in a way that separate creations from dust could not have done.[19]

5. Ortlund asserts that upon her creation, the woman was "uniquely suited to the man's needs." He emphasizes that the woman was created to meet the man's needs, but man was not made to meet woman's needs.[20] Nothing in the creative account states or even infers this interpretation. Male and female were the same substance, *adam*. She completed the creation process. Bird notes that once the female Adam was formed, the earthling *adam* became the male Adam:

> The man, now Adam, recognizes the woman Adam as his equal, a "helper fit for him" (Gen. 2:18). She is emphatically not his servant. "Helper (ezer) carries no status connotations, while the Hebrew expression is translated "fit for" which basically means "opposite" or "corresponding to." The statement simply expresses the man's recognition (the story is told from his point of view exclusively) that he needs her and that she is essentially like him…Woman is not a separate order of creation like (each of) the animals…The essential

oneness of the two distinct persons is proclaimed in the man's recognition."[21]

A Destiny for All

In the end, female subordination is not corroborated in the creation account, and it is only through the study of the actual creation account that one can ascertain what really happened in the beginning. Firstly, male and female were created equally in the image of God. (See Genesis 1:27.) She was taken from *adam* (the earthling), but it was a direct creative act of God and "her first and primal contact was with her Maker. Woman herself knew God before she knew her counterpart, the man."[22] Secondly, priority of birth has no relevancy here. Both man and woman were created *adam* (the earthling/human being). In addition, creation was not good (it was incomplete) until the manifestation of the female Adam. (See Genesis 2:18.) Thirdly, the female Adam was not an afterthought of God. God's plan was conducted as planned; He makes no mistakes. God was showing *adam* that it was not good for him to be alone. He would make him a comparable helper. (See Genesis 2:18.) A society of human beings had to be comparable, from one source. Fourthly, the female Adam was not created for the purpose of satisfying the loneliness of the male sex, for *adam* was not just the male. To believe that females are made to take care of males' loneliness misses the point. *Adam*, as the earthling, had to know that the social structure of a society could not be made of a one-person entity, thus the one-flesh union of male and female and the social order began. Fifthly, the female Adam was not created an assistant to meet the male Adam's needs. She was the final manifestation of the creation. The male recognized her, not

as an assistant, but as himself. She was woman—"bone of my bones, and flesh of my flesh" (Gen. 2:23).

God established no hierarchy between man and woman. Both were made equally in His image. However, rather than analyze the creation text on its own merits, some traditionalists use Paul's teachings on gender roles to substantiate male authority, not considering that Paul's restrictions may have applied to specific problems within the early church. The study of the New Testament should not be the basis for interpreting Creation; the study of Creation should be the foundation for interpreting the New Testament. Those who have restricted women in fulfilling their God-given destinies often have interpreted the Creation by using the New Testament.

The gender traditionalists' problem then becomes one of showing how male authority was written or implied in the Genesis text. They then use New Testament scriptures and revisit Genesis, as Carlson–Theis asserts, to "show how the opening chapters of Genesis can be reconsidered such that male leadership is proved to be embedded in the created order."[23] Failure to start at the Creation is placing the cart before the horse.

Since there is no mandate at Creation for male authority, the belief system of men and women as equal in being but unequal in function is unfounded. God gave the mandate to both male and female; He did not place boundaries on either.

Chapter 2

WHAT THEY DIDN'T SAY
ABOUT THE FALL

Because it resulted from the Fall, the rule
of Adam over Eve is viewed as satanic in
origin, no less than is death itself.[1]

—GILBERT BILEZIKIAN, THEOLOGIAN

RENA SAT IN church one Sunday in March 2006. She
was anxiously anticipating the Sunday's message. To
her disappointment, the pastor did not speak that day;
he introduced a visiting speaker, who began his sermon
by recounting the Creation story. He spoke of Eve being
deceived into eating the "apple" by Satan. As he recounted
the Fall, he noted that her disobedience was getting out
from under her husband's covering. (The speaker never
mentioned the woman's disobedience to God; that did not
appear to be relevant.) As the traveling minister continued
his sermon, he stated that no one knows how long that
good and just man (he was speaking of Adam) had to

walk around that garden dealing with that (evil) woman after she had eaten the apple. He finally gave up and ate the "apple," too. Stunned, Rena walked out of church. She could not believe what she had just heard! Could this really be happening in the twenty-first century?

How many women have experienced what the lady in this story experienced? Down through the ages, many have viewed the female Adam (Eve) as the destroyer of humankind. There has been this hidden message in the church that women's plight is punishment for the curse placed on the first woman. Women have been besmirched with the taint of being the daughters of Eve. The distortion of the Fall has wrought havoc on the lives of women for far too long. This chapter takes another look at the Fall and its consequences.

The Fall

The couple was placed in the garden to take dominion over it. God also placed the tree of life and the tree of the knowledge of good and evil in the garden paradise. The tree of life brought forth eternal life with heavenly benefits, while the tree of the knowledge of good and evil brought forth death, excluding God's presence and security. God had commanded His image-bearers to guard and tend the garden, but not to eat from the tree of the knowledge of good and evil. (See Genesis 2:15.) The male and female Adam were created to be God's ambassadors here on earth. Their destiny or commission, as God's ambassadors, was to complete the designated mission (take dominion). Their failure would place God's government in peril. Both had been told not to eat of the fruit of the tree of the knowledge of good and evil. They knew that disobeying God's order would result in death!

The general consensus is that the male Adam imparted the information about the tree of knowledge to the female Adam. This is a possibility, but it is more plausible that God taught the woman. It is also probable that the couple had been in the garden for some time before they were approached by the serpent/tempter. God had been communing with the couple (not just the male) on a daily basis. The tree, no doubt, was discussed in the daily communions with God. God does not withhold any good (or needful) thing from His people.

One day, the serpent, a trespasser in the garden, approached the couple. It was the female Adam who had discourse with him about the tree of the knowledge of good and evil, while the male Adam remained silent by her side. In discussing the edict, she added to it by saying that God told them not to touch the tree. As the narrative continues, the woman ate of the fruit and gave some to her husband, who also ate from the tree.

Much controversy has surrounded the events of the Fall. As the traveling minister remarked, traditionalists surmise that the woman got from under her husband's covering, usurping his authority. The assumption they make is that authority was given to the male Adam at Creation. Many Christian leaders have preached that the woman was targeted because she was the weakest link.

Traditionalists make several typical assumptions concerning the Fall. Those assertions are critiqued here using Stephen B. Clark's *Man and Woman in Christ* as the example of the traditionalists' point of view.

1. Firstly, Clark notes that God leaves to Adam the task of passing on the commands to the female Adam. One of the obvious commands was the prohibition against eating from the tree of knowledge of good and evil.[2]

The idea that God passed to the male Adam the assignment of sharing the edict with the female Adam is somewhat simplistic. As McClelland asserts, "For the woman to know the prohibition as well as she did, she must have been educated in its content. Either God specially revealed it to her, or in what would be most natural as a fitting interchange between the supposed co-sovereigns of the creation, Adam would have taught her."[3] In other words, she learned the prohibition from either God (a natural conclusion) or the male Adam. If she learned it from God, it is obvious that she added the prohibition about not touching the fruit. Now, if she learned it from Adam, "is it not just as likely that it was Adam who added this injunction (about touching) in the first abortive attempt by one human being to educate another?"[4] After all, he raised no objections to what she said or to eating the fruit (himself).

According to some traditionalists, it was Adam who was solely responsible for the Fall because he allowed the female Adam to get out from under his authority; her sin, they assumed, was usurping the man's authority. If the man (as some reason) taught the woman the prohibition, God held him responsible for the Fall, not because of any supposed allowance of the woman usurping his authority, but because of his improper teaching of the edict! It could also have been that His calling on the male Adam first after the Fall had no particular relevance other than desiring that he face up to what he had done, for God also called on the woman and held her responsible for her own act of disobedience.[5] God held them both accountable for their acts. He never stated or inferred that the female Adam got out from under the male Adam's covering.

2. Clark then asserts that the female Adam was alone when the serpent confronted her and chose to communicate with her rather than the male Adam because it was easier. But the female Adam was not alone when the serpent approached her. They were both there, and the serpent enticed both as indicated by the use of *you*, the plural, in Genesis 3:1, 4–5.[6] The serpent/tempter was talking to both the man and the woman when he asked, "Did God really say you must not?" (Gen. 3:1, NLT). Hamilton makes a case for both the male and female's presence in the encounter. He emphasizes that in English, *you* can refer to one or more than one, but Hebrew has two different words for the singular and plural: the word *you* here is the Hebrew plural. The woman also responded in the plural by using the word *we.* The tempter used the plural *you* again when he said, "You will not surely die."[7]

More corroboration of the male Adam's presence is found in verse 6, "She also gave to her husband with her, and he ate" (NKJV).[8]

3. Clark believes that the serpent approached the woman because she had a weakness, which possibly made it easier for her to disobey God. He disagrees with some other traditionalists who believe that it was her character that was weak. He believes that the New Testament does not claim that the female Adam fell because she was more deceivable. Yet, he states that there is "something in the author's mind" concerning the woman's greater vulnerability.[9] Clark uses his interpretation of 1 Timothy—that the woman stepped out from under the man's "headship" and usurped his authority—to make his point.

One problem with Clark's view is that even though he sees nothing in the passage to note a greater weakness in

the woman's character, and even though the New Testament writers speak of no greater vulnerability (his own words in a footnote at end of the page), he still asserts that there was "something in the author's mind concerning the woman's greater vulnerability."

There is nothing to substantiate just what a "greater vulnerability in the author's mind" means. Clark justifies his belief that the female Adam must have had a "greater vulnerability" because the woman's dialogue with the serpent/tempter and her subsequent fall was presented more fully than the man's fall was. He believes that this more expansive presentation of the woman's dialogue with the tempter conveyed something that was unstated in the author's mind as to her "sense of greater vulnerability." There is no way that Clark or anybody else can use a "feel/sense of greater vulnerability" in the author's mind to make a determination or case about any aspect of the Fall.

Clark then uses his "greater vulnerability" theory as the main reason the female Adam stepped out from under the man's covering and usurped Adam's authority. He notes that Genesis does not explicitly state a reason as to why the serpent approaches the woman. Again, rather than sticking with the Genesis account, Clark establishes his point by introducing New Testament verses to qualify his belief in male authority.[10] There are more plausible explanations as to why there was only discourse between the serpent and the female Adam. For one thing, it signifies that Adam was not in authority. If Adam had been in control, it would have made more sense for the serpent/tempter to have made Adam his priority, for he could have secured the Fall of both by getting Adam. Also, Adam could have run interference or refused to eat the fruit, which would have thwarted the whole thing. Belezikian notes

that the cleverness of the tempter led him to believe that he would get the most resistance from the woman, and that if she fell, Adam would, too. It was the female Adam who faced the serpent with authority, and she put up more resistance; Adam fell instantly![11]

> ... The fact is that the tempter was not dealing with a chain of command in the garden. Either one of the two would do for the tempter to gain entrance into their lives. Adam's willingness to follow "Eve's" [author's quotes] example and to take of the fruit she gave him confirms the absence of predetermined roles in the garden.[12]

4. Clark infers (he does not state) that the female Adam's greater vulnerability/weakness was that she accepted the tempter/serpent's reasoning about the prohibition that she would not die, but would become like God (or possibly gods).[13]

There are two things that are omitted in this and other interpretations by traditionalists of the dialogue between the serpent and the woman. Firstly, while much is written about the woman's adding to the prohibition and consequently sinning because she was enticed/deceived by Satan's argument that she would not die, but be like God, nothing is written as to her reasoning for engaging the serpent (Satan). Her reasoning was more complicated than previously noted; she did not just partake of the fruit because the serpent said that she would not die. Her deception was not due to an intellectual deficiency or a blank slate (tabula rasa) as some have alluded over the centuries. The Bible states that she "saw that the tree was good for food, and that it was pleasant to the eyes, and a tree to be desired to make one wise"

(Gen. 3:6). In essence, she desired to be wise like God. She communicated extensively with the serpent/tempter concerning the prohibition, improperly stating that God said that they could not touch the fruit. It was evident by her conversation that she desired the nutrition, aesthetics, and knowledge that partaking of the fruit would provide her. The female Adam's disobedience was to God. The male Adam, present along with her, had no discourse with the serpent; he just ate the fruit. The deception was not that the serpent/tempter talked a gullible woman who had no desire for the fruit before their discourse into eating it. The female Adam became deluded in her desire "to become like God, knowing everything."[14]

Secondly, it bears reviewing the male Adam's motive in partaking of the fruit. He was there, and yet he did not argue as to whether they should or should not eat the fruit. As stated earlier, he did not offer a correction for the woman's misquote. Adam was complicit in the deed.

5. Clark explains that when God arrived, the man and woman hid from him. He states that when God questioned the couple about their behavior, their disobedience is then revealed.[15]

The assumption that their sins were revealed when God questioned them is not accurate. The man and woman realized their nakedness and sin before God approached them. Their inward sin had already caused them to try to hide by covering their outward appearances. (See Genesis 3:7.) The covering of their physical nakedness did not hide their inward spiritual sin. As they shared their disobedience with God, they began to justify their sin with the blame game. (See Genesis 3:12–13.) As for God, he already knew what they had done before they revealed their hidden sins. God confronted

them in the discourse so that they would acknowledge their sins, rather than cover them up as they had begun to do. He asked them, "Where are you?" God knew where they were, but they needed to be open with the nakedness and ramifications of their sinful deeds.

6. Clark talks about God divvying out consequences to the couple for their sins. He accepts the view that the indictments against the man and woman were curses from God.[16]

The couple set in motion their own spiritual death—separation from God—and physical death. Their sin put into motion the fallen state of the entire world. They had been forewarned that this would happen. If you eat of the tree of the knowledge of good and evil, "You shall surely die" (Gen. 2:17, NKJV). The consequences of their fall was more cause and effect and, as Belizikian emphasizes, the couple unleashed a cataclysmic disaster that would reverberate down through the centuries.[17] In their fallen state, everything became distorted, even their relationship with each other.

The Consequences of the Fall

After the Fall, the world was no longer an idyllic place. Because of their disobedience, the couple had severed their relationship with their God and Creator, leaving their dependence on the earth from which they were formed.

When God revealed the consequences of their sin, He engaged each individually. There was no hierarchy. In approaching *ishshah* (the female Adam), he did not talk to her through her husband. He did not ask her why she did not seek the permission of her husband, neither did He tell her that she usurped her husbands' authority and would reap curses because of that. Belizikian notes that the woman faced the serpent/tempter with authority that substantiated

the absence of a chain of being. The tempter realized that getting either one would have given him entrance into their lives. For Adam to have directed the female Adam's actions (been in control of her), the discourse would have had to have begun with him.[18]

God told the woman, "Your grief and sorrow will be multiplied in pregnancy and childbearing and you will desire your husband and he shall rule over you" (Gen. 3:16). Fleming states that the woman's bearing of children in pain was not an indictment from God because of her sin. It was a consequence of her disobedience; God was not the direct agent who brought about the action. He told her in verse 16 what her life would be like with a partner who would rule over her. This was not an indictment; it was in fact the result (cause and effect) of the sinful nature brought on by her sin.[19] Yet, the woman would turn to her husband even as he ruled over her. Schmidt states that a culture of sexism changed the original translation of the Hebrew word *teshuqa* from "turning" to the word "desire" now used in translations:

> Thy *desire shall* be to thy husband, and he shall rule over thee.
>
> —Genesis 3:16

Other ancient texts (Syria Peshitto, A.D. 100; the Old Latin, A.D. 200; the Sahidic, A.D. 300; the Bohairic, A.D. 350; and the Ethiopic, A.D. 500) also define *teshuqa* as "turning" and not "desire." The word *will* was also changed to *shall* in the various translations down through the ages. *Will* was a voluntary (volitional) act in the Hebrew translations, and *shall* inferred a sense of obligation.[20] Thus, what should be, "Your turning will be to (toward) your husband," has become: "Your desire shall be to your husband" (Gen. 3:16).

God also told the female Adam that her turning away from God toward her husband would be inordinate and result in dire consequences for her. Neither the biblical text nor subsequent natural observations support the argument that the woman's turning away from God was driven by sexual desires for her husband or other men.[21] In a distorted reversal, the husband takes priority over God in the woman's life. Walter C. Kaiser declares that the woman's turning away from God is grossly misinterpreted when it is seen as sexual rather than a form of idolatry:

> This is both a misrepresentation of the text and a male fantasy born out of some other source than from the Bible or human nature. Even if the word is tamed down to mean just an inclination or a tendency, we would be no further ahead. These renderings would still miss the point of the Hebrew. The Hebrew reads: "You are turning away [from God!] to your husband, and [as a result] he will rule over you [take advantage of you]."[22]

This change (from *turning* to *desire*) dates back to the Italian Dominican monk, Pagnini. The Hebrew Old Testament had used the word *turning* before that time. It was used three times—in Genesis 3:16, 4:17, and Song of Solomon 7:10. Even the church fathers—Clement, Irenaeus, Tertullian, Origen, Epiphanius, and Jerome—interpreted *teshuqah* as "turning" rather than "desire."[23]

The damage continues with the interpretation of Genesis 3:16, "He shall rule over thee." The argument that this statement is mandatory misses the point. According to Kaiser, the verb "to rule" states what will happen in the future with no hint of a mandate from God. God is telling the woman

that because she turned away from Him (God) toward her husband, he (her husband) would take advantage of her.[24]

Thus, *teshuqah* did not mean the sexual or lustful desire of the woman for the man and neither did the use of the verb "to rule over her" mean that God commanded husbands to subordinate their wives. The translations of these words have done much to malign the relationships of men and women.

Another error in many Bible versions today is the translation of Genesis 3:16 as, "I will greatly multiply your pain in childbearing; with pain you will give birth to children. Your desire will be for your husband, and he will rule over you" (NIV).

Fleming states that the above version of Genesis 3:16 does not reflect the original Hebrew text. She emphasizes that "such looseness in translation takes unwarranted liberties with the Hebrew text. These versions have borrowed the concept from 3:16, "in pain you shall bring forth children", where it may properly belong, and wrongly infused it into line *a*. The King James Version of the Bible provides the best version of Genesis 3:16, which notes, "I will greatly multiply thy sorrow and thy conception."[25] This version is closer to the original Hebrew text, and it brings a totally different dimension to the verse. Sorrow and conception are greatly multiplied, not pain in childbearing.

As for Adam's sin, it was not that he ate of the fruit because his wife gave it to him; they were obviously in agreement. God told the man that the ground had been cursed because of him:

> In sorrow shalt thou eat of it all the days of thy life;
> Thorns also and thistles shall it bring forth to thee; and
> thou shalt eat the herb of the field (not the garden).
> —Genesis 3:17–18

Adam's relationship with the ground was now reversed; he no longer had dominion over the ground, for it was now cursed and his toil would be painful. The ground once ruled by man now rules him and eventually reclaims (absorbs) him. His domain becomes his cemetery; his throne becomes his grave. In his pilgrim journey toward the grave, he is afflicted with pain, itself a harbinger of death that will inevitably devour his being.[26]

The man's relationships became distorted; he turned away from God and his wife. Fleming asserts that the man seized power for himself and subsumed the woman into what was now a usurped kingdom with radically different authority structures.[27] It is here that the man names the woman *Eve*, "mother of all living;" she was no longer *ishshah,* or the female Adam. It is here that the same words that were used to name the animals were used to name the woman, thus sealing their separation, disunity, and his dominion over her in a fallen world. She becomes part of the kingdom dominated by him. In so doing, he would take the place of God in her life and claim to be her new lord.[28] When Adam renamed the female Adam, he named her Eve and thereby severed their unity. They would now have two names and be two separate entities. This, too, is what God warned the woman of in Genesis 3:16. Adam dethroned God in his own life and subordinated Eve's existence under his authority.[29]

Because of sin, Adam and Eve's marriage was no longer a true representation of the one-flesh union. Instead of cleaving to his wife in a face-to-face partnership, he is about to "rule over her." Instead of ruling together over the animals as they used to do, she is under his rulership, along with the animals. Eve was no longer seen as Adam's complement; she was identified solely by her role as mother, the bearer of

children, especially male children. Motherhood became the barometer by which she and subsequent women determined their self-worth.

God cursed the ground and the serpent/Satan. He tells Adam that because of him the ground would heretofore be cursed, "Thorns and thistles shall it bring forth to thee" (Gen. 3:18). The serpent (proud and crafty) is brought low, humiliated, and made to move on his belly. (See Genesis 3:14.) To Satan, God says in Genesis 3:15:

> I shall put enmity Between you and the woman, and between your seed and her Seed [Jesus]; He shall bruise your head, And you shall bruise His heel. (nkjv)

Not only would there be enmity between Satan and the Seed of the woman, but there would also be enmity between Satan and the woman herself. (See Genesis 3:15.) Since the Fall, Satan has despised the very existence of woman. This oppressive hold on the lives of women has transcended the consequences of the first woman's sin. Because of his influence on a fallen world and sinful humans, Satan has, with a vengeance, wreaked havoc on women's destinies. Women have been thwarted in every realm.

God did provide a way to bridge and reconcile the man and woman's relationship with Him and thereby restore them into the kingdom. That bridge was the Seed of the woman, Jesus Christ. In the fullness of time, He would crush the head of the serpent and repair the breach between God and His creations. Jesus Christ, through His death and resurrection, also provided for reconciliation between man and woman. Other divisions brought on by the Fall have also been included in Christ's atoning death. (See Galatians 3:28.)

Contrary to what gender traditionalists believe, the woman was never considered a secondary player in the creative events. She was not reproved for taking the initiative in the garden conversation with the serpent/tempter, even though the content of her conversation was wrong. God highlights this in His conversation with the couple after the Fall.[30] Plus, she bore the Savior of humankind. If man had had anything to do with the birth of Christ, it would more than likely have been used to signify a male authority, in that he was the earthly parent of the Savior of the world. It would probably have been used to corroborate Clark's assertion that man is "the embodiment of the race."[31]

Mickelsen penned a satire pocking fun at traditionalists' use of isolated Bible verses to "supposedly" prove their belief in male authority and rule. (See the Appendix.) In the satire she uses the same technique to demonstrate that women could also be depicted as the superior sex if certain isolated scriptures were used. The satire shows the sheer folly of using certain scriptures out of context to argue authority of one human being over another or one sex over another. This narrative emphasizes the relevance of using the entire Bible to determine God's will for both men and women rather than choosing isolated scriptures to prove a man-made doctrine.[32]

In spite of the dire consequences of the Fall, God presented a message of hope in the midst of the chaos and despair. God assures the couple that the death sentence would not change the blessing of Genesis 1:28, to be fruitful and multiply. God even delivers a new promise: the woman's seed will defeat the enemy.[33] The epitome of human restoration is the Seed, Jesus Christ, ultimately bringing redemption to humankind.

Adam and Eve were expelled from the Garden of Eden and away from the tree of life. God did not want them to eat

from the tree of life; He could not take the chance that they might eat from it and live forever in the state to which they had become. The couple had become like God, knowing good and evil. It would have been disastrous to have a disobedient people live forever in a sinful state:

> And the Lord God said, Behold, the man [humankind] is become as one of us, to know good and evil: and now, lest he put forth his hand, and take also of the tree of life, and eat, and live for ever: Therefore the LORD God sent him out of the garden of Eden, to till the ground from whence he was taken.
>
> —Genesis 3:22–23

Their disobedience had also allowed the tempter to trespass and take dominion of the world system. Satan/the tempter had succeeded in causing the couple to disobey; they were now separated from God and under his control. Satan used the tactic of divide and conquer to separate God from His image-bearers. (See Genesis 3.) In his conversation with the couple, he insinuated that God had made them inferior. This resulted in the first identity crisis, which parlayed the Eden dwellers into doomed humankind.

They did not sin against each other by eating the fruit; each of them sinned against God. Their fellowship with their Maker was destroyed. In addition, Adam blamed God and the woman; the woman blamed the serpent (this was essentially true); hence the beginning of the division and polarization of the sexes and man's inordinate rule over woman.

Both experienced spiritual death in their relationship with God. Van Leeuwen notes that both were created to be both sociable and dominion takers. The Fall exhibited the peculiar way each fell. The woman overstepped her boundary of

accountable dominion (toward God) by desiring and seeking that which belonged solely to God. The results were that her relationship with God ceased and her sociability became distorted and moved into social enmeshment toward her husband—she has since had problems with taking dominion in the world. The man overstepped the human boundaries when he accepted the fruit by disobeying God to maintain social unity with his wife. As a result, his spiritual relationship with God ceased, and his legitimate dominion became distorted as he moved into taking authority over his wife. According to Van Leeuwen, the Fall distorted their relationship, and social enmeshment by the woman and male domination by the man fit their particular sins.[34] Fleming asserts that not only did the man subsume the woman under him and became her lord, but there was also a drastic change in his countenance, evident by his accusation against God.[35]

> And the man said, "The woman whom You gave to be with me, she gave me [fruit from] the tree, and I ate."
>
> —Genesis 3:12, NKJV

The man took the place of God in the woman's life. God foretold of this; His declaration of their judgments was a *description* of what would happen to their marriage, not a *prescription* for what would happen.[36] Adam, in declaring lordship over his wife, declared his independence from God.[37]

Clark and other traditionalists have legitimized the distorted view of God's ultimate plan for humankind with their belief that female subordination began at Creation, not at the Fall. Clark contends that "His [meaning Adam's] life was the center of attention and the woman's life received direction from his life." He asserts that this pattern in marriage should serve the larger community.[38]

The traditional assessment is that the woman's relevance was in assisting her husband, for she was created for him. They assert that this specific type of subordination is not like that of a servant, but that it is the kind that "makes one person out of two." The merging of two into one flesh becomes, for traditionalists, not a blending of two, but rather a structural merging in which one takes a dominant role and one takes a subordinate role.[39] No amount of explanations for this "peculiarly complementary relationship," as traditionalists like to call it, can make a structural hierarchy into a one-flesh union. A union and hierarchy are diametrically opposed, and it is impossible to make these polar opposites synonymous in a marital relationship.

God wanted a united people who would represent Him on Earth, as well as a people to simply take dominion and inhabit His garden. The multi-personed God created a multi-personed human to represent Him on Earth. As His ambassadors, the first couple was created to carry out God's orders, just as governmental officials represent a government. When the orders are disobeyed or compromised; it is treason! That is what the Adam couple committed.

The natural and spiritual effects of the first couple's distorted relationship after the Fall still permeate the earth. Even though Jesus made the ultimate sacrifice of death and resurrection to bridge the gulf between human beings and God, the divisions between the sexes remain. For one thing, a spirit of male hierarchy has been passed down through the centuries, resulting in an entitlement that has permeated both the world and the church. This male authority is believed to be a spiritual mantle placed on men by God. Hyatt says, "'This false sense of divinely bestowed entitlement' causes them [some men] to think that anyone who does anything to embarrass or challenge them

has sinned against them and is rebellious against God."[40] Men who feel this way justify their belief system by noting that the Bible has given them this right. This belief, "the divine right of man," is derived, from among other things, "an incorrect understanding of biblical headship."[41] In many church settings, this belief carries with it the idea of "headship as a privileged place with the right to privileged treatment by others who are not privileged, that is, women."[42]

From that moment—the Fall—until the birth of Jesus, there was a dearth in the relationship between God and His creation. Not only did the evil increase, but also the knowledge of good (from the tree) as man saw it. Man's good became a substitute for godliness. This good manifested itself in religion, idolatry, and "what seemed right in their own eyes." Idolatry became the spiritual counterfeit for having a personal relationship with the living God. Religion and good works became prevalent, "forms of godliness without the power thereof" (2 Tim. 3:5, author's paraphrase). Thus, the good from the tree of the knowledge of good and evil became just as pervasive as the evil from the tree.

Male authority and rule reigned after the Fall, and those cords continued throughout the Old Testament times, entered the church after the first century, and is still alive and well today, even though it was not God's initial intent for the relationship of men and women. Keener states that Genesis 3:16 mourns the effects of sin and its consequences on human beings. He goes on to say, however, that Genesis 3:16:

> ...does not prescribe them (effects of sin) as a norma-
> tive rule we ought to follow, any more than the Fall's
> introduction of sin and death into the world is reason
> for us to promote sin and death.[43]

Chapter 3

THE DEADLIEST ENEMY OF ALL

The devil is not only attacking the character
of God but also doing all he can to destroy the
image of God. He knows that male and female
together are created in God's image.[1]

—LOREN CUNNINGHAM, FOUNDER,
YOUTH WITH A MISSION

SATAN'S ROLE IN woman's degradation and subordina-
tion has often been overlooked or ignored. The impact
of God's words to Satan in the Garden of Eden cannot be
discounted. After the Fall, God told the tempter, "I will put
enmity between thee and the woman, and between thy seed
and her seed; it shall bruise thy head, and thou shalt bruise
his heel" (Gen. 3:15). Satan has had a vitriolic hatred for the
Seed of the woman, Jesus Christ, since the Fall, for it was
Jesus who redeemed humankind through His atoning death
and resurrection. Jesus took back the keys of life and death
from Satan. Jesus did indeed get bruised through His suffer-
ings on the cross. The final and fatal wound, which is yet

to come, will bring about the total destruction of Satan. He knows that his days are numbered!

Satan's wrath does not end with "the Seed"; just as God stated in Genesis 3:15, his "enmity" was aimed at the woman as well. This aspect of the Fall is never adequately discussed in the theological debates about the consequences of the Fall, even though Satan has despised the very existence of woman. This oppressive hold on the lives of women has transcended the consequences of the woman's sin. Because of Satan's influence upon the world and the fallibility and sinful natures of humans, woman's destiny has been thwarted since the Fall.

This venom has been unleashed against women in all cultures, leaving in its wake women without the rights to fulfill their God-given destinies. As David Cunningham notes, "When we look at this issue of women and their role, we are entering humanity's most ancient battleground—the war of the serpent against the woman."[2] Down through the ages, Satan has used every tactic that he could to guarantee the devaluation of women in all societies and religions, including traditional Christian circles. He would like nothing less than to seal woman's fate so that she never walks out that destiny as co-dominion-taker with man. He would like no less than to insure and seal woman's subordination for eternity!

Cunningham asserts that the devil, in an attempt to prevent women from obeying God's call, has manipulated men by appealing to their pride in ascertaining that women are not equal to them and are, therefore, not worth as much. Cunningham views the issue from a leadership position after being in ministry for four decades. He says that two-thirds of Bible-believing Christians are women. Eliminating two-thirds of the Christian workforce from the harvest field is devastating.[3] Satan attacks women on the surface, but, in

actuality, he is also assaulting men. Men, in some cultures, are deceived into believing that this false sense of superiority is macho, when, in reality, it is the basis of all the "isms."[4]

The devil ferociously attacks women of all cultures. Women are suffering injustices all over the world. Their treatment in the Western world is better than their counterparts in many countries, but even here in the United States, women earn less than men for the same job. Here in America, deadbeat dads leave women to support children; teenage mothers are left to raise babies without the help of the young men who fathered them; more than one hundred thousand women will be raped this year; and one in every three girls will be sexually abused before they become an adult. On top of this, in the United States this year, husbands and boyfriends will beat more than eight hundred thousand women.[5]

World Vision paints a picture that is much worse in countries with no Christian heritage. Women, who are half of the population of the world, have just one percent of the world's wealth. In Africa and the Middle East, two million girls are mutilated through female circumcision.[6]

Satan sought to kill the Messiah when His time came to be born, but he has also waged war against womankind for centuries. This avarice toward women has been aided and abetted by those not just in most cultures, but also in most religions, including some Christian denominations.

The temptation to keep women from obeying God's call on their lives is an attack on males in the body of Christ. On the surface, this attack appears to be only against women, but when viewed on a deeper level, it is also against men. The enemy appeals to the pride of men by saying that women are not equal, not worth as much. This macho attitude is nothing more than pride.[7] As long as Christians do not discern the

tactics of Satan, women will be hindered in their destinies, which will ultimately hinder God's plan for all His people.

In many countries, women are still considered property and are subjected to countless acts of violence. Farrell recounts the many atrocities women face in the 10/40 Window, an area between the tenth and fortieth parallels, from northern Africa to China. Islam, Hinduism, Buddhism, Shintoism, Taoism, and tribal religions see women as inferior, less intelligent, untrustworthy, and subhuman. They are uneducated, exploited sexually, and, most importantly, prevented from hearing the gospel:[8]

- In Hindu countries, women are indoctrinated to the fact that they are valued less than cows, so they pray to be reincarnated as men.

- Some men in India marry rich women for their dowries; they then burn them alive for their money.

- Many Muslim countries prevent women from entering places where men pray, and they cannot go out in public unless they are accompanied by a male relative.

- Parts of Africa allow only men to eat nutritious foods, such as eggs, milk, and chicken.

- Four hundred and fifty million women suffer physical impairment due to childhood malnutrition. This malnutrition is the result of girls and their mothers having to wait to receive food until the men and the boys have eaten.[9]

- Before the overthrowing of the Taliban,
 Afghanistani women had to wear head-to-toe
 covering, which included a mesh screen over
 their eyes. Failure to do so resulted in beatings
 and stonings.

- Genital mutilation in some African countries
 insures a woman's virginity, which, the family
 asserts, maintains their honor.

- In many places, two female witnesses are equal
 to one male witness.

- Fathers, brothers, and husbands beat and
 murder women for what they deem as
 "disgracing" the family in many countries.

- Daughters are forced into prostitution by
 impoverished parents.[10]

- Of the 1.3 billion poor people in the world,
 seventy percent are women.[11]

Satan's attack on women does not just occur in other
countries; he also stirs up problems here in the United
States. Cunningham provides several areas where the devil
has launched attacks, heightening conflicts between men and
women and seeking to divide them through radical feminism
and the promotion of a homosexual agenda. All of these have
had profound effects on the plight of women.[12]

Upon His death on the cross, Jesus went to hell to confis-
cate the keys of life and death, and He paid the price for the
full restoration of all human beings, including the valua-
tion of women. Being saved does not always mean that one

is walking in total resurrection power. Jesus did not die for partial restoration for women and full restoration for men. Both men and women must be allowed to walk in restoration. Many women are ignorant of what has been granted to them. They have opted to walk in the residual effects of the Fall, even though they have received salvation. God has established laws for his people, just as He established natural laws. When a law is broken, whether natural or spiritual, it causes a negative chain reaction. The Fall caused a negative chain reaction on Earth. Jesus had to come to redeem humans from a fallen world system.

Much of Jesus' atoning and sacrificial death that would allow women to fulfill their destinies has been lost on the church. Plus, the church has not come to grips with the role that Satan has played in providing a smokescreen that keeps men pridefully believing that they and they alone are the representatives of God here on Earth. Man, using the name of God, has created a hierarchical chain of being by placing man and woman in a top-down status in which man represents God—thus creating God in the image of man rather than allowing man to be conformed to the image of God. (See Romans 1:23.) Many women, who have been complicit in this belief in female subordination, have passed down this inferior status to generations of their daughters. This has hindered many Christians, both men and women, from going to the harvest field and also from being used in many spheres for which they could have great impact.

Satan, the archenemy of all humans, has caused the traditional church to place more emphasis on religious formalities and restrictions on women rather than on fulfilling kingdom purposes. The church has succumbed to "a form of godliness but denying its power" (2 Tim. 3:5, NIV).

Satan is out to deceive even the elect. (See Matthew 24:24; Mark 13:22.) What Catherine Booth said in the nineteenth century is still apropos today: she emphasized that Satan is still deceiving God's people into circumventing His purposes, and, in the process, he is keeping the world under his control. He deceives with "a form of godliness," a caricature of the real thing.

Many are unable to discern the original from the facsimile. Satan has done this in several ways. Firstly, he has stymied God's purposes, as various people use their own religion and religious life as the standard-bearer of God. Secondly, he has been successful in deceiving many of God's people as to their duties and responsibilities to the rest of the world.[13] God's standard is His Word, and the Word made flesh is Jesus, the Christ, the Messiah, who came to redeem the world from their sins through His life and atoning death on the cross. The main goal of all Christians should be fulfilling kingdom purposes; it trumps everything else. Jesus left his people with the Great Commission to go into the world and take the message of salvation. That mandate is for all! (See Matthew 28:18–20.)

Chapter 4

CAPTIVE SOULS

Our teaching and treatment of women have often
had more in common with the ancient Greek and
Roman philosophers... Instead of shaping our culture
according to the Bible, we have allowed our culture
to shape us and even color how we read the Bible.
We have erred... making generations of women
believe that the God of the Bible is against them.[1]

—DAVID HAMILTON, BIBLE SCHOLAR

THROUGHOUT THE AGES, mankind has put into place
unjust systems that have been the result of their fallen
natures, not mandates determined by God. This spirit of
subjugation is still alive and well in some segments of Christ's
church, just as the church has condoned unjust practices in
the past. Some Christians once persecuted the Jewish people
as the killers of Jesus Christ. There were Christians who
condoned slavery and racism, even using the Bible to justify
their heinous beliefs.

Unjust practices relating to women fulfilling their destinies continue to be defended by certain denominations today. When women sought the right to vote in the United States, many in the church viewed women's suffrage as ungodly. Before 1920, women were believed to be ill-equipped intellectually to make sound decisions about politics; therefore, they were not allowed to vote.[2] As a consequence of the perception of women's inferiority, they had no rights in their own governance, in the church, school meetings, or governmental elections. Some of these injustices have been rectified, but, sadly enough, many in the traditional church still harbor some of these views about women.

Man-made hierarchical institutions have been justified by invoking the name of God. For instance, kingships began when the Israelites began to desire a king like the other nations around them. The heathen nations had kings and monarchies that ruled over them. When the Israelites asked Samuel to find them a king, God clearly noted that their desire for a king was not His will and that it was a rejection of Him:

> Then all the elders of Israel gathered themselves together, and came to Samuel unto Ramah, And said unto him, Behold, thou art old, and thy sons walk not in thy ways: now make us a king to judge us like all the nations. But the thing displeased Samuel, when they said, Give us a king to judge us. And Samuel prayed unto the Lord. And the Lord said unto Samuel, Hearken unto the voice of the people in all that they say unto thee; for *they have not rejected thee, but they have rejected me, that I should not reign over them.* According to all the works which they have done since the day that I brought them up out of Egypt even unto

this day, wherewith they have forsaken me, and served other gods, so do they also unto thee. Now therefore hearken unto their voice: howbeit yet protest solemnly unto them, and show them the manner of the king that shall reign over them.

—1 Samuel 8:4–9, emphasis added

Samuel proceeded to tell the people that a king would take one-tenth of their resources, their lands, and require service of their children and servants. He told them that they will cry out to the Lord because of the king that they had chosen, and He will not hear them. They rejected what Samuel told them:

The people refused to obey the voice of Samuel; and they said, Nay; but we will have a king over us; that we also may be like all the nations; and that our king may judge us, and go out before us, and fight our battles.... the Lord said to Samuel, Hearken unto their voice, and make them a king.

—1 Samuel 8:19–20, 22, NKJV

The people desired another god. Having an earthly king like the other nations was tantamount to idolatry. The Israelites, rather than looking solely to God Almighty, chose to have an earthly king rule over them.

Although earthly kingships were derived from the desire of the Israelites to be like other nations, God, as usual, worked within the confines of fallen man and allowed them to have a king. In His infinite wisdom, God used man's flawed earthly estate to bring forth the true King, Jesus Christ. God raised King David, and through his lineage came the King of both heaven and Earth. God allowed them to feed their depravity in the days of Moses when, after Moses did not come down

right away from Mount Sinai, the people made themselves a golden cow. Even today, God sometimes gives His people what they want, things that are signs of depravity, just as He did the Israelites when they wanted a king.

Even in the United States, some people continue to long for a king. This is evident in the way some Americans look longingly at the monarchies of other countries. Similarly, God continues to work within Christian organizations that have a misguided view of "a woman's place" in Christendom and marriage.

The patriarchal system that ushered in the total repression of women in Judaism was the result of tradition and male pride; it was not a true picture of the whole counsel of Scripture.[3] It came around the time of Ramses II (1324–1258 B.C.) and Moses, when Israel was in captivity. Women had enjoyed some freedoms immediately after Eden that lasted until the rise of the law. The Jews imposed restrictions and limited freedom because of the fear of foreigners mixing with the Israelites. Jewish women had no influence outside of the home. Taking care of children, husbands, and working within the domestic domain was the only role that they played. They were under the rule of their husbands. Their religious role was nil—they were limited from worship or the study of Scriptures.[4]

Along with the restrictions came the notion that women were evil, and this depiction of women continued for centuries. Philo of Alexandria, who lived during New Testament times, along with others, such as Josephus, the historian, and Sirach, one of the authors of the Apocrypha, sought to mix Judaism with other philosophies. They embraced the Greek's hatred of women and the belief that man was the measure of all things.[5] They embraced the notion that women were

sensual, weak in judgment, and intellectually inferior.[6] He, among others, was instrumental in spreading the hostile Greek view of women throughout Western civilization. It was Greek philosopher Aristotle's belief that women were defective accidents. "Normally, male insemination produced another male in the image of his father. But sometimes the male form was 'subverted' by the female matter and produced a defective human specimen—a female."[7] Philo's repetition of Aristotle's mantra, "the male is more perfect than the female" has permeated Jewish and Western culture.[8]

Philo's love of Greek culture and his disdain for women caused him to misinterpret Scripture. Philo believed that a woman's nature was "irrational and akin to bestial passions, fear, sorrow, pleasure, and desire from which ensue incurable weaknesses and indescribable diseases."[9] His influence provided the impetus for the infiltration of the church with Greek and Roman philosophies.[10]

Walls were built within Judaism that devalued women and relegated them to the status of possessions. The Jewish rabbis' teachings, in an effort to protect Judaism, often reflected the pagans rather than Scripture. Many of the rabbinic laws concentrated on controlling what they viewed as woman's natural tendency toward lust and evil. Their view of male superiority is noted by their teachings, as the following excerpt illustrates:[11]

> Though a man has the exclusive right to his wife's sexuality, the wife's right to the husband's sexual function is never exclusive. She cannot legally preclude her husband from taking additional wives or having sexual relations with unmarried women.
>
> Woe to him who has female children! A daughter is like a trap for her father...When she is small he fears

that she might be seduced; when she is a maiden—that
she becomes promiscuous; when she matures—that she
might not marry; when she marries—that she might
not produce children; when she grows old—that she
would practice witchcraft.[12]

Man, enmeshed in the fallen state, continues to see things
in terms of authority and subordination. Because of the
Fall, some men tend to view everything on a hierarchical
continuum or through a power play with themselves at the
top of the continuum. Any attempt to change the status quo
is viewed as usurping their authority, and change is viewed
as someone's desire to take away their God-given power.
When women desire to fulfill what they believe to be their
God-given destinies, they are viewed as either rebellious for
getting out from under the authority that man has ordained
for them, or they are viewed as controlling and desiring to
wrest "God-given authority" from men. Men who believe
like this fail to hear the heart cry of women to be used by
God. This pathology is neither ordained nor sanctioned by
God; it is demonstrative of a fallen nature that is earthly
and devilish.

One theologian, Evans, made some startling revelations
concerning men and how they viewed women in a research
study on women and their spirituality. He chose to immerse
himself in the study rather than to use his research for what
he called an attempt to "figure them (women) out," place them
in neat categories, or "put things in perspective." He called
these terms, often used by men, euphemisms for "putting
things and people in their place." Evans states that he, like
other men, never realized the outcome of his desire to deter
women from what he termed as "specifically male vices."
These "specifically male vices" that women were to stay away

from included: lawful hierarchical structures, pride, disobedience, aggression, and lust. He emphasized that man sees these behaviors as fitting only for men! Men do not mind it if women have such vices as self-hatred, the submersion of personal identity, timidity, self-absorption, jealousy, smallmindedness, or manipulation. He states that those are fitting vices for women, not men.[13]

Evans began to see that men have tended to place women in categories, to set their boundaries for them without their consent. The tendency to categorize women comes from a tendency to patronize them. Anytime a person or thing is categorized, there is a tendency or desire to know about someone or something rather than to really know them.[14]

Bem takes this view of the male as the center of the universe even further. The male as the center of the universe divides reality into self and "other." "Everything [is] categorized as 'other'—including women—in relation to themselves."[15] This definition of everything beyond the male as "other" does two things. Firstly, the meaning of everything rests upon its similarity to or dissimilarity to man. Secondly, man's being and experiences become the reference point from which standards for the culture and species are determined; that is, all things are defined based upon their meaning or significance to man rather than being defined on their own terms. Thus, woman has been defined either by her domestic and reproductive functions within a male-controlled environment, or she has been defined by her power to arouse and satisfy the sexual desire of a man.[16]

In their research, Hubbard and Hubbard arrived at four major characteristics that define men who hold entrenched views of women as subordinates. Those characteristics were prejudice, power, pride, and privilege. This husband and

wife team studied the psyche of some men who believed in male authority. They called them men who were "highly resistant" to biblical equality. The Hubbards believe that the highly resistant male's core belief system is a social belief system based on emotionally motivated defenses. The belief of the highly resistant men is not predicated on a rejection of anyone else's theological doctrine or those who disagree with them scripturally.[17] Their belief system is based on these characteristics:

1. *Externalized prejudice against women* which is derived from an internalized stereotype that is synonymous with their self-identity. The teaching of male superiority has been ingrained in their psyche since childhood, and it is a part of their masculine belief system. Thus, the changing of their views on women would, for them, change who they are as men. The social reinforcements that reward these men for their biases and attitudes are not consciously realized. When these men realize these biases, many experience a crisis in their identity and faith.

2. *The male power structure and the threat of losing it* which also contributes to the resistance to female equality. For these males, winning is controlling relationships and diminishing the power of others, especially women. Anything else is a losing proposition. The controlling of women is intricately bound up in the control of their own lives, and they are threatened when they are not in total control.

3. *A distorted sense of pride and a resistance toward female equality* which is the manifestation of the entitlement bestowed upon males in a hierarchical system. This "divine right" instills in these men the belief that anyone who challenges them in their beliefs has sinned against them and is rebellious against God.

4. *The sense of privilege garnered from a false comprehension of biblical headship* which causes a resistance to female equality. Headship for these men becomes a privileged status, which entails being served, having their needs take priority over others, and solving problems according to their priorities.[18]

Male Power Structure and Abuse

This male bias can also contribute to spousal abuse. The potential abuser is the man who views himself as superior to women (and sometimes even other men) and who never matures beyond adolescence.[19] One in every three girls will be sexually abused before she becomes an adult.[20] In the United States, a woman is beaten every fifteen seconds by a husband or boyfriend.[21] One thousand women will die this year as a result of physical abuse.[22] Abuse is the major cause of injury to women, exceeding the combined totals of automobile accidents, rapes, and muggings. (See page 46.) There is violence in one of six American households each year. One of every three women will be physically abused in her lifetime. Murders by husbands or boyfriends contribute to one-third of the deaths of women. Pregnant women make up nearly 45 percent of those who are abused.[23]

This type of sexual abuse can thrive in an overly strict religious environment. Alsdurf and Alsdurf depicted the experience of one Christian woman who after forty years was still traumatized by abuse. As a child, Alice, along with the other little girls, had sat in front of their church nearest to the pulpit. She remembers the hellfire-and-brimstone sermons on harlots and adulterers, which decried sins as the woman's fault. In the meantime, her brother was sexually abusing her. The sexual abuse started when she was only eight years old:[24]

When my brother was after me, I'd want to open the bedroom door and tell someone, but I couldn't. After I left home, I finally realized why: my folks wouldn't have believed me. My brother was kingpin. I guess I would rather go on believing that they loved me than find out the truth.[25]

Alice's husband was also raised in a strict religious home, and she felt that the church provided him with what he felt was the right to abuse her:

Five weeks after marriage, her husband's emotional and sexual abusiveness started. "Being in control was so important to him. He would make comments about needing to break me like a horse. He didn't want his family to think he wasn't in control. I felt like I was in prison, like a caged bird. A bird who could fly, but wasn't allowed."[26]

In marriage, male hierarchy is neither biblical nor psychologically sound for a healthy relationship. Physical abuse may result when wifely subordination is inordinately emphasized. People may tend to ignore wife abuse and disregard

the Christ-like sacrificial love that should be demonstrated by husbands. The ignoring of the husband's sacrificial Christ-like love sanctions unscriptural and one-dimensional submission.[27] Many women have been told that either God will stop the abuse or He will give them the power to endure it. Their personhood is thus overlooked. Alsdurf and Alsdurf assert that it becomes the woman's responsibility to "love, love, love, and to give, give, give."[28] A view of submission, which suggests that the wife is the one who does all the giving and serving distorts the biblical intent of submission in the marriage relationship.[29]

Psychological abuse is another form of abuse in some male-dominated homes. This emotional and manipulative abuse is a "masked violence." When a man sees himself as superior, with that status ordained by God, he justifies his actions by misinterpreting Scripture. He need not use force; he has psychologically overpowered his wife. A husband who tells his wife that she is not submissive enough is really saying that "I am insecure when I am not dominant and in charge." This treatment, psychological abuse, can be as damaging as physical violence.[30]

Masked violence can even be seen in some church settings. Baker-Miller, a psychiatrist, reports that "Within a framework of inequality the existence of conflict is denied [in some denominations] and the means to engage openly in conflict are excluded." She goes on with "there are no acceptable social forms or guides because this conflict (psychological abuse) supposedly doesn't exist."[31] This inequality between men and women then spawns a hidden conflict. This hidden conflict is never acknowledged or talked about and manifests itself in male outbursts of destruction and violence.[32]

Excuses are often used to sanction abuse. A man who engages in this type of abuse will tell his wife, "you made me do it," which infers that she is in some way masochistic and wants to be victimized and beaten or that she deserves to be beaten. This Freudian theory of masochism—that "sexual gratification depends on suffering, physical pain, and humiliation"—has been examined and rejected as a cause of abuse.[33] Many men and some women still believe that women who are beaten have a masochistic desire to be beaten and this keeps them in the abusive relationship. Some have tolerated violence against women because they believe that the woman deserved the beating—she was "too bossy, too insulting, too sloppy, too uppity, too angry, too obnoxious, too provocative, or too something else." Psychologist Lenore Walker states that women do not select abusive relationships because they have some kind of personality deficiency. They do, however, suffer from "learned helplessness," in which their victimization causes a psychological paralysis.[34] Clinical research refutes this claim that women seek to be beaten rather than to get out of a marriage; they note that women continually stay in abusive relationships, hoping to change their husbands and save their marriages.[35]

The church has often been complicit in the abuse of women, and this has affected some people's view of the church. Only a few of the women interviewed by the Alsdurfs viewed the church positively in protecting them from abusive husbands. "Being pro-life requires more that opposing abortion; it means taking a stance against all which stifles life and personhood...violence by a husband towards his wife is one obvious offense to the integrity of human life."[36] Preventing women from escaping an abusive marriage by using rigid doctrines and heartless counsel can

in itself be considered an act of violence and a subtle form of complicity with evil. It is the church's responsibility to look for signals of wife abuse, such as couples that are "too good to be true," constant changing of churches, sporadic church attendance, husbands with inappropriate outbreaks of anger, and the very private couples who do not socialize or interact with other church members.[37]

McDill and Mc Dill recount one minister's interview with Roger, an abuser.

> The interview came in a roundabout way. The minister of a local church called about a twenty-two-year-old woman in his congregation who had come to him for counseling.... The pastor discovered that the girl was being sexually abused by her father and had been since she was fifteen. Roger was her father...Roger and his family are active in their church. Roger is an abuser who had just been asked about his early relationship with his wife. He got up, walked to the office window... Then, with a lopsided grin, he turned around and said, "We'd only been married a few months when she pulled a pout and started acting like a child. So, I turned her over my knee and spanked her as I would a child. And you know? She's kept in line ever since." Roger looked proud of himself. "All I have to do nowadays is lift my eyebrow, like this, and she gets that half-scared look and cows under. She doesn't say a thing, but she does what I want. I can't believe my eyebrow has that much power." Roger laughed. "But it sure keeps my wife in line."[38]

Pastors fail to acknowledge abuse and victimize the battered woman even more. Researchers have found that pastors of women in Roman Catholic, Greek Orthodox,

and conservative Protestant churches (such as some Church of Christ and Southern Baptist churches) tend to find their ministers and priests more likely to be of little help.[39] A survey of eighty abused women noted by Alsdurf and Alsdurf states that in dealing with the matter, their pastors focused on changing them rather than their abusive husbands.[40]

There are several reasons why abuse has not been confronted seriously in the church from both a biblical and a psychological standpoint. For one thing, men have been the writers, ministers, counselors, interpreters of the Bible, as well as authorities on the family. In addition, this inattention to wife abuse may be the result of men being "unable to remove the blinders of bias they wear" from their position of power and control and begin to view things from the bottom up.[41]

Secondly, to confront domestic abuse is to confront the failure of the church. It brings two very direct indictments against the church: how do they deal with their own guilt and with the fact that this problem exists in their own flock? Pastors very often find themselves floundering theologically when confronted with a battered woman.[42]

Male Authority Parallels Other Religions

A cultural view of male authority remains prevalent in most cultures, even in Western societies, and the woman issue is one of the most controversial subjects facing the world today. According to Myles Munroe, several perceptions of women persist today. He notes that women are considered as:

1. Inferior to men, second-class citizens.

2. Objects for sensual gratification alone.

3. Weak, incapable of real strength.

4. Lacking in intelligence and therefore having nothing to contribute to society.

5. The personal property of men, the equivalent of cattle.

6. Personal servants, whose only purpose is to meet the needs of their masters.

7. Domestic slaves, to be used as desired.

8. Objects to be passed around until finished with and then discarded.

9. Sub-human.

10. Deserving of abuse.[43]

Munroe, a traditionalist who believes in women using their leadership gifts in the church and on the job, states that women, especially those in Western cultures, may be offended and shocked by these perceptions. He further cautions that women who live in industrialized nations and have seen progress in the status of women may believe that these negative views pertain only to the third world countries, but they have failed to realize the underlying and deeply entrenched mindset of men in many cultures. Munroe states that:

> The underlying assumptions behind them persist in every nation because they are not so much influenced by legislative and societal changes as they are by

ingrained attitudes in the hearts and minds of men and women.... It's not easy to change a man's mind about a woman's place in the world... In industrial nations as well as developing nations, the plight of the female is still very real. It is tragic to have to admit this is true in our modern society.[44]

"Christian attitudes toward women have in many cases more closely resembled the degrading treatment of women seen in Hindu or Muslim cultures than what Jesus called His disciples to demonstrate."[45] The parallel between the views of gender-restrictive societies and today's traditionalists as it relates to women is worth exploring. Holy books in various religions are used to justify male domination as part of a deity's original creative plan, just as gender traditionalists infer that God ordained male authority and female subordination at Creation.

While it is true that other religions are more gender repressive than some Christian denominations, the caveat is that the belief of other religions is that women are equal in essence (the spirit), but unequal in function. This belief by many cultures and religions hinges on the fact that they believe that men and women are different in substance and that they have totally separate destinies. In these cultures, men have the place of dominance and women are their properties. In some of these cultures and religions, men are the masters and women are the equivalent of being their slaves.

Many societies all over the world include restrictions on the behaviors of women. Taking care of husbands, children, and the household have often been the only purpose that women have had. Different religions may use different words, but the "essence" of their belief about women is the same. They believe that boundaries and limitations that

women face here on Earth will be nullified in the hereafter. Like some traditionalists, other religions also use their holy books to justify this power; many even believe that there is a hierarchy even in the hereafter.

Gender traditionalists, as those in other religions, restrict their women and infer that total equality will be granted fully to women after death, not while they are living. Massey notes that other religions and cults believe that everybody has an equal relationship and equal blessings in their spiritual relationship and spiritual status with their deity here on Earth. Yet, in the ancient world, and even today, other religions do not allow outward manifestations of spiritual freedom and expression for their women. Women are also excluded from ceremonial activities and rituals.[46] This also happens in many conservative churches.

Anthropologists have studied the transcendence of male domination and female subordination, as well as observed the nature of a woman's place in relation to man in various cultures. Rosaldo, Lamphere, and other anthropologists studying customs of various groups have found two common factors in the relationships of men and women. Firstly, men dominate in many of the cultures that have been studied. Secondly, women are complicit in their own devaluation.[47]

Many cultures tend to place men in a dominant category that affords them a value and moral worth that is opposite to that of women. Biology, in and of itself, is not the determinant for the male dominance. It is the interpretation of biology by the human players that determines its foundational significance, along with other varying factors in a human society.[48] Rosaldo notes that:

> Most societies find relatively few ways of expressing the differences among women...Womanhood is an

ascribed status; a woman is seen as "naturally" what she is... Women are given a social role and definition by virtue either of their age or of their relationship to men.[49]

Ortner also refutes the idea of biology as the reason for male authority and female subordination; it is the cultures themselves that define and give value to male authority and female subordination. Ortner sought to unearth the generalized structures prevalent in the observed cultures that generate a lower value and status on women. Anthropologists have noted that women are viewed in most cultures as closer to nature physically, socially, and psychologically. In a vast number of societies, women's reproductive faculties often limit them to the creation of human beings, while men, lacking natural creative functions, assert their creativity in the areas of technology and symbols. Secondly, women's social role is identified with birth and the caring for the young. However, with the exception of nursing and childcare, women do not have to be limited to motherhood. Yet, it is mothers who are the representatives of socialization in the training and teaching of the children, moving the young into a fully participative state in society. Thirdly, women's psyche is culturally seen as nearer to that of nature.

Just as with gender traditionalists, there is an argument for a generalized, innate psyche for women. These "innate" characteristics consist of an emotionality, irrationality, subjectivity, pragmatism, personableness, and detail orientation. However, these traits are not innate or biologically determined; they are generated by society (social-structural arrangements). A woman's psyche is the result of a global family structure where women are responsible for childcare and female socialization. The training of a "female psyche"

is programmed into males and females and is replicated in adult socialization. Ortner notes that the men's creative symbols are lasting and transcendent, while women's creativity consists of human beings who are perishable. Even the hunting and warfare of men are given more prestige than the giving of birth. However, it is not the hunting and warfare that is significant, "It is the transcendental (social, cultural) nature of these activities, as opposed to the naturalness of the process of birth."[50] Ortner reinforces Simone de Beauvoir's assertion that superiority has not been given to the sex that brings forth life, but rather to the one that risks his life. However, it is preposterous to view a woman as part of nature, as she is half of the human race and without her there would be no human species.[51]

What puzzles some anthropologists is that women take part in their own devaluation.[52] It is only in societies where women can transcend the domestic limitations that they seem to be able to gain a sense of value.[53]

> ...Most egalitarian societies are not those in which male and female are opposed or are even competitors, but those in which men value and participate in the domestic life of the home. Correspondingly, they are societies in which women can readily participate in important public events.[54]

Because women have been viewed as the designated "other" in many contexts, men have defined them. "It should not be surprising, then, that so much of the fundamentalist agenda (regardless of the religion) focuses on defining the roles and monitoring the behavior of women."[55]

However, the prevalence of male authority and female subordination in many cultures and religions signifies

something far more profound than gender traditionalists' argument that it was God's intention at Creation. After the Fall, the couple relinquished their dominion of the earth to Satan, and at the same time, according to Fleming, the man usurped God's authority by taking dominion over the woman. After the Fall, God never commanded the man to take dominion over the woman, nor did He tell the man to name her; He told both the man and woman what the consequences of their sins would be. Thus, male domination and woman's inordinate desire for her husband entered the world, and practically every society on the earth reflects in some ways this consequence of the fallen state.[56]

In Christianity, it is the gender traditionalists' interpretation of Scriptures, not what the Bible actually states, that seeks to justify male authority. The Bible, as some would interpret it, does not introduce male authority and female subordination in the Creation story, notably Genesis 2:18–23. The Fall did, however, introduce into the world male domination (control) and female complicity to male rule.

In the centuries leading up to and during New Testament times, the life of Jewish women resembled those of other women of the ancient Near East. The father of a girl had absolute power over her and could require her to marry a man of his choice or sell her into slavery at the age of twelve and a half. With betrothal, fathers transferred their unconditional power to the husband in what was considered a purchase. A woman's place was in the home and that alone. Her duties included the household cleaning and cooking, caring for children, and attending to her husband's needs, including washing his hands, face, and feet. It was a wife's duty to obey her husband. Her acquisitions belonged to him. He could have more than one wife, and he alone could file suit for a divorce.

The Jewish woman was chiefly valued for her reproductive ability to bear sons.[57] In ancient Jewish culture, a woman's functions were considered the essence of who she was. The house was a synonym for wife. One Rabbi, Hisda, translated Genesis 2:22, where God takes the rib or portion from adam to form the woman, in this way:

> This teaches that the Holy One, blessed be He, built Eve in the shape of a storehouse. As a storehouse is [made] wide below and narrow above so that it may contain the produce, so was [the womb of] a woman [made] wide below and narrow above so that it may contain the embryo.[58]

To reflect her lower status, a Jewish woman referred to her husband by his title. Some used the term *rabbi*, meaning "teacher." The term used most frequently was *adon*, meaning "lord." Schmidt states that the Jewish woman approached her husband the way a slave addressed his master or a subject addressed his king.[59]

Daughters were not as treasured by men or women as sons were. Schmidt asserts that most references in the Old Testament were speaking of "sons," and the texts have been misread in the translations. The King James Version of the Bible speaks of teaching the commandments to your children; however, he notes that the Hebrew text speaks only of teaching the sons.[60]

Religiously, women were second-class citizens. The Torah was binding for men only. The priesthood was limited to men. Rabbis viewed women as sex objects, tempters, dangerous, and inclined to disrupt socially. The rabbinic literature disdained women and presented them as inferior.[61] This

denigration was especially prominent in their Mishnah and Talmud. Jewish men prayed the following three-fold prayer:

> Blessed art thou who has not made me a Gentile,
> Blessed art thou who hast not made me an uneducated
> man (slave).
> Blessed art thou who hast not made me a woman.[62]

(Remember Funmi in Chapter 1.)

In Islamic religious law, even today, women and men are proclaimed as equals before God; however, the differences in rights between men and women are clearly delineated with men having the greater rights. The Quran states that men and women are equal in their works and that there was a unity in their creation; however, it notes that men and women are not considered equal in worth.[63]

One-Flesh Unions Trump Hierarchical Marriages

Extensive studies have been undertaken over the last fifty years by demographers, sociologists, and marriage and family professionals that show a more balanced and mutually participating structure in marriage is more successful. The research shows that significant numbers of husbands and wives who share power and authority have more fulfilling marriages than those in which authority lies in the hands of one spouse. The research has done several things. Firstly, it has successfully challenged the gender traditionalists' belief that shared authority is debilitating in a marriage. Secondly, the research implies that it is the hierarchical marriages that lead to problems in marriages. Thirdly, the evidence maintains that egalitarian marriages provide healthy, intimate, and stable marital relationships. The research showed that higher percentages of wives in traditional marriages suffer from depression

and other mental problems than do unmarried women and working married women. Women in traditional marriages suffer beatings at a 300 percent higher rate than wives in egalitarian marriages.[64]

Research shows that about one-half of marriages will end in divorce within seven years. This is true even in Christian marriages. The Barna Research Group studied the divorce rate among Christian churches in 2001:

Divorce Rates by Denominations

Non-Denominational Churches	34 percent
Baptists Churches	29 percent
Episcopal Churches	28 percent
Methodist Churches	26 percent
Presbyterian Churches	23 percent
Lutheran Churches	21 percent
Catholic Churches	21 percent[65]

According to Barna, 33 percent of Christians have been through a divorce. This number is comparable to non-born-again adults. Barna notes that these statistics raise the question as to whether churches are providing life-changing aid, as well as practical help for married people. There are social, ethical, and economic reasons, even beyond the biblical ones, as to why churches should promote equality in marriages. One therapist, Austin, echoing Barna's findings, believes that fundamentalist couples lay foundations in their marriages based on irrational and unrealistic principles. Austin continues, "Problems occur when some men, as head of the household, become 'cruel dictators' who 'expect their wives to become servants.'"[66] The foundation of every

marriage and the authority over it should rest on the only true authority, Jesus, and Him alone. (See Matthew 28:18.)

The point is that marriage was never meant to be a struggle over power or who is "in charge." Rather, the male and female are meant to exist in a covenant commitment in which the "two become one" through mutual love and support (*hupotasso*).[67]

Jesus' teachings condemning power structures and hierarchies are seldom mentioned in the discussions of woman's subordination in the church and home, even though it was at the very heart of his ministry. Many gender traditionalists lean on their positions of hierarchy, even finding it in odd places.[68]

> But Jesus called them to Himself, and said, "You know that the rulers of the Gentiles lord it over them, and those who are great exercise authority over them. Yet it shall not be so among you: but whoever desires to be great among you, let him be your servant; And whoever desires to be first among you, let him be your *slave— Just as the Son of Man did not come to be served, but to serve, and to give His life a ransom for many.*
> —Matthew 20:25–28, NKJV, emphasis added

The church has continued to place new wine in old wineskins by refusing to recognize a new dispensation. Jesus' death and resurrection represented a revolution, a change of guard from the male hierarchy. His atoning death represented a change from the notion that an earthly king is needed or can bring liberation. The King of kings, and Lord of lords is all that every person (male or female) needs. (See Revelation 19:16.) "Old things have passed away; behold all things are new" (2 Cor. 5:17, NKJV). In this new dispensation, men and women can walk hand-in-hand toward their destinations.

Chapter 5

LETTING GOD BE GOD

Professing themselves to be wise, they became fools,
And changed the glory of the uncorruptible God
into an image made like to corruptible man.

—ROMANS 1:22–23

SOME FUEL THE male hierarchical debate by comparing
it to the Trinity. Those traditionalists surmise that the
Godhead reflects a chain in which Father God is the sole
authority, the one who makes all the decisions, with the Son
as the eternal subordinate. They reason that the hierarchical
pattern is passed down to human beings, with man taking
the place of Father God in the marital relationship.

Ortlund's view represents the view of most who believe
in male/female hierarchy. He asserts that Christians should
be able to accept the paradoxical truth of male authority
and female subordination. After all, God exists in the three
persons in one Godhead, equal in glory, but unequal in role.
Ortlund goes on to assert that within the Holy Trinity, the
Father leads, the Son (Jesus) submits to Him, and the Spirit

submits to both. Yet, the three are fully equal in divinity, power, and glory. According to Ortlund, the Son submits, but not because He is inferior; it is the ranking that is part of the sublime beauty and logic of the deity. As Ortlund continues, he states that it should come as no surprise that there is a corresponding paradox existing with God's creations.[1]

This premise, a supposed analogy between a hierarchical Godhead and male authority and female subordination in marriage, needs to be explored. Jesus' subordination to the Heavenly Father while He was here on Earth should not be confused with the Godhead in a heavenly environment. Jesus stripped himself of His royal, kingly garments when He came to Earth to provide human beings with an example of how they should relate to Father God. He assumed the function of a mere man, not God. It is faulty to compare the lifelong subordination of women to Jesus' subordination to Father God while He was here on the earth. It also denigrates the role that Jesus played in the decision-making process to come to Earth to redeem His creations. His purpose was to show His creations (male and female) how to relate to God, to show humankind "the way." Jesus stated, "My Father...is greater than all" (John 10:29). Grentz discounts that Jesus' obedience to the Father here on Earth was in some way representative of a male hierarchy over females. He states:

> This interpretation (that women should reflect the same subordination that Jesus reflected as a man here on earth), however, goes beyond what the biblical texts in fact assert. Nowhere does the New Testament declare that the Son's obedience to the Father is a model for how one gender/sex (women) should relate to the other (men). We would be better to see in Jesus' obedience...the model as to how all human beings—

whether male or female—should live in obedience to God. And we ought to find in Jesus' example a grand illustration of the proper attitude that all Christians, female and male, should demonstrate toward one another. Rather than encouraging the establishment of lines of authority and submission.[2]

Christ voluntarily laid down His godly powers to come to Earth. The decision to come was a collaborative effort that was decided before the foundation of the world by a triune, relational God. (See John 6:38; Philippians 2:6–8; Hebrews 10:7.) He did not come to Earth to use His power as God. Jesus came to Earth to bring reconciliation between God and His creations *through His example of obedience*. He came to deliver and restore those whom He had created. He could not have redeemed His creations as God. Christ's submission is directly related to His becoming a man.

With the taking upon Himself the humanity of His creation, He automatically became subject to Father God. He experienced the carnal or fleshly temptations in His man nature, and it was this nature that came under submission to Father God, not His God nature, which was one with the Father. Hebrews 4:15 states that Jesus "was in all points tempted as we are, yet without sin." His example of submission was, therefore, not just an example for women, but for men as well.

As noted earlier, the Creation was not a hierarchical effort; it was collaborative. During Creation, God said, "Let us make man in our image, after our likeness" (Gen. 1:26). John notes in discussing Jesus' role in Creation,

> In the beginning was the Word, and the Word was with God, and the Word was God...All things were made

by him; and without him was not any thing made that
was made...He was in the world, and world was made
by him, and the world knew him not. He came unto
his own and his own received him not.

—John 1:1, 3, 10–11

In speaking to Mary, His mother, and Joseph when they
sought Him after finding Him missing in their journey home
from the Passover Feast, Jesus said, "How is it that ye sought
me? wist ye not that I must be about my Father's business?"
(Luke 2:49). In Luke 10:22, Jesus states:

All things are delivered to me of my Father: and no
man knoweth who the Son is, but the Father; and who
the Father is, but the Son, and he to whom the Son will
reveal him.

Jesus spoke often of His relationship with His Father. His
accounts often reflect the singleness of purpose and unity/
oneness of their relationship; there is no hint of hierarchy
in His representation of the Godhead in the Bible. When
the Pharisees asked Him who His father was, Jesus spoke
of bearing testimony as to His Father and that it was the
Father who sent Him. He notes that the Father also testifies
of Him. He goes on to say, "If ye had known me, ye should
have known my Father also" (John 8:19). "I and my Father
are one" (John 10:30). Jesus, in praying for those who will
become believers, said, "That they all may be one; as thou,
Father, art in me, and I in thee, that they also may be one
in us: that the world may believe that thou hast sent me"
(John 17:21).

The dynamic of the Godhead transcends earthly analo-
gies. It is an example of mutuality and interdependence. Just
as the Son is part of the Father, so is the Father part of the

Son, for without the Son, there can be no Father God, as Grenz explains:

> The ancient theologians declared. The generation of the Son—the act which constitutes the Father as Father—is an eternal dynamic, so that the Father never was apart from the Son...In short, the eternal generation of the Son indicates that the First and Second Persons of the Trinity enjoy a mutuality of relationship. In a certain sense, each is dependent on the other for his own identity.[3]

In the same way, in *adam* God made humankind both male and female. It is only with the generation of the female Adam that there could have been a full manifestation of the male Adam. The mandate and earthly creation included both. To separate them in some hierarchical stance distorts the whole Creation process, as well as God's mandate to take dominion.

When the equality and mutuality of the sexes is understood as God's destiny for mankind, it is clearer as to how the one-flesh union of man and woman, physically, spiritually, and emotionally, replicates in some ways the three-in-one relationship of God. "Any undermining of the union of the human partners tends, in turn, to diminish appreciation of the nature of the Partners in the divine union."[4] Husband and wife are one flesh; when you see a wife, you should see the husband and vice versa. It should not be that when you see the wife, you see an assistant to the husband.

God Transcends Gender

Referring to Father God as the One who loves and protects is universal. Father God is not a sexual being; He is metaphysical. Sexuality is a physical, earthly attribute. Groothuis

believes that women feel marginalized and alienated when God is spoken of as having male sexuality. However, God's fatherhood is rightly understood when He is seen as a personal, powerful, and protective provider.[5] Some, however, in humanizing the Almighty God, have run the risk of changing God and making Him in the image of man rather than the other way around. Romans 1:23 speaks of changing the glory of the incorruptible God into an image made like corruptible man.

Hamilton notes that Jesus, when He was on Earth, desired to provide an image that the people could grasp, an image of God that would show how intimate God wanted to be with humanity. Jesus changed the way God's people related to God because before Jesus' time God was considered distant and theoretical for Jews and non-Jews alike. The use of the term *the God of Abraham, Isaac, and Jacob* initially was a personal term used by those who had had an encounter with God. Down through the generations, God became the God of the dead fathers; there were no longer personal experiences with God. It became important to be a descendant of Abraham, Isaac, and Jacob, rather than to know the God these men personally knew.[6]

The designation of God as Father was foreign to the first century Jewish community, for it was seldom mentioned in the Old Testament.[7] Today, using the term *Almighty Father* to refer to God's powerful, protective, and yet, personal and loving nature is normal within Christendom.

Chapter 6

THE LURE OF ENTANGLEMENT

Since women have always experienced themselves as
subordinate to men and have been dependent on men for
affirmation and approval, they have remained unwilling
and unlikely to do anything to jeopardize that tenuous
relationship. In fact they are often threatened by anything
that presents a danger to that relationship, such as the
emergence of leadership potential in other women.[1]

—SANDRA M. SCHNEIDERS, WRITER

SOME WOMEN DO not see their inherent nature as God
sees them. Munroe asserts that these women see themselves as extensions of men, and it is men who develop their
identities. They are the products of the societies in which
they live.[2] God shared with the woman that the consequences of her sin was that her desire *will* (not *shall*, as some
translations state) be to her husband, and he *will* (not shall)
rule over her. (See Genesis 3:16.) Since the Fall, women have
acquiesced in the home and church, taking a secondary role
in all things. Schmidt explains that the Septuagint and other
ancient versions of the Old Testament state that Genesis 3:16
says that "he will rule over you," not "he shall rule over you."[3]

Will is an unyielding doggedness, but *shall*, the future tense, does not indicate or require a sense of obligation. Linguistic Semitic expert, Alphonse Mingana, states that when *shall*, the future tense, is used in place of *will*, it never implies a sense of obligation in Semitic languages.[4]

In many traditional circles, the only role women have had is that of assisting their husbands or other males in achieving their destinies. These women live in the shadows of their husbands or other designated men, and it is from the men that these women derive their purpose, rather than from God. Fowler calls it "shining like the moon, with borrowed splendor."[5]

Because of limitations placed on some women, they have resorted to various pathologies. They have had little direct voice in their own lives. Many have resorted to various tactics to gain a voice. They do not see these tactics as a cry for help in gaining a voice in their own lives. Some of these women may tend toward manipulation, passivity, dependency, or social enmeshment. All of these pathologies are the consequences of the fallen nature, resulting in many women's hearts turning toward their husbands/men and away from God as their Lord. In the process, men have ruled over them, leaving them with no voice in their own governance. They end up using crafty, underhanded tactics to gain some kind of leverage.

Hyatt notes that while some women publicly subscribe to male authority rule and female subordination, they privately use subterfuge in trying to gain a voice in their marriages. Some become hopelessly depressed because of their situations, which entails the lack of influence in and over their own personal lives. Even more telling is that this lack of control over their own lives contributes to these women becoming

masterful manipulators. It is this behavior that contradicts the very theology that they claim to profess![6]

The manipulation used by women is usually of a sexual nature. Some husbands in traditional circles, rather than allowing women to participate mutually in the decision-making process, often condone sexual manipulation. This often reinforces the centuries old view of women as "seductresses." Women have, because of feelings of powerlessness and being considered sexual objects, used the so-called epithet of sexual seductress as leverage in decision-making in their marriages. The conventional wisdom in many traditional circles is that it is okay for the wife to sexually manipulate and influence her husband indirectly. It is just not appropriate for her to be a part of the direct decision-making process. Many men, even pastors and church leaders, often state that they are the heads in their families, but their wives are the necks and it is the necks that turn the heads (the men). Much of the neck turning the head is a reference to sexual pillow talk between husbands and wives. When women use sexual manipulation to dialogue with their husbands, the husbands do not feel threatened. This makes men accomplices in these manipulative acts of sexual interplay that are used to give their wives indirect input. Thus, women's sexual manipulation is sanctioned because it does not involve direct authority.

These traditional couples believe that direct authority belongs to the husband and any direct interaction by the wife is seen as ungodly and unbiblical. However, the unstated manipulation used by these couples distorts God's plan for males and females and also perpetuates the myth of women as sexual objects. Women are forced to get a piece of the pie in marital decisions by using sex as their entrance.

Many women, including more Christian women than generally acknowledged, rightly perceive their marriages as situations in which their psychological health, if not also their physical well-being, is at risk. Yet for women who are not in immediate danger, there is fear of being rejected if they become "too assertive." Frustration with always being in the "power-down" position and resentment against being told rather than being consulted encourage women to become manipulators of their husbands in a culture that gives so much permission to men to dominate others simply because they are males.[7]

There is also the peculiarly female sin of social enmeshment. Social enmeshment is on a somewhat opposite continuum to the male sin of domination. Man's sin is and has been the exercising of sole dominion and control without regard for God's original plan for male/female relationships, while woman's sin of social enmeshment has been to use the preservation of those male/female relationships as an excuse not to exercise accountable dominion in the first place. Passivity and dependence correspond with social enmeshment. There is nothing inherently wrong with a woman's desire for community and relationships, as they are God-given attributes. The problem arises when she desires to preserve relationships, especially with men, at all costs, avoiding any risks in her desire to maintain those relationships. Van Leeuwen describes this condition as:

> The woman's analogue to man's congenital flaw (domination), in light of Genesis 3:16, is the temptation to avoid taking risks that might upset (male/female) relationships. It is the temptation to let creational sociability become fallen 'social enmeshment.'[8]

Social enmeshment is often derived from the fact that many women experience themselves as subordinate to men. These women "have been dependent on men for affirmation and approval, they have remained unwilling and unlikely to do anything to jeopardize that tenuous relationship. In fact they are often threatened by anything that presents a danger to that relationship, such as the emergence of leadership potential in other women."[9]

This failing to exercise dominion is often cloaked in a mantle of virtue.[10] "By valuing the preservation of relationships (however unhealthy) more than the pursuit of biblical justice—and sometimes even more than the dignity of God's image in themselves—they are now contributing to the very circumstances which devalue them."[11] Gilligan discusses a divorced, middle-aged woman and mother of adolescent daughters who had been socialized to passively depend on males to make all of her decisions. The socialization moved over into social enmeshment when she realized her choices and yet she continued to allow men to take full responsibility for her life:

> As a woman, I feel I never understood that I was a person, that I could make decisions and I had a right to make decisions. I always felt that that belonged to my father or my husband in some way, or church, which was always represented by a male clergyman. They were the three men in my life: father, husband, and clergyman, and they had much more to say about what I should or shouldn't do....I still let things happen to me rather than make them happen, than make choices, although I know all about choices. I know the procedures and the steps and all. *(Do you have any clues about why this might be true?)* Well, I think in one

sense there is less responsibility involved; because if you make a dumb decision, you have to take the rap. If it happens to you, well, you can complain about it. I think that if you don't grow up feeling that you ever have any choices, you don't have the sense that you have emotional responsibility. With this sense of choice comes this sense of responsibility.[12]

Male authority and female social enmeshment are both the consequences of sin in the Garden of Eden. They each disobeyed God. They disobeyed God in unique ways. The woman, in her desire to be like God, succumbed to the serpent's lie that she would not die and partook of the tree of the knowledge of good and evil. There was never an issue of man's authority over woman with God when he confronted the woman after the Fall. She coveted that which was forbidden and disobeyed God's mandate not to eat of that tree by listening to Satan. The man partook of the fruit when his wife gave it to him and did not heed God's mandate as well. As a result of their sins, they relinquished Earth's dominion to Satan. Their relationship with God ended in spiritual death. In addition, their dominion of the earth was lost, and their relationship with each other became distorted and turned into male domination and female subordination.

The couple was called to take dominion, and they were to have a communal relationship; however, they crossed the lines of their prescribed territories. Thus, socialization cannot completely account for the distortion in the male/female relationship.[13] The woman transcended her dominion by desiring to know both good and evil and, thus, be like God. The man transcended his dominion by choosing to comply with his wife's wishes rather than to obey God's command not to eat of the tree of the knowledge of good and evil. As a result of

their fallen state, earthly dominion has eluded woman, and a social and loving relationship in marriage has eluded man.

Many traditionalists translate the results of the Fall as women's desire to control men; thus, they reason that men's rule and authority somehow mitigates women's inordinate desire to control them. P.B. Wilson (a traditionalist) notes this in a discussion she had with her husband:

> My husband once asked what I thought God meant when He said, "And their desire shall be to their husbands." After some thought, I smiled and responded. "I think we are cursed to want you. Even when we don't want you, we want you." He laughed and said, "I think there's more to it than that."...When God cursed Eve, it was almost as if He said to her, "Okay, Eve, You want to be the boss and make the decisions? When you leave this garden you will always want to control and lead the course of your husband's life. But he will rule over you instead!"[14]

The Wilsons, and many other traditionalists, believe that women innately want to control men, while it is in the nature of men to leisurely lie around and enjoy life as they say Adam was able to do in the Garden of Eden. They seem to believe that there were innate flaws in woman and man after Creation and that God then used the Fall to rectify the problems that He created in forming man and woman at Creation. In other words, God decided to reverse the situation of his "flawed couple" after the Fall. Wilson goes on to tell women to wait before they declare that what she is saying about woman's desire to control men is wrong. This is what she has to say:

Consider a statement commonly made by women, Christian and non-Christian alike. I believe it is a garden conversation instituted by Eve and passed on through the generations. The statements is, "I need a strong man!" Have you ever heard a woman say, "I need a wimp?" But if you were to hear the rest of the sentence, it would go like this, "I need a strong man because if he is not strong, I'll walk all over him!" A woman innately knows her desire to control.[15]

So for Wilson and her husband, the consequences of the Fall solved the innate creative flaws in man and woman because man was not exercising his authority over woman prior to the Fall and woman was not acting as his subordinate. She surmises that after the Fall, God tells the man to rule over the woman, so that she will be submissive the way she was supposed to have been at Creation. She goes on to say that Adam had to begin to work to take care of his family by the sweat of his brow (the way he was supposed to have done when he was created). He had been lounging around doing nothing. She states that God told Adam, "Worst of all, you must rule over a woman who has proven by making her own independent decision in the garden, that she will not be ruled. I know that you'd rather relax, but you're going to have to take a leadership role, anyway!"[16]

It is worth examining these flawed assessments in Wilson and her husband's view of the Creation and Fall of the first man and woman. The first problem is that Wilson reasoned that God put the man in charge, but he failed at his responsibilities because he preferred to loaf around in the garden. The second was that the woman, from Creation, desired to control the man. The third was that the woman saw in eating the fruit and then giving it to the man, a means of

usurping his authority. Lastly, Wilson assumes that women want strong men because their innate desire to control men causes them to dominate what she perceives as men who do not take charge.

Wilson's first flaw was the notion that God put the man in charge, but he preferred to lounge around in the garden without taking charge. Although Adam failed to guard against the serpent's trespassing in the garden, there is no reference that he did not carry out his other responsibilities before the serpent trespassed in the garden. It appears that the Wilsons believe that Adam did not take charge even though he should have taken an authoritative stance over the female Adam. Thus, they surmised, the male Adam shirked his responsibilities. In addition to no biblical reference that the male Adam shirked his responsibilities previously, as stated earlier, there is no reference in the creation story that the male Adam was the female Adam's authority. This use of his priority of creation or that he was given a directive to do so from God is not backed up by Scripture. The couple was told to take dominion over the earth and yet the serpent, a field animal, was allowed to trespass.

The second faulty premise was that the woman from the beginning had an uncontrollable urge to rule over the man. This infers that God created the woman from the beginning with a flawed characteristic, a desire to control the man. According to Wilson, the Fall allowed God to reinstate the man in the authority position over the woman even after he had reneged on this before the Fall. For Wilson, God used the Fall to correct His flawed creations by having the defective man rule over the defective woman who would not submit before the Fall. If God had already given Adam the authority to rule over the woman at Creation, why was

there a need to give him the authority again to dominate her? Wilson and her husband note that Adam did not exercise his authority during the dialogue with the serpent; he allowed the woman to usurp his authority. Their thinking is that God, therefore, gave Adam authority over the woman *again* at the Fall to curtail her desire to control him, even though he, too, had disobeyed God's commandment along with the woman. That kind of circular thinking is nonsensical and fraught with error.

The third inaccuracy in their premise is that the woman saw in eating the fruit and then giving it to the man a means of usurping his authority or controlling him. The assumption appears to be that God created the female Adam with a defective need to control the man and He created her that way just so that Adam could prove after the Fall that he could rule over her need for power. However, there is no scriptural reference to hierarchy in the garden before the Fall. God, when speaking to the woman after the Fall, did not speak to any hierarchical disobedience to the male Adam. God spoke to each about the consequences of their own individual sin. The Creation narrative presented a depiction of the woman's creation as being good, not defective. She was the man's complement (completer) in a one-flesh union. In addition, she ate of the fruit because she desired to be like God, to know good and evil and not to die. Thus, wanting to be like God was the woman's reason for eating the fruit and eating the fruit was her sin. She did not give the male Adam the fruit to control him, nor was she usurping authority that traditionalists believe had been given to Adam by God. They both sinned against God—Adam was there with her and must have been in agreement with what was going on, for he ate the fruit when she gave it to him. Neither rebuked

the serpent during the conversation. Gilbert Bilezikian puts it this way:

> The tempter, being the most clever among his kind, rightly perceived that the greatest amount of resistance would come from the woman. So, he concentrated his attack upon her in the expectation that if she fell, Adam would follow suit. He was proven right in that (*the woman*) Eve put up a good fight whereas Adam fell instantly, without saying a word. The fact that Eve faced the tempter's challenge with a greater degree of authority than Adam confirms the observation that God had not weighted the advantage of decision-making power in Adam's favor. In the end, Eve's sin was in disobeying God. [17]

Lastly, the assumption that women want strong men to control them, rather than weak men who would not dominate them, is pathological, not scriptural. The Wilsons and others state that women since the Fall have desired that men would rule over them; that is what they are referring to when they talk about the weak man/strong man syndrome. They surmise that this characteristic is part of the Fall. They go on to surmise that many women want strong men because they seek to be dominated by men, and when men do not dominate them, they tend to dominate the men. The truth is, women who want to be dominated, as well as those who want to dominate men, exhibit pathological behavior, and it is not an innate tendency in every woman. In addition, a distortion in the biblical interpretation of the consequences of the woman's fall has contributed to this inaccurate belief.

This assumption that women want strong men because they would dominate weak men is tied to the belief that God

granted the sole authority to man even before the Fall. The premise, inferred here, and stated in other parts of Wilson's book, is that God created male authority from Creation. This belief gets even more dicey any time a woman assumes a leadership role, for whatever reason. According to Wilson and other traditionalists, she is usurping control from men. Their reasoning is that men have been given a mandate to rule over everything and everyone, including women, and this mandate comes from God. Traditionalists reason that Adam did not exercise his authority over the woman when confronted by the serpent; hence, God told him that one consequence of his disobedience would be that he would now rule over the woman—exercise his authority over her. This, again, is circular reasoning—why would God tell the man, as traditionalists reason, that one of the consequences of the Fall for him is that he will now have authority over the woman if he already had been given rule over her at Creation? In essence, they are saying that the Fall rehabilitated the proper role of male authority. God, the traditionalists infer, used the Fall to correct what they view as a deficiency in the garden (deficiency at Creation?). Hamilton counters with, "The fruit of sin (the Fall) is never the will of God."[18]

There is a need for mutuality in marriages, and anything else causes imbalance. In any marriage, if there is a weak husband, or for that matter, a weak wife, the other spouse will take on more of a leadership role, not to control, but to get things done. Both spouses should be a part of the decision-making responsibilities because they are one. A spouse who assumes responsibility in a marriage because the other is not carrying his/her load is performing what they believe has to be done. In addition, any person who exhibits a perpetual

rule or domination over another in a marriage is in error, whether it is a woman or a man. Inordinate authority is wrong and is not an act of creation. The woman was in no way made solely to meet the needs of and provide gratification for man any more than the man was created solely to meet the needs of and provide gratification for the woman. Lerner explores the views of Sarah Grimke, a nineteenth century Southern suffragette and abolitionist who expounded on women who see themselves as assistants, created to meet the needs of men:

> Can we marvel that woman does not immediately realize the dignity of her own nature, when we remember that she has been so long used as a means to an end, and that end the comfort and pleasure of man, regarded as his property, a being created for his benefit, and living like a parasite on his vitality. When we remember how little her intellect has been taken into account in estimating her value in society, and that she received as truth the dogma of her inferiority?[19]

Sarah and her sister, Angelina, defended the unequal treatment of women in their essays. The sisters were denied access to the pulpit and often censured in the press.

The prestige and esteem of most women in traditional circles are restricted to the domestic realm and those who step outside of the limitations and confinement of the domestic sphere are viewed as abnormal. Because a woman's goals and dreams are assumed to be under those of men, leadership roles and prestige for them are deemed illegitimate. Authority, prestige, and arbitrating cultural values are deemed the domain of men. Women who exercise power are seen as manipulators, deviants, and at best, they are called

exceptions.[20] This reality is reflected in American and other Western societies, where powerful women are sometimes referred to with derogatory or obscene terms, regardless of their actions. In other cultures in the world, powerful women are considered witches.[21] In actuality, it is often the behavior of women who are under total subordination who use deviant tactics to influence men. They do it through "behind-the-scenes" tactics and manipulation. These behind-the-scenes tactics of subordinate women often pit them against other women, causing women to be in conflict with each other.[22]

The prevailing traditional culture of the church has played a part in the confusion that women have as it relates to their priorities. They are constantly preached the message that the authority of a woman is her husband or male leadership, while God is his authority. Some, through socialization in the church, home, and society, want men to control and dominate their lives. Often times, the women's husbands are the center of their attention, and their lives revolve around these husbands. For many of these women, God takes a back seat; they place their husbands above God—and this is idolatry!

This belief, that a woman must have a head/male authority, also gives rise to a pathology of the headless single woman! Women are raised in many traditional circles to believe that they are not whole unless they have a husband—their head. In essence, the single woman, after a certain age, becomes a deformed body. She becomes an entity who walks around without a head (a man) to lead her, a body without a head to rule over her and make decisions for her. Unlike the single man, the single woman becomes invisible until she finds her head! In many churches, she is an ignored, deformed blob of bodily flesh.

There is no Scriptural context that states that the only purpose in a woman's life is to find a husband and have children. God has made no requirement that bases a woman's worth or value on getting a husband or on having children. Neither finding a husband nor having children will validate the worth or personhood of a woman. It is Christ who completes a woman, whether she is married with children or whether she remains single all of her life. A woman is betrothed to Christ; He is first. (See Luke 14:26.)

Unmarried and divorced women have struggled with the idea that because they do not have a man in their lives to cover them, they too must live on the outskirts of the Lord's presence. This is a revolting heresy; Jesus did not shed His blood for men only. When He commissioned them (women) to be witnesses of His resurrection, He did not require them to secure a male "covering" first.[23]

Certainly women want to get married, but the message ministered to single women should be that of total surrender to God, just as it is done with men. They should not be trained to believe that their number one priority is that of searching for a mate.

Rather than enticing them to serve the false idols of fulfillment, they need to be challenged to surrender every aspect of their futures to God. He requires all to lay their fleshly romantic fantasies on His altar. He would much rather that all of his people find full satisfaction in Him rather than sell out to the world. He wants each person to wait for Isaac rather than settle for Ishmael.[24]

With this message, the heart-cry of single women might then become a willingness to serve God, no matter what the cost might be; whether married or single, to serve God and to be content in Him.[25]

This message—of total surrender to God—is not palatable to those who believe that women were created to serve men, to assist them as they take dominion. People who have a limited view of women's destinies will continue to view them as insignificant without husbands. These people will continue to devalue women's roles in the kingdom of God.

Another issue that is pathologically used against women by both men and women is that of hormones. Hormonal changes take place at various times in both women and men's lives. Women have three estrogens: estrone, estradiol, and estriol. Each is located in different parts of the female body. Estradiol, the primary estrogen, is made in the ovaries. Levels of estradiol remain high in a female from puberty until menopause when menses cease. (The progestins, sexual hormones in women, take a managerial role during pregnancy.[26]) There was a time when physicians tried to increase women's virility by injecting them with ground testes, while removing their ovaries to prevent moodiness. The irony of this is that science has found that the estrogens protect the health and well being of women.[27] In addition, recent research has questioned the premise that estrogens produce those undesirable behaviors in women.[28]

Research on male testosterone has not been as extensive as that of female estrogen. The male hormone, testosterone, is an androgen. It is made in the testes.[29] Testosterone production begins to decline after forty, the average male's testosterone concentration in the blood falls to around 50 percent by the time he reaches eighty years of age. During aging, men lose pounds of muscles and almost two inches in height. There is a correlation between testosterone and the "edgy, assertive, in-your-face" attitude exhibited by men.[30] This area needs

more research before ascertaining a definitive answer as to the influence of testosterone on men's behavior.

The interrelatedness of man and woman are even demonstrated in the hormonal production. Men get a steady, low dose of the female hormone, estradiol, while both men and women make testosterone. Women make testosterone mainly in the adrenal glands and the ovaries.[31]

Some research has ascertained that cultural and social conditions may factor into the hormonal equation as it relates to women. Van Leeuwen notes that a woman's reaction to her monthly cycle and menopause may vary in different cultural and religious settings. Jewish Orthodox women who are considered unclean for two weeks tend to attribute more pain and inconvenience to the monthly event than Catholics or Protestants. Catholics with strict traditional gender restrictive upbringings and with no sense of the priesthood of all believers, have more emotional and physical problems than some Protestants. Protestants who are from Northern European heritages tend to be less reactionary. The Northern European cultures, asserts Van Leeuwen, tend to have more emotional reserve than those of Southern European ancestry. Van Leeuwen did not discuss women of other national origins. She emphasizes, though, that not all symptoms are psychosomatic.[32]

Culture also affects the responses of men and women to menopause. Van Leeuwen states that women in Third World countries have a heightening sense of their status rather than a lowering of it as middle age occurs. Menopause for these women is not particularly stressful or depressing. According to Joanna Rohrbaugh, a Harvard psychologist, when women are depressed during menopause, it is difficult to discern for what reason it is occurring. It could also be the woman's

reintroduction into her career field, it could be "the empty nest syndrome," or it could be that she sees herself as getting old and becoming less sexual. Some women do actually deal with chronic menopausal symptoms.[33] While biology sets parameters within which women *and men* develop, cultural and other environmental influences help to shape what happens within those parameters.[34]

Even more telling is the social and cultural reaction to what some deem the "raging hormones"—the estrogen-induced mood swings. Recent research has questioned the premise that estrogens produce those undesirable behaviors in women.[35] Yet, the old argument continues to emphasize that women's emotions constantly change and that it is just part of their physical makeup. Johnson recounts several instances where men adamantly proclaimed what they perceived as women's emotional and irrational character flaws. One pastor commented that he did not allow women on his frontline because of their "gender-specific flaws," emotional instability and tendency for deception. Johnson notes that while that pastor was asserting women's weaknesses, women in his congregation were administering the clothes closet and food pantry. These women ministered to drug addicts and alcoholics in the rough section of town, often winning many souls to Christ. Johnson goes on to say that the time she and her husband attended that pastor's church, "Not one person came down front to receive salvation. Who…was really on the frontlines of battle?"[36] In another instance, Revell, editor of the Southern Baptist Convention's *Life Magazine*, writes, "We should understand that a woman's emotions can swing dramatically as a result of her physical make-up."[37] He continues by emphasizing that to live with a wife "means being patient with what we might perceive as insecu-

rity or irrationality or being patient when her mood or mind changes without warning." Perhaps there should be research and more emphasis on other causes for some of the "raging moodiness and depression" demonstrated by some women. This vilification of women requires a more objective perspective. Firstly, Johnson comments that Revell's assertion of women's over-emotionality and their meriting high, but not equal status was the same view that her grandmother's generation had of African Americans. In addition, the Bible speaks of two times when someone was overcome with emotions, and both were men! Joseph was overcome when his brothers visited Egypt. (See Genesis 43:30.) David in 2 Samuel 18:33 was overcome over the fate of his son, Absalom. The Bible depicts women who were not mindless and emotionally-driven—Deborah, Phoebe, Esther, Priscilla, and Junia to name a few.[38]

A more important aspect of setting the record straight on hormones is that hormonal changes are not limited to women. There is scientific data that shows hormones influence moods; yet, not all women are victims of hormonal mood swings. In addition, men's moods and emotions are also influenced by the hormone testosterone, but "why do we not say that all men are slaves of testosterone-induced violence and rage? Neither is accurate."[39] No one is enslaved to the hormonal changes in their bodies, whether they are men or women.

Culture plays a role for women not assuming responsibility for their own destinies. Both women and men are accountable for their own destinies. Everyone will stand before God individually and account for what he or she does with his/her talents and callings. Joy Strang recalled her hunger for God in the nineties and how He began to speak to her. He wanted

her to lead prayer meetings in her home and mentor women. At that time this whole thing was foreign to her. One day in her protestations during prayer, God revealed to her that, "When you stand before Me (He said), saying your husband didn't agree will not be an excuse. You'll be held accountable for what I asked you to do."[40]

Because of cultural influences that are pathological, women in many circles are not taught survival skills. One sociologist notes that, in spite of so much talk about changing sexual roles, young girls are still set up through training to be victimized. By limiting the boundaries of girls, they are susceptible to becoming someone's prey. They "learn to be cute, sexually attractive, flirtatious, and submissive in a dating relationship. The young man, meanwhile, still learns to play the aggressor."[41] Men and women learn to relate in familial relationships, but they do not learn to relate to the opposite sex outside of their families in any way but sexual. This has resulted in many keeping restrictions on women to prevent the manifestation of inordinate sexual impulses that traditionalists surmise will occur when the two sexes fraternize outside of relational boundaries. This also allows traditionalists to keep women (as Piper notes in his book), receptive, responsive, vulnerable, delicate, and expressive. [42]

Women have often been set up for victimization in a yet fallen world. Those who are raised to believe that finding a husband to take care of them should be their number one priority often become victims in the event of divorce or the untimely death of their husbands. Some have no clue as to how to take care of their families, for that was not part of their training. Not only must women in Christian faiths be trained to take care of themselves and their families in the event of tragic circumstances, but they must also be educated

in ways to protect themselves physically. Rather than fathers and mothers teaching their daughters to be passive, receptive, vulnerable, and delicate, they should provide them with the means to survive in various instances when danger may be eminent. One Florida dad, Scott Schuering, demonstrated a way that prevented his daughter, Ashley, from becoming a victim. Schuering told his daughter that if she were attacked, she should "fight—go down fighting. Don't give up at all." He also made her watch a video from a car wash surveillance camera of another girl, Carlie Brucia, who a few weeks earlier was led away in Sarasota without a struggle by the man who eventually raped and murdered her. Ashley was attacked one Monday afternoon, and the words of her father came back to her. She jerked herself free, pushed her attacker in the chest with all of her might, and pedaled off on her bike.[43] In a world that can sometimes be cold and cruel, victimization is a cultural set-up for women, and it does not have to be that way.

PART 2:

THE JESUS REVOLUTION

Chapter 7

JESUS, THE LIBERATOR

Perhaps it is no wonder that the women were first
at the Cradle and last at the Cross. They had never
known a man like this Man—there never has been
such another... who rebuked without querulousness
and praised without condescension; who took their
questions and arguments seriously; who never mapped
out their sphere for them, never urged them to be
feminine or jeered at them for being female; who had no
axe to grind and no uneasy male dignity to defend.[1]

—DOROTHY SAYERS, AUTHOR

As LIBERATOR, MESSIAH, and Savior, Jesus came to Earth
to redeem mankind. Jesus' birth from the Virgin Mary
also marked the restoration of women from the curse, for
redemption for all came through Jesus. However, Jesus did
more than that—He revolutionized the status of women while

He was here on Earth! His ministry and behavior tore down every taboo and cultural barrier that had been inflicted upon women for centuries! Most encounters that Jesus had with women had spiritual, cultural, and historical ramifications. Remember, women at that time were not allowed to talk to or socialize with men!

Within the Constraints of Culture and Tradition

The time had not come to reclaim this world system—that would come later. (See Revelation 11:15.) The Roman Empire had conquered Israel, and yet Jesus did not come to depose the Romans: "My kingdom is not of this world: if my kingdom were of this world, then would my servants fight, that I should not be delivered to the Jews; but now is my kingdom not from hence" (John 18:36).

Jesus worked within the confines and social restraints of first century society, for His purpose here on Earth was not to oust the leadership of that time. When the Pharisees came to Him and tried to entangle Him by asking if it were lawful to pay taxes to Caesar or not, Jesus asked them to show Him the tax money. He then said, "Whose image and inscription is this?" They said that the image was Caesar's. And He said to them, "Render therefore to Caesar the things that are Caesar's, and to God the things that are God's" (Matt. 22:17–22, NKJV). This was demonstrated to Peter when the temple tax collectors questioned him about whether his teacher paid the temple tax. (See Matthew 17:24–27.) When Jesus came into the house, He anticipated the situation, asking, "What do you think, Simon? From whom do the kings of the earth collect duty and taxes—from their sons

or from others?" (Matt. 17:25). Peter's answer was that it was from strangers. Jesus said to him:

> Then the sons are free. Nevertheless, lest we offend them, go to the sea, cast in a hook, and take the fish that comes up first. And when you have opened its mouth, you will find a piece of money; take that and give it to them for me and you.
>
> —Matthew 17:26–27, NKJV

Jesus' purpose was not to bring government reform to a dictatorial Roman Empire or a patriarchal Jewish culture, but to bring reformation to the hearts of men and women. Trying to overthrow the existing ruling structure would have meant the kiss of death for the newly found Christian sect.

The plight of the Jewish women in antiquity was agonizing. Few Jews seemed to have been actual Roman citizens, and a woman's citizenship was determined by her relationship to a male citizen. Among other conditions, women were considered the legal property of men—they would pass from their fathers to their husbands. Widows were placed back under the jurisdiction of their fathers, sons, brothers, or brothers-in-law. Polygamy was legal for men. Failure to adhere to restrictions set by the family patriarch was met with penalties. Inheritances were passed from father to son. Adult life for women meant entering a marriage and bearing children. Many Jews signed a prenuptial contract called a *ketubbah*. Josephus noted that only a husband could divorce his wife. Fathers customarily arranged the first marriages of women, who appeared to enter marriage or other unions at very early ages—twelve to eighteen—usually to much older men. They started having children early, and those who did not die from childbirth were usually widowed. The birth of a male child

was a woman's only means of gaining status. Sterile women or those who had only female children could be divorced.[2]

Women's public life was similar to that of non-Jewish women. The elite and respectable were sheltered and often secluded from public life. Public places, such as the marketplace, council halls, law courts, and assemblies, were the domains of men. The household was the sphere of women—the more interior for virgins and the outer rooms for mature women. Poor women and freed women had more public lives.[3]

The society of Jesus' time remained repressive to women. God explains a similar scenario in Jeremiah 2:20 concerning Israel and their Egyptian bondage: "For long ago [in Egypt] I broke your yoke and burst your bonds [not that you might be free, but that you might serve me]" (AMP). The operative words are that women should have been allowed to serve God to the fullest without the man-made yokes that had constrained their lives. It was Jesus who began a revolution that showed women that they were also God's chosen.

From Shame to Grace to Glory

The shame of the Fall was a legacy for all mankind; it has been, however, the woman down through the centuries of tradition and cultural mores who has borne the brunt of the shame. Societies and cultures, even today, oppress their women. Women, along with the culture in general, often pass down feelings of inferiority to their daughters. To talk about the practices that go on today would take another book on that topic alone. As noted earlier, in many third world countries, girls go hungry so that the boys can be fed. Female babies are often aborted in China. Girls endure genital mutilation in Africa. Physical abuse and murder are sometimes punish-

ment in Middle Eastern countries when women spurn men. When Jesus went to the cross, He bore centuries of women's degradation, shame, and subordination.

From Being Seen as One-Dimensional— Mothers Only

As discussed earlier, women down through the ages had no worth outside of their ability to bear children, particularly sons. Jesus in Luke 11:27–28 moved the woman in the crowd from an emphasis on procreation and redirected her emphasis. "Now it occurred that as He was saying these things (teachings), a certain woman in the crowd raised her voice and said to him, 'Blessed (happy and to be envied) is the womb that bore You and the breasts that You sucked!'" (v. 27, AMP). Jesus in confronting the woman says in verse 28, "Blessed (happy and to be envied) rather are those who hear the Word of God and obey and practice it" (AMP). Jesus, in speaking to the woman, de-emphasized the role of a woman as procreator and stated that hearing, obeying, and practicing the Word of God is the most important thing, even more than motherhood!

From Centuries-Old Stereotypes

Jesus obliterated the age-old prevailing social perception that women were the cause of men's sexual sins and placed the responsibility for the sins of adultery and fornication squarely on the shoulders of the guilty—male or female! Jesus did not view women as evil temptresses who were to be isolated from men except for procreation. He cut to the core of the issue in Matthew 5:27–28, while teaching the Beatitudes. He said, "You have heard that it was said to those of old, 'You shall not commit adultery.' But I say to you that whoever looks

at a woman to lust for her has already committed adultery with her in his heart" (NKJV). In another incident, as Jesus sat in the temple court teaching, the Scribes and Pharisees brought a woman to him who had been caught in adultery. (See Matthew 8:3–11.) They brought her to Him hoping that His answer would provide a means of bringing charges against Him. They persisted in questioning Him about the law and what His judgment would be. Finally, in answering their queries, Jesus pointed out the evil within them with: "Let him who is without sin among you be the first to throw a stone at her. Then he bent down and continued to write on the ground with his finger" (John 8:7–8, AMP). It is unclear what He was writing on the ground. In speculation, perhaps, He was writing down sins that He saw in each of them. Maybe He was writing about the quality of their hypocrisy: men laden-down with sins bringing to Him a sinful woman. Or perhaps He was writing about men who condemned an adulterous woman, yet refused to condemn the man who participated in the act of adultery with her. The Bible states that they began to leave one by one because they were convicted of their own sins. They exited, leaving only Jesus with the woman. To emphasize the point, Jesus asked the woman where her accusers were. "Hath no man condemned thee?" (John 8:10). She states that there were none to condemn her. Jesus then ultimately said, "Neither do I condemn thee: go and sin no more" (John 8:11). The hypocrisies of the Pharisees and Scribes were exposed. Jesus did not adhere to the age-old view that women alone were responsible for all sexual sins.

Toward Total Restoration for Womankind

It was after the Fall that the woman was no longer viewed as co-image-bearer with Adam. She became one-dimensional, relegated to the status of "supplier of male heirs." When she was unable to meet the job description, her barrenness was viewed as a curse. Not only were her life roles limited, but she also bought into that identity of herself as solely the bearer of male heirs.

Jesus redeemed womankind from a one-dimensional role and from being the age-old cause of humankind's fall from grace. Women were and are blood-washed through Christ. They once again became the female Adam, the name that was given to both male and female by God. Although Eve means "mother of all living," it was the fallen name given to the woman by Adam after the Fall.

It is obvious that Jesus believed that the primary purpose for everyone, including women, was to know Him and His Word. For Jesus, a woman's identity or lack thereof was not determined by whether she was barren or fertile. Jesus, in Luke 11:27–28, redirects the emphasis of the woman in the crowd away from procreation.

From an Unclean Status

Jesus did not consider the woman who had the issue of blood unclean, nor did he prohibit her from being in the company of others. (See Leviticus 15:15–27.) The woman with the issue of blood ran the risk of being summarily humiliated because of cultural prohibitions as she reached out to Jesus.

> And there was a woman who had a flow of blood for twelve years and who had endured much suffering under [the hands of] many physicians and had spent

all that she had, and was no better but instead grew worse. She had heard the reports concerning Jesus, and she came up behind Him in the throng and touched His garment, for she kept saying, If I only touch His garments, I shall be restored to health. And immediately her flow of blood was dried up at the source, and [suddenly] she felt in her body that she was healed of her [distressing] ailment. And Jesus recognizing in Himself that the power proceeding from Him had gone forth, turned around immediately in the crowd and said, Who touched my clothes? And the disciples kept saying to Him, You see the crowd pressing hard around You from all sides, and You ask, who touched Me?...the woman, knowing what had been done for her, though alarmed and frightened and trembling, fell down before Him and told Him the whole truth...He said to her, Daughter your faith (your trust and confidence in me, springing from faith in God) has restored you to health. Go in (into) peace and be continually healed and freed from your [distressing bodily] disease.

—Mark 5:25–31, 33–34, AMP

Jesus knew that the woman was there; her stepping forward was part of her healing. He was also showing the crowd that He was not a respecter of persons, that He came to redeem man and woman.

Toward the Discipleship of Women

When Jesus visited his friends, Martha and Mary, Martha served Him, but Mary sat at His feet and listened to His teachings, as disciples typically did when they were being taught. As Martha set about serving Jesus and making sure everything was in place, she scolded her sister for not doing

the same. She sought Jesus' support, but Jesus said to her, "Martha, Martha, you are anxious and troubled about many things; There is need of only one or but a few things. Mary has chosen the good portion [that which is to her advantage], which shall not be taken away from her" (Luke 10:41–42, AMP). The traditional role for women was to serve and not be seen. It was unheard of at that time for a woman to sit at the feet of a rabbi or teacher, for she was deemed unteachable. Sayers notes that every sermon she has heard has attempted to explain away the text of this story. Most within the church greatly prefer what Martha did, for it was the feminine thing to do. Mary, on the other hand, was behaving like any other disciple and that is "a hard pill to swallow."[4]

Toward Teaching Women

Women did not associate with men in the home, and especially in public, so Jesus' disciples were baffled and amazed when He talked with the woman at the well. (See John 4:1–26.) To make matters worse, she was a Samaritan. Jesus went through Samaria specifically to talk with the Samaritan woman. The Bible notes that Jesus needed to go through Samaria. (See verse 4.) In John 4:7–10, Jesus, not only talked to the woman, but He also taught her the salvation message and identified Himself as the Messiah:

> When a Samaritan woman came to draw water, Jesus said to her, "Will you give me a drink?" (His disciples had gone into the town to buy food.) The Samaritan woman said to him, "You are a Jew and I am a Samaritan woman. How can you ask me for a drink?" (For Jews do not associate with Samaritans.) Jesus answered her, "If you knew the gift of God and who it is that

asks you for a drink, you would have asked him and he would have given you living water." (NIV)

The woman, who was preparing to draw water from her ancestor Jacob's well, did not understand at first Jesus' gift of living water. She believed that the water Jesus provided would eliminate her having to come to the well to draw water:

> Jesus answered her, all who drink of this water [from Jacob's well] will be thirsty again. But whoever takes a drink of the water that I will give him shall never, no never, be thirsty any more. But the water that I will give him shall become a spring of water welling up (flowing, bubbling) [continually], within him unto (into, for) eternal life.
>
> —John 4:13–14, AMP

The Samaritan woman began to understand. She asked Jesus for the living water, which led Jesus to address her current living situation. He knew this would cause her to evaluate her life. Jesus told her to call her husband, to which she declared that she had no husband. Jesus then began to tell her about her five husbands and the man with whom she was now living. At that moment, the Samaritan woman had a divine encounter with the living God.

A bishop in Houston revealed several key points in a Sunday service—factors that heretofore have been overlooked in sermons about the Samaritan woman.

1. It is not likely that the woman was a prostitute, even though she had had five husbands and was at that time living with a man, as some have taught. Divorces were not that prevalent during the New Testament era, especially for women,

for women could not obtain divorces. Plus, in light of the cultural climate, to have lived with five different men or divorced five times would have made her an unlikely candidate for the sixth man, with whom she was living.

2. The woman was perhaps widowed five times and if that were the case, it is possible that she did not want to go through the ordeal with the sixth man.

3. The woman was a descendant of Jacob, and thus, a member—although outcast—of the Jewish family. (Samaritans were part Jewish.) She mentions Jacob as her forefather, so she could have been familiar with the Torah.[5]

There was also the possibility of kinsman redeemers in her husband's family, men who married the wife of a deceased relative to carry on the family lineage. She could have very well married kinsman redeemers and at that time be betrothed to the sixth, choosing to live with him rather than marry for a sixth time.

In teaching the process of salvation and restoration, Jesus proceeds to tell the Samaritan woman about worshiping the true and living God, rather than emphasizing the place of worship. When she mentions knowing about the coming Messiah, Jesus identifies himself as the Christ.

A time will come, however, indeed it is already here, when the true (genuine) worshipers will worship the Father in spirit and in truth (reality); for the Father is seeking just such people as these as His

> worshippers.... Jesus said to her (after she mentions
> the coming Messiah, the Anointed One), I Who now
> speak with you am He."
>
> —John 4:23, 26 AMP

When the disciples came, they were surprised to see Jesus talking to the Samaritan woman. They, however, said nothing. The rest is history; the woman hurriedly left and went back to the town, where she told the people about Jesus and the salvation message that He had taught her. Many, because of her proclamation, went to meet Him.

In another instance, Martha was the first person to which Jesus acknowledged that He was the "resurrection and the life" (John 11:25). Jesus had come to literally raise Lazarus from the dead. Martha did not understand and replied that she knew that Lazarus would at the last day rise again in the resurrection. To this Jesus said:

> I am [Myself] the Resurrection and the Life. Whoever
> believes in (adheres to, trust in, and relies on) me,
> although he may die, yet he shall live; And whoever
> continues to live and believes in (has faith in, cleaves
> to, and relies on) me shall never [actually] die at all. Do
> you believe this?
>
> —John 11:25–26, AMP

Martha proclaimed that she did believe that Jesus is Christ, the Messiah, and Son of God. She declared that He was the One for whom the world had long awaited.

Toward the Empowerment of Women as Witnesses

During and before Jesus walked upon the earth, women were not considered reliable witnesses; they were seen as flighty light-weights who were not dependable in giving testimony in court or for that matter, providing an accurate account of any event. Jesus treated women with the dignity that had been heretofore denied to them. He did trust and esteem their views.

Mary Magdalene was the most unlikely representative, for she had been the one from whom Jesus had cast out seven demons, yet she was the first person Jesus appeared to after His resurrection. Jesus found her faithful. She had been at His side during the Crucifixion. She was a disciple who had traveled with Him and contributed to His care. (See Luke 8:2.) As Mary Magdalene (and the other Mary) approached the tomb that fateful day after the Sabbath to prepare Jesus' body, they witnessed the angel of the Lord rolling back the stone:

> The angel said to the women, do not be alarmed and frightened, for I know that you are looking for Jesus, Who was crucified. He is not here; He has risen, as He said [He would do]. Come, see the place where He lay. Then go quickly and tell His disciples, He has risen from the dead, and behold, He is going before you to Galilee; there you will see Him. Behold, I have told you.
>
> —Matthew 28:5–7, AMP

Mary was the first to witness Jesus' resurrection. "Although Peter and John [ran] to the tomb, Jesus [waited] until after they…left to appear to Mary."[6] Jesus commissioned her to go

tell His disciples. The male disciples saw Him that evening.
Mary was a faithful disciple; however, she could not have
gone before the Sanhedrin and Pharisees to contest their
treatment of Jesus. She did all she could do by bringing
spices to embalm His body. Jesus, however, gave to her the
first gospel message: she was to proclaim to the disciples that
He was alive—He had risen from the dead!

About the Twelve Male Disciples

The traditionalists argue that there were no female apostles
among the twelve; therefore, the church should follow Jesus'
example and select only male leaders. More importantly, it
can be said that not only were women not part of the twelve,
but neither were Gentile men or slaves. Of course, those
making the argument to restrict women are Gentile men. So,
if Jesus' ministry is examined closely, the very ones within
the traditional ranks, who advocate prohibiting women from
ministry—Gentile men—would not have been eligible for
leadership as well. Jesus came in the fullness of time, born of
a woman, and yet the world was not ready for the representa-
tion of different groups as His apostles. "Had He waited until
the world was ready to receive representatives of disadvan-
taged groups of society among the twelve, the world might
very well still be waiting."[7] Jesus could not wait for the world
to accept disadvantaged representatives.[8] Hamilton takes
it even further. Not only did He select only Jews, but He
selected only Jews from one nation and one region—Gali-
leans who spoke Aramaic. Thus, should the church choose
only Aramaic-speaking male Jews born in Galilee? When
playing the limitation game, then only those who actually
were eyewitnesses to His three-year earthly ministry meet
the requirements.[9] Beyond the twelve, Jesus did teach women,

and women traveled with him, even in a society that prohibited public communication with women.[10]

Though Jesus treated women as equals to men, He still had to live within the jurisdiction of a repressive Roman regime and a traditional Jewish culture. Jesus realized that others were not as accepting of women as He was. Liefeld and Tucker present three points they believe are significant in explaining the dilemma that He faced:

1. It would have been very dangerous for a woman to travel alone as a missionary in that society.

2. Many in that culture did not accept women as teachers. Men did not publicly speak to women; most tended to change directions if a woman approached.

3. Women were not accepted as witnesses, and that is why Mary Magdalene's witness of the resurrected Christ was so relevant. It broke centuries-long barriers, which prevented women from being believed as witnesses.[11]

Jesus, the Christ, the Resurrection, and the Life, redeemed womankind by breaking the curses precipitated by the Fall. What Satan had meant to destroy, Jesus came to redeem.

> And I will put enmity between you and the woman, and between your offspring and her offspring. He will bruise and tread your head underfoot, and you will lie in wait and bruise his heel.
> —Genesis 3:15, AMP

Jesus is the great liberator of women!

Chapter 8

PAUL AND PETER—
CLANDESTINE OPERATIVES?

It becomes evident that certain problems which
existed in the first century would not find a practical
solution till centuries later... This means that while
in principle the New Testament might oppose slavery,
racism, tyranny, and other forms of social injustice, it
appears to advocate or at least tolerate such undesirable
concepts in practice simply because the time had not
come for their overthrow. This would take years, in
fact centuries, of growth on the part of the church
and of advancement of social mentality. This seems to
be the same case concerning the status of women.[1]

—LESLY F. MASSEY, AUTHOR

G ALATIANS 3:28 STATES that "there is neither Jew nor
Greek, there is neither bond nor free, there is neither
male nor female: for ye are all one in Christ Jesus." In reality,
equality was not practiced in the first century. Massey notes

that the inequality and injustices were precipitated by the social and cultural stratification within the church and society. She emphasizes that if Paul's words did not apply to the emancipation of women (Gentiles and slaves) in the church and social milieu, then they were meaningless.[2] Several factors were at work in the early church, and they are reflected in the controversial New Testament scriptures:

1. Due to Jesus' atoning death and Resurrection, many believe that the earth was being redeemed at that time. Therefore, God had already started a new order and ethics for people.

2. The early church believed that the end times were upon them and there was a sense of urgency. As a result, women achieved heretofore unachievable status within the church.

3. This new theology presented difficulties for those who penned the New Testament books because it conflicted with their existing cultural and social ideas of women and their roles.[3]

4. To complicate things, the Gnostic movement had infiltrated the church. Gnosticism, a mystic cult, incorporated some of the foundational material about Jesus. There were some women who became active in this group.[4]

Early New Testament writings showed interest in reforming, but not altogether dismantling, the patriarchy outside the Christian community. This does not mean that the early church was in agreement with patriarchy; they

had to work within the culture in which they lived. This reformation included new freedoms and roles for women within Christian families and communities. These views were not accepted in the greater society, and the resistance to freedom for women within the church grew as heretical problems arose.[5]

Paul was not only an agent of the Holy Spirit, but he was also a product of his time. "Paul must always be understood as a man of three worlds and consequently three interconnected worldviews: Jewish, Greco-Roman, and Christian."[6] It was important for him to work within the confines of his culture. This best reflects Paul's philosophy:

> For though I am free from all men, I have made myself a servant to all, that I might win the more; and to the Jews I became as a Jew, that I might win Jews; to those who are under the law, that I might win those who are under the law; to those who are without law; to the weak, that I might win the weak. I have become all things to all men, that I might by all means save some. Now this I do for the gospel's sake, that I may be partaker of it with you.
>
> —1 Corinthians 9:19–23

Paul believed in putting others and their well-being first in order to win them to Christ. (See 1 Corinthians 10:23.)

Paul wrote to prescribe remedies for first-century problems. As Thurston declares, "Paul wrote for pastoral, not historical reasons....to address issues of contemporary concerns, not to document the development of early Christianity."[7] The problems noted in his prescriptions for the first century are not the problems of the twenty-first century church.[8] Paul did not know when his letters were penned that they would be later canonized. The principles of the Bible

are eternal, universal, and transcultural; however, as Craig Keener asserts, "Those principles would have to be reapplied in different ways in different cultural settings: all biblical passages may be for all time, but all biblical passages are not for all circumstances."[9] He further notes that Paul was writing letters to specific congregations concerning relevant issues that were happening in their particular churches; they had no Bible to cross-reference with other letters that were written.[10] The problem today arises when scriptures related to circumstances or social customs from the New Testament era are spread across multiple cultures, rather than extracting the universal principals from them, as has been done with most other culturally relevant scriptures. God also used parables of social customs of a specific time to convey relevant spiritual principles.

Paul wrote the epistles under the inspiration of Holy Spirit, which means that they are relevant today; however, the cultural relevance in which he was writing cannot be ignored. The letter to the Ephesians was meant to encourage and unify. Paul treaded cautiously through cultural traditions of the time, knowing that it was dangerous to upset traditional Jewish and Roman mores. The Roman government viewed the Jewish sect, called Christians, surreptitiously. Sects were viewed very suspiciously because many did cause uprisings and distorted the traditional family structure. In essence, it was not safe to expound a new liberty in Christ. Paul struggled with trying to make The Way (Christianity) palatable. He saw his mission as working within the existing society. He talked about being all things to others to win them to Christ. (See 1 Corinthians 9:19–23.) He placed himself under the existing authorities, and unlike Jesus, Paul allowed

the social order to restrict him, whereas Jesus transcended cultural and social orders.

New Testament writers, including Paul, did not anticipate that the deference to Roman culture of that time would be used centuries later; after all, the first-century believers anticipated Christ's soon return. Having to bow to the existing government is not a problem within the Western church today; however, the biblical principles can still be applied transculturally.

In addition, Paul never differentiated that some gifts were for men and some for women. He stayed within the confines of the culture as much as possible so as not to bring attention to the Christians' differentiated lifestyles. Many who choose certain scriptures to literally interpret a woman's role while ignoring others are employing selective literalism.[11]

Paul did affirm, value, and work with women.[12] If you know of women's predicament in Iran, Pakistan, Jordan, Afghanistan, and some African countries, you can then begin to visualize a first-century Jewish culture in which the Jewish sect, called The Way, entered the scene. That society was ruled by an even more repressive Roman Empire. Paul had to walk a thin line in encouraging liberty, yet not causing Christianity to be viewed by the Romans as trying to overthrow their existing social order. Therefore, Paul adapted the philosopher's traditional household codes, which had also been adopted by Jews and other groups, to prove that Christians were not social subversives. Paul sought to prove that Christians were good citizens who upheld traditional Roman family values, namely the submission of wives, children, and slaves.

…many scholars have pointed out [that] members of the Roman elite suspected Christianity, like several

other non-Roman religions, of subverting Roman family values. By upholding what was honorable in Roman values, the Christians could try to protect themselves from undue persecution and from misunderstandings of the gospel.[13]

Neither Male Nor Female—
Galatians 3:28

Galatians 3:28 addressed the three deepest divisions within first century society—Gentiles, women, and slaves.[14] This verse represented Paul's desire to address the abolishment of differences that separated Jews and Gentiles, whether they were attitudes, beliefs, or practices. However, Paul took it further, not limiting the differences to Jews and Gentiles; he also emphasized the other two couplets—slaves nor free, and male nor female. "For Paul there must have been an inseparable linkage of these couplets as descriptive of new clothing put on in Christ."[15] Paul declared that all Greeks (Gentiles), women, and slaves were just as free in Christ as Jews, men, and freedmen. In Christ, "Women, no less than men, wear the uniform of Christlikeness, which alone qualifies a person for spiritual service."[16] Some believe that with the three couplets in Galatians 3:28, Paul was nullifying the three-fold prayer chanted by Jewish men each day in which they stated gratitude to God that they were not born a Gentile, a slave (uneducated man), or a woman.[17] (See Chapter 4.)

Espousing spiritual equality and social inequality as traditionalists do, women in today's conservative churches are given the same status as that of women in the repressive cultural climate of the first century. Equality before God in the afterlife does not negate what appears to be the greatest

fear of traditionalists—the blurring of maleness and female-ness, or the lack of role differentiation here on Earth.

Traditionalists imply that Galatians 3:28 refers only to salvation for women (spiritual equality), even though at that time the verse granted equal status beyond the spiritual for Gentiles within the church. The problem of slavery was also nullified in that scripture, even though emancipation of slaves was not practically realized at that time. Today, cultural restrictions have been eradicated for Gentiles and slaves and they have been granted equal status. Only equal status for women has been relegated to the hereafter.

If the good news of the gospel is that people are indeed new creatures, why would opportunities to serve God in this present life be restricted according to attributes of the perishable flesh—especially since Jesus Himself said, "the flesh counts nothing"?[18] Limiting Galatians 3:28 to spiritual terms renders it meaningless. Jesus freed people from incon-sequential and unbearable weights of tradition through His sacrificial death on the cross. If Galatians 3:28 is limited to only the spiritual plane for women, then it has no practical significance for women even as it relates to basic conduct and social interactions.

The subordination of wives usually appeared with the subordination of slaves, which represented the stage of social development and spiritual immaturity of that time. Even though Paul and other New Testament writers felt a need to conform to the existing culture, they, along with the Old Testament prophets, looked to the day when the biblical stan-dards of the gospel and spirit of Christ would be manifested. Galatians 3:28 refuted slavery, persecution, and on the prac-tical side, the subordination of women to their husbands, viewing the marriage covenant as vows between mutual

beings. It nullified the superiority and lordship of husbands and the inferiority of wives as invalid and antiquated.[19]

Submitting One to Another,
Ephesians 5:21–33

Paul was imprisoned at the time of the writing of Ephesians. The epistle was addressed to Christians, but it also attempted to appeal to those in power in Rome. Even though Ephesus was in Asia, Paul was interested in defending Christianity against charges of sedition. He exhorted Christians to live in a way that would not bring offense against them.[20]

Ephesians has the longest Bible verses that address the roles of women and men, using the household codes. (The household codes were discussed briefly earlier in this chapter. It merits taking a more succinct look here.) Paul used the household codes, as he did not want Christianity to offend the larger population or give any possible hint of trying to overthrow the Roman social order. The household codes were used to determine the father's rule and the nature of his relationship with members of his household. Household codes, introduced by Aristotle, were the usual way that ancient writers showed the nature of a father's rule. Families were determined by rank and duty and were defined by subordinate relationships rather than blood relationships. The father as ruler was often compared to a king reigning in his kingdom, a microcosm of society. The household management fell into three pairs of relationships with the head of the family: master and slave, husband and wife, and father and children.

A man's idea of "ruling the family" was to keep his wife shut away in the house to do back-breaking chores, tend

the family farm, provide sexual gratification, and bear as many children as he wanted so he could have plenty of laborers to harvest the crops. If she died in childbirth, he found another wife. If she didn't please him in bed, he paid a younger woman outside the home to meet his sexual needs. If his wife shamed him, he beat her. If she dared to run away, he found her and beat her again.[21]

It was important for sects, such as The Way and others, to present a pro-family stance, so the various sects often used the three-part household codes—the *haustefel*—to show that they were upstanding members of the Roman society.[22]

Paul's argument here is both powerful and well crafted. If wives submit to their husbands, Roman moralists and others could not claim that Christianity subverted pagan morals. But if the husband also submits, and husband and wife act as equals before God, Paul is demanding something more than Roman moralists typically demanded, not less.[23]

Submission is a horizontal action that is mutually applicable to all believers, including husbands and wives. It is not a command; it is naturally passive, resulting from the infilling of the Holy Spirit. It is a heartfelt attitude, not an action.[24] A brief examination of Ephesians 5:21–33 would suggest that Paul "places her submission squarely in the context of mutual submission, and qualifies her husband's position…as one of loving service."[25] Ephesians 5:21 must never be isolated from verses 22–33 when discussing submission in marriage; to do so is to insinuate that wives are not granted the same grace as other Christians. Preato notes that verse 22 is not a separate sentence from verse 21; it continues and completes it and should be comprehended in context of its relationship with verse 18

through 23, a long sentence in the Greek. He reports that verse 22 should not be translated as a command for wives, as some translators have elected to make it.[26] The following examples show various translations' selective use of wifely submission:

1. "wives, be subject"—NRSV, NASB, REB
2. "submit"—NIV, NKJV
3. "submit yourself"—DNT, KJV, ISV
4. "yield"—NCV
5. "will submit"—NLT
6. "must submit"—TLB

However, there is no verb in the Greek text. There is no command solely for wives to submit; both husbands and wives are meant to cooperate and support one another in the spirit of love and unity. Only a few translators place "be subject" in italics or brackets to show that the verb is not used in the best Greek manuscripts.[27]

Keener notes that Paul discusses wifely submission and husbands' sacrificial love, but he never discusses the words *obey* and *rule*, even though he tells children and slaves to obey. Paul's exhortation of wifely submission in Ephesians 5:22 is an example of all believers' call to submit to each other in 5:21. He discusses the wife's submission, using the traditional household codes, but he qualifies that submission under the general submission of all Christians one to another:

> It is clear that the submission of verse 22 cannot be other than the submission of verse 21 for the simple fact that the word *submitting* does not appear in the Greek text of verse 22. It has to be borrowed from verse 21. It is perfectly legitimate to read verse 22 as, "Wives, submitting to your husbands," as long as we

understand that we must take verse 22 as an example
of verse 21's mutual submission.[28]

Bristow alludes to the use of the notorious "Ephesians 5
Syndrome" as the scriptures men have used to denote their
superiority over women. He refutes the notion that this
chapter refers to men and women in general; it is dealing with
husbands and wives. He goes on to note that Paul is writing
against rather than in favor of the superiority of males over
females. When Paul says, "The husband is head of the wife, as
Christ is the head of the church," the controversy surrounds
the word *head*. Paul uses the word *kephale* to denote "head."
Intensive research has shown that *kephale* has no reference
to a chain of command or hierarchical structure between
men and women. It means "source of life" (in Creation), a
definition that omits any hint of authority.[29]

Woman came out of man; he was her source of life in
Creation. Now she is his source of life in procreation.[30] Paul
provides a more objective analysis of creation by saying that
woman came from man, but man now comes from woman.

The husband's role as head of the wife as Christ is head
of His church presents another issue that is misinterpreted
by traditionalists. In telling husbands to love their wives as
Christ, the Savior, loved the church, Paul is commanding
them to give themselves up for their wives.[32] The analogy is
centered around the husband's selfless and sacrificial death
for his wife, as Christ did for the church. Ephesians 5:21–
33 describes the husband as similar to Christ, the Savior,
in that he is a life-giver. In laying down his life—his own
needs, rights, and desires—out of love for his wife (whom
he regards as his own body), a man becomes a source of life
for his wife.[33] Thus, this passage is not an analogy to Christ's
authority over the church, and therefore there was no

assumption or statement made by Paul that a husband had authority over his wife. Husbands should never point their wives toward themselves as the authority. "No servant can serve two masters; for either he will hate the one and love the other; or else he will hold to the one, and despise the other. You cannot serve God and mammon" (Luke 16:13, NKJV). In addition, man can never compare himself with Christ's sinless death on the cross for all humankind:

> We know that unlike Christ, a husband does not offer a sinless sacrifice of his own life for the sake of his wife's eternal salvation; for he is as much in need of salvation as his wife....It is particularly significant that there is no mention (or parallel) here of either the authority of a husband over his wife (which he [the husband] had through civil law at the time of Paul's writing) or the authority of Christ over the church (which he [Christ] has always had in full measure).[33]

In essence, both husband and wife are serving each other. Any teaching that uses the analogy in Ephesians 5 to place husbands (much less all men) in positions of sovereignty over their wives (or women in general) is proceeding down a dangerous slope into male idolatry.[34]

Admittedly, Paul did not challenge the existing authorities' hierarchical structure. Paul's reticence to challenge many structures of his day, in light of Jesus' activism, has been a disappointment to some modern scholars. However, Paul obviously had to tread lightly living in the context of the existing culture that viewed women as inferior creatures, evil, ignorant, mainly sexual, and immoral. In addition, Keener states that Paul wrote only a fraction of the New Testament letters that have been attributed to him; additionally,

others have altered some of the letters that he wrote in an effort to show developments that happened later in church theology.[35]

In Ephesians, Paul not only spoke of mutual submission within marriage, but more importantly he showed the relationship of Christ and His church. He used marriage to show the oneness that Christians should demonstrate with each other and Christ.[36]

Mickelsen states that 1 Corinthians 7 is the only place where Paul talked solely about marriage. It is here that Paul deals with sex in marriage, keeping marriages together, and winning the unsaved husband or wife. He tells both husbands and wives that they are responsible in these matters. He does not, however, discuss husbands as the ones who are in charge.[37]

Head as Source, Not Authority— *1 Corinthians 11:3–16*

The use of *kephale* to refer to a source or a beginning shows that Paul did not teach a chain of command in 1 Corinthians 11:3. His word order infers no chain of command, but rather he was showing that woman was made of the same substance as man.[38] Hamilton presents several facts that refute the traditionalists' claim to male authority/leadership. Firstly, the word *submission* is missing from this passage, and the term *authority* is used only once pertaining to the authority a woman has over her own head. Secondly, Paul changed the two pairs of relationships from universal in the first—every man/Christ—to specific in the second—a woman/the man. Hamilton states that the shift from the universal in the first relationship (every man/Christ) to the specific in the second relationship (a woman/the man) presents a problem for

those who believe that the second relationship is speaking of the universal man's authority/leadership over the universal woman. One would have a problem noting which man has authority over which woman. Paul switched from every man in the first pair to the singular, a man, in the second pair. Hamilton notes that the passage does not speak of marriage; if it were discussing marriage, then what about the single woman or the widow? If this means authority over any woman, does that mean a man's mother? Therefore, head/*kephale* interpreted as authority/leader presents some "messy questions."[39] Thirdly, Paul did not mean to convey a chain of command by the way that he listed the three pairs. If he had meant hierarchy, he would have started at the top in the chain of command—God, Christ, men, and women. He instead presented them as "every man/Christ," then "a woman/the man," and lastly "Christ/God." Because of Paul's usual orderliness, it was obvious that he meant something other than a chain of command in the way that he listed the pairs. By using the word for "origin/source" instead of "authority/leader" to explain "head"/*kephale* in 1 Corinthians 11:3, Paul's statement makes sense.[40] When using the pairs to refer to creative order, Hamilton infers:

> Adam was created first, from whom "every man" descended. Then God created Eve (the female Adam), "a woman" from "the man." Finally, "When the time had fully come, God sent his Son, born of a woman, born under law, to redeem those under law, that we might receive the full rights of sons.[41]

Hamilton states that the church fathers were in agreement that "a woman/the man" was not written to mean "authority/leader." Because Paul was orderly, precise, and

clear in his writings, "a woman/the man" obviously did not mean hierarchy in this passage. Lastly, Hamilton asserts that for theological reasons, Christ/God did not mean authority/leader because there is no hierarchy in the Trinity. Jesus came to Earth and gave up His heavenly rights. That voluntary earthly submission by the Son to Father has nothing to do with a permanent, one-sided hierarchy between men and women. There is mutuality in the Trinity, with each member "preferring one another in love and honor."[42]

Silence, Not an Eternal Mandate for Women—
1 Corinthians 14:34; 1 Timothy 2:11–15

Many people who believe 1 Corinthians 14:34 refers to Genesis 3:16 miss the mark. When Paul stated, "Let your women keep silence in the churches: for it is not permitted unto them to speak; but they are commanded to be under obedience as also saith the law," he was speaking of Jewish law. Paul was probably answering a question that had been asked of him. It was the Jewish law written in the Talmud and Mishnah to which the questioners had referred, and Paul had responded. Jewish law, not the Old Testament, taught that women should be silent and not speak.[43]

A literal interpretation of 1 Timothy 2:11–15 has done more to hinder women being used in the church than any other traditional doctrine. Paul, in his letters or pastorals, addressed problems in particular churches. Some scholars believe that Paul, in his last years, was trying to bring structure and order to the church. There are still others, in fact, who do not believe that Paul wrote the two Timothy books.

First and Second Timothy were pastorals written to Timothy, but intended for church reading, as Timothy was attempting to bring order to the church in Ephesus. Mick-

elsen states that 1 Timothy was not a letter to the churches as Ephesians was. The central theme of 1 Timothy is false teachings. Ephesus was the center for the worship of Artemis, the Asian fertility goddess. Her temple, at that time, was one of the seven wonders of the ancient world. Other churches of that time could have used these pastorals if they had been dealing with the same problem that Paul addressed; however, many of the other churches faced different issues. [44]

The mistake lies with the assumption that the problems facing the New Testament church of newly liberated and uneducated women are applicable in today's church. It was not women being silent that was the emphasis, but rather women learning. Paul was not dealing with women not being allowed to teach or have authority over men. Paul was addressing the confusion that came from women hollering from their "place" to their husbands for explanations of the teachings. Uneducated women were abusing their newly acquired Christian freedom. These scriptures suggest that unlearned women were assuming teaching roles they were not prepared to administer, asserted Mickelsen.[45] Women had not been educated for centuries. In Jewish culture, they were not taught the Torah in most families. The women and children, at that time, were separated from their husbands in the temple services. So, all of a sudden, there was this group of people being allowed to participate in the services, when throughout the centuries they had been stereotyped, reviled, and cursed. An illiterate populace who is suddenly told that they are free—not just spiritually, but also culturally—is bound to present some disorder for a time.

Paul is not summarily advocating silencing women; he was discussing the fact that women were not yet ready to be placed in leadership positions—they needed to be educated

and brought to maturity. Paul expected the women to learn in silence as he would any novice. Unless learners had knowledge of a subject, they were expected to learn quietly and with a submissive spirit. Keener states that some teachers at that time expected their students to remain silent for a long period, possibly for moral discipline. The word for silence here means "a quiet demeanor."[46]

Women were newly liberated. Some theologians mention that there were women who were spreading false Gnostic teachings, which threatened the fledging church. Much of what Paul wrote to Timothy was concerning the danger of false teachings.[47]

Paul did not restrict or forbid women to teach, and this is evident in other scriptures. Paul commended his co-worker Priscilla, who taught Apollos. In addition, he frequently mentioned other women who held positions of responsibility in the church. Phoebe worked in the church, according to Romans 16:1. Mary, Tryphena, and Tryphosa were the Lord's workers, as were Euodias and Syntyche. (See Romans 16:6, 12; Philippians 4:2.) Some commentators have noted that Paul's words "I suffer not [I never let]" can be more literally translated as "I am not allowing." He was restricting the Ephesian women, but he was not placing a prohibition on all women for all times.

Today, the closest cultural example that might resemble first-century society is the plight and devaluation of women in third world countries. The uneducated, lowly status of women from third world countries must in many ways replicate the first-century women, when they were given the liberating message of Jesus Christ. A newfound freedom might indeed cause some chaos and need for structure and order until the newly liberated got over the giddiness of being

set free. They would, in addition, have to be educated to fully participate in church activities. The message that both men and women are new creations in Christ and that all things are made new would free these women today from spiritual as well as cultural bondage, as it did the first-century woman. (See Galatians 3:28.)

As noted earlier, traditionalists have tended to interpret Genesis 2 by using their interpretation of 1 Timothy 2:12–14. Genesis 2 does not teach women's subordination.[48] First Timothy 2:12–14 should be interpreted in light of the Genesis passages on Creation and not the other way around. Women in Western countries are not an illiterate people with newly found freedoms. There is no need to structure their behavior or silence them!

Paul's words were turned around and used to prohibit the freedom that he advocated for women. Bristow notes that the misinterpretation of Scripture was aided by the infiltration of Greek philosophy into the church, which represented a victory for Greek influences. Thus, "the ideas of Aristotle prevailed, bolstered by Augustine and other writers, and the words of Paul were reinterpreted and quoted in defense of practices that Paul opposed!"[49]

There are other difficulties with the traditionalists' interpretation of 1 Timothy 2:11–15. First, these are the only verses that specifically limit women from teaching. Second, there is no universal applicability because it was meant to remedy problems within the Ephesian church of that time.[50] And finally, the word *authentein* did not mean having authority over; it occurs only once in the New Testament. From a comprehensive study of *authentein*, Wilshire notes that it was used to connote violence rather than having authority over. *Authentein* in the Greek meant "murder"

or "murderer."[51] *Authentein* probably did not mean the authority usually referred to by the word *exousia*. It probably meant "abusive" and "domineering," which is biblically inappropriate for both men and women.[52]

New Creation in Christ—
2 Corinthians 5:16–19

Wherefore henceforth *know* we no man after the flesh: yea, though we have known Christ after the flesh, yet now henceforth know we him no more. Therefore if any man be in Christ, he is a *new creature*: old things are passed away; behold, all things are become new. And all things are of God, who hath *reconciled* us to himself by Jesus Christ, and hath given to us the *ministry of reconciliation*; To wit, that God was in *Christ*, reconciling the *world* unto himself, not *imputing* their *trespasses* unto them; and hath committed unto us the *word* of reconciliation.

—2 Corinthians 5:16–19, KJV, emphasis added

In these verses, Paul is talking to all believers—Christ also reconciled women so they are no longer known according to the flesh. Women are ambassadors of Christ, too, which means that no restrictions are placed on their gifts and abilities to proclaim, teach, prophecy, and represent Jesus Christ to a dying world.

Some traditionalists believe that, for women, the new creation spoken of in 2 Corinthians 5:16–19 is not manifested in this life. After realizing the truth of theses verses, Gabelein Hull approached her friends excitedly, exclaiming that all people, including women, had been called to be Christ's representatives. Her friends responded that it was true that Christians have a new spiritual standing; however, it

does not come into fullness in the earthly realm. During the earthly realm, they told her, human beings are still housed in the physical (fleshly) bodies. Their explanation tended to nullify the belief that people are no longer known after the flesh. Hull pondered that if being a new creation is limited to the hereafter, then there is no need for women to become saved until it is time for them to meet their Maker. Yet, if women are indeed ambassadors of Christ as 2 Corinthians 5:16–19 states, then their diplomacy cannot be relegated to the hereafter where there is no need for ambassadors to represent Christ.[53]

Was Peter Also Subversive?

Peter, too, was determined to uphold the cultural traditions and to avoid the Roman government viewing Christians as aberrant. He expressed this in 1 Peter 2:13, 15–16:

> Therefore submit yourselves to every ordinance of man for the Lord's sake…For this is the will of God, that by doing good you may put to silence the ignorance of foolish men—as free, yet not using liberty as a cloak for vice, but as bondservants of God. (NKJV)

The key phrase, the one that is often missed or ignored here, is "not using liberty to hinder others from the gospel, but rather having your conduct honorable before Gentiles." Peter's view seemed to be that of "bondservant of God" in submitting to the culture, values, and laws of the Gentile world, which for early Christians was the Roman Empire. Thus, he pinned ordinances that pertained to culture rather than to immoral behavior or sin, such as "Servants be submissive to your masters" (1 Pet. 2:18, NKJV), and "Wives, likewise, be submissive to your own husbands, that even if

some do not obey the word, they, without a word, may be won by the conduct of their wives" (1 Pet. 3:1, NKJV). These verses by Peter certainly would not offend the Romans, and they would cause women and slaves as bondservants not to use their liberty to hinder others (Gentiles), in this case, the Roman leaders.

Christians in some traditional circles have used the "headship" passages as permission to nullify other passages that call for mutuality in submission and making decisions in marriage. S. Scott Bartchy writes that many Christian men use leadership models from the battlefield and the corporate world.[54] This is a dangerous practice, a "lavish slavishness," toward particular Scriptures. Mickelsen exposes the folly of traditionalists using certain scriptures to denote what she perceives as male superiority. Mickelsen goes on to note that the promotion of either male or female superiority is invalid (flawed and unscriptural).[55] (See the Appendix.)

Chapter 9

QUASHING THE REVOLUTION AFTER THE FIRST CENTURY

Gender equality is not only traceable to the attitude
and teaching of Christ, in contrast to the male bias
of all ancient cultures, but was expressed in a variety
of ways in the early Christian community.[1]

—LESLY F. MASSEY, AUTHOR

THE EARLY CHURCH existed within the Roman Empire.
Rome rose to power in the vast geographical expanse
that was the Hellenistic Empire, created by Alexander the
Great. Jesus was born and lived within this backdrop. As
previously mentioned, men did not associate with women
except for procreation, for they were viewed as sexual objects
and evil temptresses. Some of the rabbinical literature was
even stronger in their language. For them, women were char-
acterized as witches and nymphomaniacs. Women could not
be counted among the minyan, the quorum of men who had
to be present for orthodox worship to take place. If a woman

was not silent, she could be punished. Her silence had to be complete—she was not to question nor rebuke a man.[2]

The early church was remarkably egalitarian in spite of the patriarchal Roman society of that time, as well as that of the Jewish culture. For one thing, on the Day of Pentecost both men and women were present in the Upper Room. (See Acts 1:13-25.) Women were also equal recipients of the outpouring of the Holy Spirit. Among those most likely present at Pentecost were Mary, the mother of Jesus; Mary Magdalene; Mary, the mother of James; Joanna; Susanna; and others. (See Luke 8:1-3; 23:49, 55; 24:10.) In addition, both men and women were responsible for their individual acts, as was demonstrated with Ananias and Sapphira.[3] (See Acts 5:1-11.) Not only were there no hierarchical distinctions as to race and social class, but there were also no hierarchical distinctions as to gender in this outpouring and empowerment of the Holy Spirit.

Women's participation at the temple had been limited; however, Jesus' message of freedom was a drawing card for them.

> Jewish women [were]…understood to be attracted to Jesus and the Jesus movement precisely for its liberating view of women. This, too, is not without some modern resonance: its implicit message is that then, as now, Jesus liberates women.[4]

There were approximately twelve women who were directly associated with Jesus while He was on Earth. Those included five of six women with the name of Mary: Jesus' mother, Mary of Magdala, Mary of Bethany, the mother of John Mark, the mother of James and Joseph, and Mary of Clopas. There were also Martha of Bethany, Salome, Susanna, and Rhoda, the

servant. All of these women were Jewish, with the possible exception of Rhoda, who had a Greek name. Two other women—Elizabeth, mother of John the Baptist; and Anna, the prophetess at the temple—were mentioned in Luke. Luke also mentions Sapphira, wife of Ananias; the widow, Tabitha (Dorcas in Greek); and Priscilla, also known as Prisca.

Paul often mentions many prominent women in his epistles, as was his practice in his travels; he calls them "colaborers." He greets ten women in the book of Romans. These women included Prisca; Phoebe; May; Junia; Tryphaena; Tryphosa; Persis, the mother of Rufus; Julia; and the sister of Nereus. In Philippians, Paul refers to Euodia and Syntyche as two women who worked *beside* him.[5]

Prominent women had leadership roles. Phoebe was highly esteemed by Paul. She held office "a *diakonos*, variously rendered 'minister,' 'deacon,' or 'servant,'" in the church at Cenchreae. Prisca, a woman minister, worked as a team with her husband Aquila. It cannot be discounted that Prisca's (Priscilla's) name is mentioned before her husband's twice in Acts, even though many traditionalists try to assert this fact as irrelevant. However, the husband's name was usually mentioned first, unless the wife had a higher social status or status was of no concern.[6] They were both Christians before Paul and were also imprisoned with him. Junia, a woman "of note among the apostles" (Rom. 16:7), continues to be discounted by those who have reasoned that only men could be apostles. Historically and biblically, there were no references as to Junia being a man until Aegidius of Rome (1245–1316). Origen of Alexandria (A.D. 185–233), Jerome (A.D. 340–420), and John Chrysostom (A.D. 344–407) had earlier verified Junia as a woman.[7]

To better understand Paul's use of the terms *deacon* and *apostle*, Thurston writes that he uses these words differently than does Luke. Thurston believes that Paul would not have met the Lukan requirements for apostleship as noted in Acts 1:21–22. She further emphasizes that:

> If Junia were a woman (and there is strong evidence for this), then she was an authorized evangelist, one "sent" (Greek stello). The role of the apostle was of particular importance because it involved the question of who had authority in the early church. The term in the New Testament did not refer to a closed circle from a past time (the "Twelve," for example) or to a function that could not be repeated, and this has massive implications for ecclesiology.[8]

Women's Repression After the First Century

After the death of Jesus and the apostles, during the early centuries of the church, the voices of women were silenced. New Testament Judaism, even within the church, reverted to more restrictions on women.

> …the only voices we are certain we hear are those of men. Certainly, it is not impossible for male authors to transmit reasonably reliable representations of women's lives and experiences. But ancient male authors often displayed such hostile attitudes toward women, and such strong assumptions about gender differences, that modern readers may feel quite skeptical. Further, ancient male authors may well have been hampered by a true ignorance of the realities of women's lives. Since many men and women in antiquity spent much of their time in the company of other members of their

sex, male authors might have had little opportunity to observe, let alone participate in women's activities and to obtain insight into their experiences.[9]

After realizing that Jesus' return was not imminent, the church had to face their position within the Roman Empire. The church faced two choices:

> ...radically living out the implications of Paul's theology and thereby incurring the wrath of an Empire powerful enough to destroy Christianity or quietly trying to find a balance between accepted and acceptable social norms and Christian teaching, thereby preserving the Gospel.[10]

Most Christian leaders chose the latter path.

PART 3:

WHAT HAPPENED THEN?

Chapter 10

IDOLATRY IN THE CHURCH

As ecclesiastical structures evolved, we find in the writings
of most early church fathers a shockingly blatant prejudice
against women—if not outright hatred of them.[1]

—J. LEE GRADY, AUTHOR AND EDITOR
OF *CHARISMA* MAGAZINE

THE LATER CHURCH lost the vision that Christ would
soon return, along with the theology that enabled
the church to live as if Christ's return was imminent. As
a consequence, the church inherited two seemingly widely
different messages: the theology of equivalence in Christ
and the practice of women's subordination. In attempting
to reconcile them, it maintained status-quo ethics on the
social level through the subordination of women (unequal
in function), and it affirmed the vision of equivalence on
the spiritual level (equal in essence) by projecting it as an
otherworldly reality.[2]

As a result of the dual message, down through the ages
men have been identified with this world, and the duties of

the church and women's spirituality has been seen as other-worldly. Their responsibilities have been that of behind the scenes help and servants to the males. Parvey notes that this belief system is closer to the dualism of Gnosticism than it is to Christianity.[3] Rather than establishing a theology that noted the differences in men and women biologically and, in some ways, practically, Christian thinkers established a doctrine of male and female differences that went beyond the practical. They created a human doctrine that incorporated God and salvation. At the heart of the debate just a few centuries after Jesus' earthly life was the argument on whether a woman's soul was as different from that of the man's as her body was from the man's body.[4]

In 584, for example, at the Council of Macon in Lyons, France, the nature of woman's humanity was debated by elders of the church. The debate asked, "Do women have souls?" What was at issue was whether or not women should be considered as human or as something less than human. Ultimately the church fathers determined that indeed women did have souls and were therefore human. The issue was decided, however, by only one vote.[5]

This anthropological human doctrine of the nature of woman's humanity led to the dichotomy between the place of men and women in Christianity. Women, viewed as closer to the physical world because of their reproductive faculties, have been seen as part of the material world. Men, on the other hand, have been seen as intellectual and rational—related to the mind or spirit. Thus, the theology that was passed down was that both men and women were damaged by the Fall and original sin, however women were diminished even more by their so-called less logical and rational natures. (Although Christians hated the Gnostics,

ironically, this abhorrence for the material and reverence for the mind and spirit were characteristic values of the Gnostic movement.)[6]

The church fathers expressed a parallel and conflicted view in their belief about women—they exalted the virginal life and eschewed other women. Their view of virgins and their dislike and rejection of women as co-image-bearers of God was complicated. It is evident that many of these men appeared to hate sex and women, as noted in much of their writings.[7] These men believed that the lower traits of the body and mind were considered feminine, resulting from Eve's sin. This precipitated a debate as to whether a woman could be saved.

If woman was essentially body and had sensual and depraved characteristics of the mind, then it followed that either she was irredeemable or else she was redeemed only by transcending the female nature and being transformed into a male.[8] Thus, praise went to the virginal woman who disavowed her femininity, abstained from sex, and dedicated her entire life to God. Women who espoused virginity were considered resurrected from Eve's curse and were freed from childbearing and male domination. The virgin had forgotten her feminine weakness. Instead, she thrived on manly vigor, using her virtue as a source of strength for her female weakness. The church fathers felt that the woman who vowed to abstain from sex disavowed her natural inferiorities, and thus, was not a slave to her body, which by nature was in subjection to man.

Virgins were to be honored. As virgins, their Master and Head was Christ. The virginal woman no longer had female weaknesses; she had "manly efficacy."[9] Their virtue then became strength because they had overcome their natural

lustful bodies, which would have been subjected to men had they married. The "redeemed" woman was unnatural in form, rejecting any aspects of a feminine physical appearance. This gave rise to the church fathers' involvement with the physical appearance, dress, and outward attire of women.

The church fathers also passed along the mindset of the Greek philosophers—Socrates, Plato, and Aristotle—for centuries. Socrates believed that a woman's birth was a divine punishment, as she was halfway between an animal and a man.[10] The Greeks saw women as weak and passive. Socrates passed his belief system down to his student, Plato, and Plato to his student, Aristotle. Aristotle believed that a husband's rule over his wife was constitutional because males are naturally more fit to rule than are females.[11] Aristotle's notion of female inferiority was evident in his narrative on a swarm of bees. Aristotle's assumption that the head bee was male was predicated on his belief that the male (of all species) is naturally more fit to lead and command than the female:

> A single bee will lead a vast swarm of bees to a new location, where they will industriously build a new nest and establish their complex society. And because the swarm follows one individual, Aristotle unquestioningly assumed that this single leader must be male, the "king bee." Centuries passed before naturalists corrected this false impression with objective observation. Only then was Aristotle's terminology changed to "queen bee." Why did Aristotle assume that the leader of a swarm must be male? Because he was firmly convinced that "the male is by nature fitter to command than the female." This is true, he taught, not just of bees, but of all creatures, especially humans.[12]

This Aristotelian philosophical disdain for women penetrated the early church and was reflected in much of the church fathers' writings. Origin (A.D. 185–254) abhorred women so much that he castrated himself. He felt that men should not have to listen to women, for they were of no consequence, and since the eyes of the Creator are masculine, He does not look at females or the flesh.[13] Augustine (A.D. 354–430), considered the greatest of the church fathers and the one who formed the foundation of Western Christian theology, had a long-term relationship with a woman in his youth that produced a son, Adeodatus. However, he saw only men as being made in the image of God. Augustine viewed women as being deformed and naturally evil. Chrysostom (A.D. 347–407), like Augustine, believed that women were not made in the image of God and was subordinate to man because of this deficiency; thus, her inferiority was not just the result of the Fall.[14] Cyril of Alexandria (A.D. 375–444) believed women were inferior and therefore were not to teach. Cyril had Hypatia murdered. Hypatia, a female mathematician and philosopher, taught men mathematics and philosophy. Because of this, she was killed and her flesh burned by Cyril's monks. They also tore her flesh from her bones in the process.[15]

Many of the first church fathers' warped views of women were complicated by the fact that they struggled with sexuality in a world dominated by Roman licentiousness. They agonized over whether sexuality was good or evil.[16] They chose an opposite direction to that of the Romans, choosing to see a preoccupation with sex as the main consequence of the Fall. The fathers determined that spirituality was heavenly, while sensuality was earthly. The body was in a neutral state that could be influenced by the spiritual or the fleshly

and sexual. They believed that a woman's body posed a threat for men, for it stirred up lustful desires. Tertullian (A.D. 160–225) noted that women should be veiled.[17]

For the church fathers, man was the powerful one, the active participant in the world; women were the passive partners in the relationship. Thus, the male Adam's sin was greater—he was strong. The woman was the weaker one, so her sin was understandable. Women were considered sexual and lustful by nature, and spiritual men were enticed by them.[18] (Men's sexual characteristics were secondary; women's sexual characteristics were primary.) They believed that women were dangerous because they used their sensuality to tempt men. It can be said, "Ambrose (A.D. 340–397) and others left woman in an ontological state of lustful temptress that defined her as carnal."[19] These men believed that as a result of women's carnality, men had to struggle with two worlds—the carnal state represented by women, and the more spiritual state that men represented.[20]

Augustine differed with some early fathers on sexuality as the main result of the Fall; however, he was not interested in liberating women. Their status remained the same in society at-large. For Augustine, sexuality was part of God's plan. Augustine believed that, after the Fall, Adam and Eve's bodies were no longer obedient to their wills. He noted that sin was in the bodily lust of men. Even though Augustine believed that women should be freed from being viewed as solely sensual and carnal, he noted that their most important trait was that of weakness, and this necessitated their subordination to men. Augustine surmised that the serpent started with the woman in the Garden of Eden because of her inferior, weaker status. Therefore, in marriage, the union is between one who rules and the other who obeys. This view

allowed Augustine to justify polygamy in the Old Testament.[21] Augustine separated men and women by associating women with weakness of character and men with strength of character. For Augustine, a woman's weakness was in need of being controlled by a man.[22]

During the era of the church fathers, women were given two choices in the church—to dedicate their lives to God as virgins in the ministry of continence or to marry, which entailed the restrictions that were placed on women as wives and mothers.[23] For the fathers, sex was either impersonal or carnal; it was never thought of as an expression of a relationship of love. This repression of sex contributed to women being considered sexual objects.[24]

Jerome (A.D. 340–420), who, like Augustine, was promiscuous in his youth, provided instructions to mothers who wished to dedicate their daughters to virginity rather than the normal state of women. First, the child should be isolated so that she would not become independent. Second, she must not be allowed to bathe with eunuch servants because these men still had sexual desires, even though they could not act on their desires. Third, the child should not go to baths with married women because of their detestable pregnant bodies, which would instill in the girl ideas that would harm her position as a virgin. Fourth, she should not be associated with married women at all. Fifth, she should abstain from bathing because of the shamefulness of her body. Sixth, the girl should be trained in vigils and fasts to prevent sexual desires. Seventh, the child should not eat foods or drinks that increased the body's heat. Eighth, the girl should neglect her countenance through dress and hygiene to counter her looks and prevent others from viewing her sexually. Jerome believed that a clean body denoted a dirty mind. Ninth, the

child should not take part in secular learning—Scripture and the writings of the church fathers should be her only literature. And finally, a girl should not be raised in the cities of Roman societies with their temptations, social sights, and fashionably dressed women.[25]

It was these church fathers who shaped the church's views about women in profound ways.[26] Firstly, they were the interpreters of the Bible. Secondly, they were the authorities as to what the church should believe. Thirdly, they were often governed by their own frailties, stemming from their cultural and philosophical prejudices toward women. Just as importantly, their views were strongly influenced by the Greco-Roman world.

The pre-Christian ideas of Aristotle, culminating with the writings of Augustine and Thomas Aquinas, were the catalysts that set back the cause of women within the body of Christ more than any other sources. Bristow asserts that it was these men who advanced the cause of sexual inequality and the devaluation of women in Christianity. They also did more to slander Paul and his belief in sexual equality than anybody.[27]

Chapter 11

A FORM OF GODLINESS
WITHOUT THE POWER

Full well ye reject the commandment of
God, that ye may keep your tradition.

—MARK 7:9

U PON THE DEATH of the first generation of believers, a
man-made movement arose. By the fifth century, the
early church fathers had compromised the church's belief
system by conforming it to the structure of the Roman govern-
ment in a desire for obedience and uniformity.[1] Initially,
Christians were hated by the Roman government and seen
as a cult. The goal of orthodox Christians was to disperse
the church throughout the world. According to Ellerbe,
they revised church writings and made Christian principles
conform to the existing society. Church officials represented
Christianity "not as a religion that would encourage enlight-
enment or spirituality, but rather as one that would bring
order and conformity to the faltering (Roman) empire."[2]

Also, the church had begun to see God as authoritative and controlling and sought to exercise that type of authority. The church began to develop doctrines to justify their control over people, even to using violence. For this, the church was given privileges (within the empire) and allowed to gain the very authoritative power that Jesus had denounced.[3]

This institutionalism emphasized organization over the Holy Spirit. This was not an accurate portrayal of the New Testament terms, for in the New Testament, all believers were both the *kleros* (the called ones) and *laos* (the people of God). The institutionalized clerics replaced the leadership of the Holy Spirit by the third century. In addition, the institutional church divided Christians into two classes, the *kleros* became the clergy, the ruling class, and the *laos* became the laity, the subservient group.[4]

By the end of the second century, the term *catholic*, which means "universal church," embodied the church in the Roman Empire. Ignatius of Antioch used it first. It was later the term that divided historical Christians from Gnosticism. This Catholicism emphasized the continuity of the faith by the leaders of the church, tested doctrinal purity through creeds, and recognized the New Testament books as canon. These attributes, along with static forms of worship, doctrine, and organization, brought legalization and rigidity to the church.[5]

Around the end of the third century, the church had begun to ascend into higher society. It was no longer exclusive; it began to compromise in ways that would not have been acceptable to the first century or even, for that matter, in the second century. The priesthood became the focus of ministry, and with it the Lord's Supper became the mass, a sacrifice by the priest to God.[6]

During the fourth century, the church had become the official religion of Rome under Constantine. The church's desire for uniformity was attractive to Constantine, the emperor. Constantine also saw in Christianity a means to bolster his military and alleviate problems in the large Roman Empire. He pragmatically used Christianity as a unifying tool in the crumbling Roman Empire by inserting it as the state religion.[7] He structured the church to parallel that of the Roman Empire with its highly developed patriarchal government. The Spirit-led life and spiritual gifts were replaced with rituals, sacraments, and church offices. This quenching of the Spirit coincided with the repression and subordination of women.[8]

Constantine was not a Christian; he was known to have executed his son and boiled his wife alive. One story had Constantine accepting Christianity because of a dream in which he envisioned a cross in the sky with the inscription, "In this sign thou shalt conquer."[9] It is believed he had a Christian conversion on his deathbed.[10]

Christians became known as the Orthodox Church and the leadership sought to solidify their power. In this political atmosphere, it was rationalized that the Jews, not the Romans, were the culprits responsible for Jesus' death. This was also a means of placating the Romans. The church allowed Constantine to preside over doctrinal disputes, as well as host the first ecumenical council at Nicea in 325.[11]

Chapter 12

THE DARKEST TIME OF ALL

(Thomas) Aquinas believed that a woman does not possess the image of God in the same way that a man does, and therefore, is spiritually inferior... Woman is both biologically and intellectually inferior to man... Woman is defective and misbegotten.[1]

—SUSAN HYATT, MINISTER AND AUTHOR

SINCE THE MIDDLE Ages, "both Catholics and Protestants have tended to read Paul's words (in the New Testament) through the eyes of pagan philosophers who lived five centuries before the apostle!"[2] During the Middle Ages, Thomas Aquinas (1125–1274) reorganized Roman theology, making Aristotelian and Greek philosophy the center of expression, particularly as it related to the place of women. Aquinas solidified the structure of the church under a male-female hierarchy. This male dominant rule was represented as:

- male superior/female inferiority
- male rulership/female subjugation
- male dominance/female silence[3]

The paradox in Christian theology during that time was that women were seen as having a stronger sexual drive, and yet they were considered the passive ones in the sexual union. Women were considered morally weaker and more inclined toward adultery. It was their shyness, according to Aquinas, that prevented them from initiating sex.[4] Thomas Aquinas, like the church fathers, believed that a woman's role was that of reproduction.

Medieval society in general felt that the woman was a greater sinner than the man, and, therefore, they emphasized that men were accomplishing the will of God when they made women suffer.[5] They were even commanded from the pulpit to beat their wives. They believed that a man belonged to himself and a woman belonged to a man. A woman could at no time refuse her husband sex, regardless of her reason. This would expose him to the threat of sin. It was the woman, according to Greco-Roman law, who was culpable in the act of adultery; a man committed adultery only if he slept with a married woman. In theory, Christian teachings held both men and women accountable, but this did not happen in practice. Aquinas believed that adultery was a crime against children in a marriage; therefore, the woman's adultery was more acute because of her responsibility toward the children. He reasoned that her sin touched the whole family. On the other hand, he surmised that the adultery of a man, the morally stronger one, was graver, but it was legally easier to punish an adulterous wife, and for the children's sake there was more reason to punish her.[6]

Thomas Aquinas viewed the place of woman as subordinate to that of man, but to a less harsh measure than previous church leaders. He believed that marriage was incorporated at Creation for procreation. Woman was the auxiliary or aid in reproduction because of her passive, inferior body. The weakness of woman, physically, intellectually, and morally, demanded domination for her spiritual and moral good, as well as for the good of any children of the union. He concurred with Augustine that sexuality should be rational, with no emotional attachment. [n prelapsarian marriage (marriage before the Fall), there was an absence of lust and an absence of pain in childbirth.] This eliminated the corruption aligned with the woman's body. As a result of marriage, a woman lost her virginity, conceived, and produced children—all symbols of her relationship to Eve and her naturally inferior body. She was also prevented from many religious orders.[7] Marriage had no spiritual or relational context. Marriages were arranged for dowries and political reasons. Aquinas believed that friendship between husband and wife was hierarchical—superior to inferior—just as Aristotle believed. Women were viewed as unclean during their menses and after childbirth. The essence of Thomas Aquinas and medieval thought was to view women and marriage as reproductive necessities and nothing more.[8]

A woman's only escape from subordination and inferiority was the virginal life. The usual emphasis for women was their appearance and the way they smelled, and their role was to find a husband. By devoting her life to God and living in a convent, a woman was engaged in spiritual things, not worldly things. Normally women were like slaves, according to Aquinas, forbidden from receiving Holy Order because of their subordinate status. They were also forbidden from Holy Order, he reasoned, because they were forbidden in the world

and the church was part of the world. A woman could participate in baptism because of Galatians 3—there is neither male nor female. However, she could do it only privately and when a male was not available. An exception was the abbess, especially in Anglo-Saxon England. She was given authority in administration, teaching, and as a missionary. Abbesses were learned in Scripture. It was believed that they were of royal lineage and that was the reason for their roles. Queens and noblewomen were felt to be less associated with Eve's sin.[9]

During the upper Middle Ages, as more women sought to live elevated, monastic spiritual lives, problems arose because of the increase in their numbers. As a result, religious equality for women who desired to dedicate their lives solely to God became a thing of the past. Failing to meet the demands of the large numbers of women aspiring to pursue the religious life was not the only problem facing the period. Women in monasteries followed different rules than those of their male counterparts. Even there, freedom was limited and reflected subordinate and auxiliary roles. They were separated from the outside world, including those men who administered the sacraments to them. Nuns were seen as little as possible, and no man was to look on them without permission. Even those women who had essentially denied their femininity were looked upon as daughters of Eve rather than rational human beings.[10]

By the late Medieval Period, the church had grown into an international body to which the whole of Europe belonged. The church was a complex structure, paralleling the secular hierarchy of the Roman government. The Pope headed the church in the West. The church in Rome dominated medieval civilization with its doctrines, liturgy, education, language, law, and control. Salvation was secured only through the church, which guarded Scripture, the creeds, and the sacraments.

Chapter 13

REFORMATION FOR SOME; STATUS QUO FOR OTHERS

The church must also re-examine (as it did other church practices) longstanding theological interpretations which have fueled the flames of the oppression of women.[1]

—James Alsdurf, psychologist, and
Phyllis Alsdurf, author and editor

THE RENAISSANCE RESHAPED the political and social life of many societies; it was also a time of change in the Roman Catholic Church. As Europeans struggled for spiritual security, corruption plagued the church. Salvation was no longer acquired through a belief in the atoning death of Jesus on the cross. In church doctrine, salvation was allowed only through penitence to a church priest. The church doctrine maintained that all sins that had not been confessed and worked off here on Earth had to be purged. This led to the doctrine of indulgences, which allowed repentant sinners to acquire release from temporal penalties through acts of

devotion and penitence, such as pilgrimages. Indulgences could be acquired by giving money to the church for causes. Indulgences eventually substituted altogether for acts of devotion. The indulgences became a widespread abuse and problem for those who desired reform in the church.[2]

Women had begun to participate in preaching and publishing religious materials in Great Britain preceding the Reformation. This was short lived, as the pressure arose that this was in opposition to Paul's teachings in 1 Timothy 2:11–15. The writings and actions of women upset religious and governmental authorities, and they were prevented from meeting together at all in many cities. In 1543, Parliament banned women from reading the Bible. The only exceptions to this ban were those of the upper class and those of noble birth. Some women, who genuinely believed in their religious convictions, left their homes to speak publicly of their beliefs. They were tortured and executed for those beliefs. Most were Anabaptists. These women, as in later witchcraft trials, were stripped, tortured, and asked to confess their beliefs and name accomplices. The usual legal procedures were not applied in the trumped-up hearings. Most of the persecuted women were poor.[3]

Even though Luther and other reformers protested the excesses of the church, they did very little to enhance the plight of women. Much was written about Martin Luther; however, none analyzed his attitude toward women—not even the major biographies—before the late 1960s. At that time, researchers began to study his views on women. They noted that Luther elevated marriage, not women, and elevating marriage was not the same as elevating women.[4] While the reformists exhorted marriage for both sexes, their exhortation was directed particularly at women, for marriage

was their vocation and living arrangement.[5] Not only were women restricted to the home, but there was a growing negativity by Luther and Protestants concerning the unmarried. For Luther, once an Augustinian monk, a woman's "anatomy was her destiny," that is, she was created to be a mother, not a thinker. He described a woman's broad hips as fit for having babies and her narrow shoulders inferred a lack of weight in her upper body, particularly her head.[6] Luther demonstrated conflict in his theoretical beliefs about women and what he actually practiced in his own home. When confronted with this contradiction in what he preached and what he practiced, he conceded that women, if able, could lead and preach if no man was present.[7]

A continued bias against women was the framework in which the Protestant Reformation Movement sprang up. The Reformers desired to establish legitimate authority and to break free of Rome.[8] The Reformation (1517–1648) emphasized faith alone as the basis for salvation. This emphasis on individual responsibility provided a sense of freedom.[9] Martin Luther (1483–1546) established the Bible as the authority of three theological principles: "*sola scriptura* (Scripture alone), *sola fide* (faith alone), and the priesthood of all believers."[10] Thus, the Reformist believed that women could be saved by faith because salvation was by grace, but women because of their inferior natures could not become leaders. "It must be noted that the interpretation (of Scripture) continued to be skewed by misogyny [hatred of women], a hierarchical worldview, and the perennial influence of Greek philosophy."[11]

Luther believed that women, when prominent in the Old Testament, had a special dispensation from God; that is, their actions were not their own. Sarah, after receiving instructions from God, directed Abraham to expel Hagar. Rebecca

had been given a command from God, which permitted her to disobey hierarchy. Judith, the one who killed the tyrant Holofernes, was considered a metaphor. He did see some women as historical figures, for example, Deborah, the judge who ruled Israel, and the women of Abel. (See 2 Samuel 20.) However, Luther noted that the women who ruled and prophesied in the Old Testament did not grant contemporary women the right to preach and teach in the church.[12] He did not discuss Joel 2:28–29 about the Holy Spirit pouring His Spirit on handmaidens or the prophecy of Philip's four daughters. (See Acts 21:9.)

He had praise for some New Testament women. Mary Magdalene was an example of faith. Mary (of Bethany) represented the relevance of faith, while Martha represented works. Nonetheless, Luther felt that the Holy Spirit commanded through Paul that women should be silent in the church. Women "may pray, sing, praise and, say 'Amen,' and read at home, teach each other, exhort, comfort, and interpret Scriptures as best they can," asserted Luther.[13]

Luther's thoughts were more aligned with earlier leaders as it related to women and spiritual things. He saw the woman as the primary cause of the Fall. He saw the male Adam's responsibility as graver in that he received God's command not to eat of the fruit. Adam should have, therefore, refused the woman's offer. He saw "Eve's" subordination as ordained at Creation. Luther believed that her punishment for her disobedience at the Fall was even more subordination and suffering in childbirth and this, he felt, was properly more severe. He stated that the Holy Spirit had exempted women, children, and incompetent people from church ministry. Women, he felt, were not qualified for ministry even though they could hear God's words, and

receive baptism, the sacraments, and absolution. Women should not occupy positions of sovereignty, noted Luther.[14]

Luther's views of women as wives was softer and a little less misogynistic than those of the church fathers and earlier church leaders. In the home, according to Luther, women are what he called "treasures of the house," for they bear and raise children and justly administer household duties. He believed that women tend to be more merciful and compassionate because God created them for that reason, and, ultimately, they bring joy to men.[15]

Martin Luther spoke of marriage as ordained by God. He believed that it was God who established the sexual urges between husbands and wives. Luther noted that it was God's purpose to propagate the species through marital partners. Marital love was above all other love, even natural love— parents and child, brother and sister. Man's activities were in the public domain where he earned a livelihood, and women's activities were in the domestic domain. The husband was also in charge in the home, delegating the household organization to his wife. Luther felt that it was the love of a husband and wife that would sustain their marriage through every tribulation. Nonetheless, for Luther, mutual respect and love did not mean equality in the marriage—the wife was still the subordinate. He stated:

> And you will be under the power of the man... You will not live in accordance with your own will as you properly did before the Fall; you shall no longer follow your own will as you properly did before the Fall to be with the man or not... authority pertains to the husband in all the matters of life... she should be subordinate and obedient to her husband and not undertake or do anything without his consent.[16]

As stated earlier, Luther's theme of women's subordination in his sermons and writings were not the reality in his own marriage, and this reflected a dualism in theory and in practice. His relationship with his wife, Katherina von Bora— "Kathe"—was interrelated in many ways, and his needs caused him to be very dependent upon her by his own admission. In his wordplay, he would sometimes call her "Herr" Kathe. He explained this by noting that the positional status in his marriage was his decision to make, not his wife's.[17] Luther and Katherina's practical relationship is noted in the following excerpt of a letter Luther sent to his wife:

> Grace and peace in Christ! Dear Lord Kethe (variation of Kathe)! I do not know what to write to you because Master Philipp [Melanchthon] himself, along with the others, is coming home. I have to stay here longer for the sake of the pious prince. You may wonder how long I will stay here or how you can set me free. My view is that Master Franciscus will make me free again, just as I have freed him, but not so soon. Yesterday I had a drink of beer and had to sing. I thought what good wine and beer I have at home, and in addition a beautiful lady, or should I say lord.[18]

Although Luther's marriage did not demonstrate noticeable subordination, his views on the subordination of women remained the same as the traditions of the Middle Ages and were reflected in his treatises and sermons. From the beginning, he believed that "Eve" was a lesser being than Adam. According to Luther, "Eve" was approached by the devil (as the serpent) because she was less rational and more emotional and therefore, more prone to temptation. He noted that for her disobedience, God changed her relationship with her husband

to that of subjection, and this pronouncement was on her and successive generations of women. Adam, on the other hand, was culpable because he was the rational one, but his punishment was not as severe as the woman's punishment.[19]

John Calvin, another reformist, remained true to Middle Age theology about women's inferiority. However, he believed women, like men, could be saved through faith. He believed that women's inherent inferiority was part of their creation.[20] He surmised that women should be governed by delegated authority in the home, the church, and government.[21] According to Calvin, "God's eternal law...has made the female subject to the authority of men. On this account, all women are born, that they may acknowledge themselves as inferior in consequence of the superiority of the male sex."[22]

Only Calvin parted ways with the notion of other reformers that women must be silent in the church. He admitted that that teaching was determined by tradition and custom, rather than being a commandment from God. Thus, he noted that women being silent in the church could be subject to change.[23]

Protestant leaders, while elevating marriage, believed that men should have authority over women, for "Eve" was created from Adam's side, not his head. Marriage was a means to control women's sexual urges, which were considered greater than those of men. Single women were suspect because there was no control over their sexual urges and also because they were out of divine order. They believed that divine order was that women should be married and be in subjection to a man. A woman's obedience to her husband was more important than her spiritual equality. They were to obey cheerfully, not grudgingly. Men had the right to enforce their authority, even through physical force, if necessary.[24]

Chapter 14

WHAT ABOUT MARY?

He (God) entrusted a woman, Mary, with providing the earthly home for the Incarnate Word. The necessity for a human womb to be the Savior's entrance into humanity puts the lie to any notion of the worthlessness of women. But Mary's character as a human being transcends gender and makes her life an inspiration to us all.[1]

—GRETCHEN GAEBELEIN HULL,
AUTHOR AND LECTURER

GOD ANOINTED WOMEN in biblical times and throughout history to break yokes and set captives free. The favor of God cannot be denied in the lives of these women, for they made a difference in the lives of men and women, oftentimes within restrictive and hostile environments. Mary, the mother of Jesus, was one of these handmaidens. It is important not to ignore or trivialize this young woman (or

the other women) who poured out her life to serve God.

Mary was the chosen vessel God used to bring forth the Messiah. This implantation by the Holy Spirit in the womb of Mary began the release of womankind from the consequences of the Fall and marked her restoration from the mantra of the destroyer of mankind. (See 1 Timothy 2:15.) The choice of a poor maiden at a time when women had no status was significant. In addition, Mary believed in the Messiah while He was still in her womb.

The angel Gabriel approached this young teenage girl; he did not ask her espoused husband or her father for permission. He went to Mary. It was Joseph who had a secondary role in the birth of the Messiah. There is no chain of command when God has placed a call on someone's life—and that includes women. "Scripture is united in teaching that when God has called an individual, nothing—and certainly no artificial notion of role playing—must stand between the individual's call and obedience to that call."[2] It is God, not man, who ultimately must be obeyed. (See Acts 5:29.)

Not only that, but God could have chosen someone of royal or aristocratic lineage to be the mother of the Messiah. He could have even brought Jesus to Earth through a fiat. Yet, He chose this young virgin girl to house the seed of the very One who would bring salvation and restoration to all people and, in the process, elevate the status of women. Although Jesus came in the form of an earthly man, earthly men had nothing to do with His coming or birth.

When Gabriel appeared to Mary, she was probably no more than fifteen. He said: "Hail, O favored one [endued with grace]! The Lord is with you! Blessed (favored of God) are you before all other women!" (Luke 1:28, AMP) To comfort

Mary because of her alarm and confusion over his presence, Gabriel continues with:

> Do not be afraid, Mary, for you have found grace (free, spontaneous, absolute favor and loving-kindness) with God. And listen! You will become pregnant and will give birth to a Son, and you shall call His name Jesus. He will be great (eminent) and will be called the Son of the Most High and the Lord God will give to Him the throne of His forefather David.
>
> —Luke 1:30–32, AMP

Mary was troubled; she did not understand the Immaculate Conception. All she knew was that she had not been intimate with a man. She was, however, betrothed to a man named Joseph. The betrothal was the engagement period. Jewish and Palestinian girls were betrothed in marriage between the ages of twelve and fifteen. Often in Middle Eastern culture, an arrangement was made in which a young girl was given in marriage to an older man. However, if a woman became pregnant before the actual marriage, she could have been stoned to death—at the least, she would become an outcast. Nonetheless, Mary accepted what the angel said. Obeying, she said: "Behold, I am the handmaiden of the Lord; let it be done to me according to what you have said" (Luke 1:38, AMP). After that, the Holy Spirit overshadowed Mary.

In obeying God, Mary had placed her very life in jeopardy. Her fate was in the hands of Joseph, her betrothed husband. Joseph, then visited by an angel, was told not to fear because the baby Mary was carrying was the Messiah. The rest of the story is historically chronicled.

Her importance was downplayed during the early centuries to disassociate her with pre-Christian goddesses, but

the church began to elevate her around A.D. 325. Because of the virginal birth, Mary was viewed as the antithesis of Eve.[3] During the Middle Ages, the mystique surrounding motherhood was applied to Mary only, for she was the mother of Jesus.[4] Although the Catholic Church compromised by not subduing the veneration of Mary, it did, however, eliminate the exaltation of her.[5]

To many, Mary represented the unreachable ideal for which other women could not attain. Although misguided, some viewed her as a member of the Trinity, similar in status to God or Jesus. Mary was seen in many of the texts as the Queen of Heaven who sat on a throne protecting children. She was depicted as *theotokos*, the God-bearer, with Christ as an adult contained within her. She was a loving mother with Christ as a child in her lap. She was also presented as a forlorn, older woman at the Cross—the *mater dolorosa*. As time went on, Mary became softer and more dependent, while Joseph became younger, stronger, and more central to Christ's life. Her mother, Anne, and grandmother, Emerentia, disappeared from the scene by the sixteenth century.[6]

The standard that Mary set for women within the Christian community was an unattainable standard of behavior that Jesus did not set for men, for Mary was fully human, not divine as Jesus was. There can be only one Savior in Christianity, and that is Jesus. The focal point of her adoration was derived from her depiction as pure, nurturing, and the opposite of Eve.

Changes in the status of Mary began and continued during the Reformation. Pictures and images of the holy family began to mimic the church's view of the ideal human family in both Catholicism and Protestantism. Catholicism depicted Mary as having no more children after Jesus and remaining

a virgin during her lifetime. In some places, Joseph began to symbolize the patron saint of fatherhood.[7]

During the Reformation, Martin Luther chastised the worship of Mary that overshadowed the allegiance to Christ. Yet, he saw her as a symbol of faith, obedience, and humility. She was the example of what happens when people trust totally in God. Plus, her virginity substantiated Jesus' humanity and purity:

> The church has left this (whether Mary had sexual relations with Joseph) alone and has not determined this. But nevertheless, the same consequence is firmly demonstrated because she remained a virgin, but on the other hand, she was viewed as the mother of the Son of God. She was not judged to be the mother of human sons and remained in that state.[8]

Luther saw her as did the Catholics, as *theotokos*, the Mother of God. He was the first to preach the Incarnation at Elizabeth's visitation; this was a position that other women could not assume.

Eventually, Luther stopped preaching special sermons associated with Mary.[9] Mary became a virtually ignored entity within Protestantism, which was different from her place in Catholicism. This stance has continued in Protestant churches for centuries, where very little has been made of her. This may be, in part, due to the Catholic Church's almost deification of her. While she was seen as a virgin, wife, and mother in both Protestantism and Catholicism, the roles differed in some aspects. Both groups noted her motherhood. Catholic Reformists emphasized her virginity, while Luther and Protestants saw her betrothal to Joseph as

representative of God's regard for marriage. Eventually, Protestants dropped her conception, birth, and Assumption.[10]

What happened to Mary will never again happen to anyone else. God saw her as a vessel that He could use and chose to entrust her with carrying His Son, the King of kings! She was highly favored by God, but she must have realized the pain, suffering, shame, and degradation she would have to endure in the Israel of that time; yet, she obeyed God. This is what she said: "He has looked upon the low station and humiliation of His handmaiden. For behold, from now on all generations [of all ages] will call me blessed and declare me happy and to be envied" (Luke 1:48, AMP).

The irony is that the generations in Protestant tradition have not esteemed her highly. She is usually mentioned in Christmas plays with nativity scenes, but that is about all. It is not clear whether she is deemed unimportant or whether there is a fear of over-emphasizing her relevance. It is a travesty, though, that the young girl who God favored above all others has not been honored throughout the centuries following the Reformation. He selected the least in the society to bring forth His Son. He looked beyond the traditions of what man deemed worthy, even to the point of Jesus being considered illegitimate (in man's eyes), to show that all God's people are esteemed by Him. Mary echoed the relevance of her bearing the Messiah in Luke 1:50, 52:

> And His mercy (His compassion and kindness toward the miserable and afflicted) is on those who fear Him with godly reverence, from generation to generation and age to age...He has put down the mighty from their thrones and exalted those of low degree. (AMP)

Chapter 15

THE CHURCH IN FLUX

Until the late nineteenth century all of the legal systems of Europe, England and early America supported a husband's right to beat his wife and so did the *community norms*.[1]

—JAMES ALSDURF, PSYCHOLOGIST, AND
PHYLLIS ALSDURF, AUTHOR AND EDITOR

THE PROTESTANT REFORMERS may have unwittingly set up the introduction of ideas that started the process of eradicating gender-based prejudices from Christian theological and social application. Since the Reformation, the belief in a "woman's place" in Christianity has differed across denominational lines.[2] In particular instances, women took part in ministry within the Baptist, Methodist, Episcopal, and Pentecostal denominations; however, by the mid-seventeenth century, the early Quakers were the only group that allowed the full participation of women. It was only during the twentieth century after women were granted the right to vote that they were allowed to fully participate in ministry in some denominations.[3]

The Quakers began promoting equality between the sexes a considerable time before the secular outcry for women's emancipation began. The Quakers, also known as the Religious Society of Friends, based their practices on the teachings of George Fox. The early Quakers believed in the Scriptures and the inspiration of the Spirit, rather than rituals and the outward manifestation of the established church institution. Preferring the compassion of Jesus to religion, both men and women were responsible for their own relationship with the Lord. Having the gift of the Holy Spirit was the determinant and qualifier for leadership roles.[4] Believing in leadership by prophecy and inspiration, their central theology was based on Joel 2:28, "I will pour out My Spirit on all flesh; your sons and daughters shall prophesy;" and 1 Chronicles 16:22, "Touch not mine anointed, and do my prophets no harm;" and Paul's priesthood of all believers and doctrine of justification.[5]

However, up until the twentieth century, women were not allowed to participate fully in church ministry in most Western countries.[6] Theologians and pastors even sanctioned abuse against women. According to Grady, men in the 1800s used Ephesians 5:22 to rationalize the beating of their wives. Before 1870, men could pull their wives' hair, choke them, kick them, spit in their face, and beat them with a stick. Some pastors even taught female inferiority from their pulpits. Some were instrumental in opposing the education of women. They noted that it was woman's destiny and divine order to be ignorant. There were those that suggested that women were unfit to be educated because, they asserted, women had fewer brain cells.[7]

Freedom for women, other than in the so-called radical Protestant groups, was often sanctioned by the secular

society, and this, in turn, caused sexually discriminatory practices to be heightened within the church. During the eighteenth and nineteenth centuries, women started to break out of the mold of traditional culture. Women moved into the fields of art and literature, even though their authorship was denied, and they were often required to use male pseudonyms. Those who braved the westward movement enjoyed the freedoms of the frontier, often experiencing less social restraints. Starting in the nineteenth century and moving into the twentieth century, women began to move into traditionally male-dominated professions, mainly education, health care, and, to some extent, science and business. Men continued to outnumber women in executive and management positions.[8]

Slavery paralleled the restrictions on women; it was another example of "man's inhumanity to humankind."[9] It too had cultural acceptance in Hebrew theology. Slavery was still a social institution during the Christian era. Christianity did not challenge the Roman belief in slavery, which is noted in 1 Peter 2:19, which exhorts slaves to even obey cruel masters. Peter goes on to say that their obedience was pleasing to God. Biblical passages often when used, particularly in isolated instances, have been used to support any idea, even absurd ones across cultures.[10]

Even though the nineteenth century saw the advancement of the abolition of slavery, people in the United States were accused of denying the authority of Scripture when they questioned slavery. Pro-slavery Christians argued against liberating slaves with what they called biblical passages that supported it—Leviticus 25:44–46, Matthew 8:9–13, Luke 17:7–10, 1 Corinthians 7:20–24, Ephesians 6:5–8, 1 Timothy 6:1–2, and 1 Peter 2:18–21. These pro-slavery Christians

believed that Paul and Peter accepted the cultural conditions as God's order for social institutions. They further legitimized slavery by noting that it was part of creative order. Those opposing slavery believed that Paul and Peter's injunction for slaves to obey their masters was a temporary compromise in an imperfect society. The red-hot rhetoric of Josiah Priest parallels the gender traditionalists of today when he called abolitionists, those who opposed slavery, "a withering blighting curse, a pestiferous excrescence."[11]

Though slavery was not racially based in ancient Hebrew, Roman, and Greek cultures, American theologians linked the enslavement of black people to an incorrect interpretation of the Bible in order to lend legitimacy to the practice. They emphasized the curse of Ham (Genesis 9:20–27) as God's pleasure in condoning the slavery of black people.[12] White theologian's linking of black enslavement with the curse of Canaan promulgated a flawed racist theology. They preached that the children of Canaan, one of Ham's sons, were cursed with being black and with slavery. This view was inherited from the Bereshith Rabbah, a rabbinic work that was completed in the fifth century. Black enslavement had been sanctioned by this inaccurate interpretation of Scripture. In actuality, Genesis shows that Cush, another of Ham's sons, was the father of African nations (Ethiopia). Black people were not the descendants of Ham's cursed son, Canaan. Canaan was the father of the Canaanites, a Caucasian (white) race.[13] Yet, this racist theology was espoused from the pulpit, even though there was no biblical basis for it. This continued even after the Civil War.

Some continued to believe that the doctrine of original sin destined some people to be slaves. The Aristotelian belief that some people were born to be slaves originated some three

hundred years before Christ. Aquinas continued the belief in slavery, arguing that original sin destines some to slavery.[14]

Slavery was not God's perfect will, and neither is woman's subordination. An injunction to cooperate with an existing cultural institution does not mean that God approves of that particular institution.[15] The abolitionists who preached the principal that "all men are created equal" realized that that principle applied to women as well. Men, such as John Stuart Mill, Theodore Weld, and Henry Blackwell, actively protested the marital law that would give men legal powers and control over their wives' personhood and property. Women, such as Sarah and Angelina Grimke, started out with the abolition movement. They began speaking against slavery in 1830 and later became a part of the suffrage movement.[16] Most Christians, however, felt that neither slaves nor women should have a say in laws relevant to their personhood. They also believed that women in authority insulted God's authority.[15] "Pro-slavery Christians had no patience with the notion that the Bible merely tolerated slavery rather than advocated it—any more than traditionalists [today] accept...that biblical revelation accommodated itself to patriarchy but was not itself patriarchal."[17] God, over the centuries, has worked within flawed institutions and cultures.

During times of spiritual revival, women participated in the spiritual renewals. Many people believed that the Great Awakening was a sign of the end times. It has been estimated that two-thirds of the conversions of the Second Great Awakening during the nineteenth century were women. These spiritual renewals were the impetus that led many women to preach the gospel.[18] Women have historically found greater freedom in Spirit-led renewals than in the traditional church. In the renewal movements, those who have the experience and spiritual

giftings, rather than those who have been picked by traditional institutions, are the ones that are recognized as leaders.[19]

These awakenings also led to the acceptance of the cult of "true womanhood." "True womanhood" would seemingly contradict more participation by women in the ministry; however, it caused more women to assume leadership roles. This domestic cult changed the view of women as sinful, weak, and lustful creatures, attributes of Eve and all who descended from her. This cult gave rise to the belief that women had greater moral fiber than men, that they were spiritually superior to men. Their meekness, sensitivity, and emotional natures were seen as more Christ-like. Because Christianity had raised their status, women were more responsive to the Christian message. It was felt that, like Christ, women brought redemption by their virtue and Christian fervor. Also, they endured the sufferings of this world with patience and silence as Christ had done.[20]

Women began to esteem themselves more highly, and since there were those who believed that women were morally and spiritually superior to men, they surmised that women should not be excluded from helping to shape the world. This period spawned what is known as "the great triumvirate of the nineteenth century": Phoebe Palmer (1807–74), Catherine Booth (1829–90), and Hannah Whitehall Smith (1832–1911). According to Clouse, these women had several things in common: they were each part of a husband/wife team in which the wife had more prominence than the husband; they each had several children, combining homemaking with ministry; and each was identified with the Holiness movement. Using Galatians 3:28 as their foundation, they, along with other women, began to view biblical equality for women in the same context as that of biblical equality for enslaved people.[21]

PART 4:

WHAT'S HAPPENING NOW?

Chapter 16

DEFENDERS OF THE STATUS QUO

The subjugation of women is not biblical, logical
or acceptable. The practice is the product of
theology influenced by fallen culture.[1]

—SUSAN HYATT, MINISTER AND AUTHOR

TODAY, THE QUESTION of male authority/female subordi-
nation in the church and home has aroused much debate.
Gender traditionalists have continued to use scriptures to
bolster their belief in a woman's subordinate role. The ratio-
nale for woman's subordination is no longer attributed to her
sexuality or evil nature, as the church fathers did; that would
not work today. They use New Testament scriptures such
as 1 Timothy 2:12 to preach that woman's subordination is
innate, beginning at Creation.

Not only is the continued use of this interpretation of
woman's creation flawed, but a chain of being, starting with
Father God, is also erroneous. Thus, the subsequent conclu-
sion supporting male authority and female subordination is

faulty. Groothuis provides a succinct analysis of this traditionalist view of the male and female relationship:

> It is the nature of femininity to be subordinate, and the nature of masculinity to be in authority...and (it is) on these grounds that they (traditionalists) reject gender equality. And when this essential gender inequality is grounded in and justified by a supposed eternal hierarchy of authority and subordination within the Trinity, it easily becomes cosmic, universal, and eternal in its scope.[2]

Martin takes a clear look at the existence of male authority over the past two thousand years and makes several analyses. Male authority has been consistently taken from the social structure rather than from Scripture. The principle of male authority as scriptural is not easily justified by searching the Scriptures, and yet it remains firmly entrenched in society over the centuries. The rationale has changed over the centuries. As the rationale for male rule changed, traditional theology has changed the concept of female subordination to fit these changes. Martin goes on to say that *headship* is the most recent synonym for male authority. This term (along with *servant leadership*) works nicely in today's culture. The conservative traditional community can maintain the norm, keeping firm control over the women and ignoring the larger issues of equality and justice.[3] "The teaching that God's perfect plan places women under the authority of men has been brought to Scripture from male-dominated cultures and a church run on the basis of authority, not grace."[4]

Traditionalists (complementarians) deal with boundaries, particularly boundaries and role limitations for women in the church and even in society. Their belief system depicts

a sexual hierarchy in the church and in the home. Piper, in his book, even seeks to define what a woman's place is in secular society and jobs outside of the home, and he rejects the notion of women in positions that give them authority over men. He states that "the God-given sense of responsibility for leadership in a mature man will not generally allow him to flourish long under the personal, directive leadership of a female superior."[5] He notes that a woman leader on a job should use an indirect form of leadership with males; she should not use a directive style of leadership with them.[6]

Piper and other traditionalists believe that direct authority belongs to men, and any direct interaction by women is seen as ungodly and unbiblical, even on secular jobs where a woman may be in authority. In discussing his two continuums (personal/directive and non-personal/non-directive), Piper notes that women can exhibit leadership over men by using non-directive procedures of petition and persuasion instead of directives (authoritative procedures). He notes that a woman with a position that entails directives toward men should be non-personal and non-directive in her interaction instead of directive and personal.[7] Piper states that even when a woman is in a leadership position her "demeanor—the tone and style and disposition and discourse of her ranking position—can signal clearly her affirmation of the unique role that men should play in relationship to women owing to their sense of responsibility to protect and lead."[8] In other words, even in a leadership position on her job, a woman is to defer to men because men are the ones that have been designated by God to lead. He admits in a tongue-and-cheek fashion that he is on the "brink of contradiction" when he states that a woman in a leadership role can carry out her responsibilities effectively and still endorse the leadership responsibility

of the men who are under her. Piper then uses 1 Peter 3:4 to refer to not only wives, but he also stretches it and makes it refer to women in the workplace as well.

> Some roles would involve kinds of leadership and expectations of authority and forms of strength as to make it unfitting for a woman to fill the role. Mature femininity...will affirm and receive and nurture the strength and leadership of men in some form in all her relationships with men...There are ways for a woman to interact even with a male subordinate that signal to him and others her endorsement of his mature manhood in relationship to her as a woman...More appropriate than a black-and-white list of man's work and woman's work is a set of criteria to help a woman think through whether the responsibilities of any given job allow her to uphold God's created order of mature masculinity and femininity...To the degree that a woman's influence over man is personal and directive [authoritative] it will generally offend a man's good, God-given sense of responsibility and leadership, and thus controvert God's created order.[9]

Piper had previously mentioned roles that he deemed to be "kinds of leadership and expectations of authority and forms of strength" that would be unfitting for a woman to fill. These positions would not be suitable for women because they would stretch their expressions of femininity beyond reparation. He lists some possible instances in which femininity would be stretched when a woman is in charge (over men):

- Prime Minister and her counselors and advisors
- Principal and the teachers in her school

- College teacher and her students
- Bus drivers and her passengers
- Bookstore manager and her clerks and stock help
- Staff doctor and her interns
- Lawyer and her aides
- Judge and the court personnel
- Police officer and citizens in her precinct
- Legislator and her assistants
- T.V. newscaster and her editors
- Counselor and her clients[10]

This emphasis on a creative order in which men are always in the leadership roles and women are always to comply to a man's leadership, even when she is in charge, continues the concept of a chain of being. This chain connotes inequality. Today's gender traditionalists who declare that women are innately subordinate have justified their doctrinal belief by inaccurately noting that God made man the authority in all things at Creation.

The Southern Baptist Convention, the largest Protestant denomination, has moved toward gender-based positions within the home and church, rather than positions based on the whole of the Scriptures and a man and woman's God-given gifts. In June 1984, the Southern Baptists passed a resolution forbidding women from the pastoral leadership, noting that the first in Creation was the man and the first in the Edenic fall was the woman.[11] A committee of seven initiated the infamous "Family Amendment" in 1998, relegating women to helper of the man.[12] This process ended with the submission statement, where wives were to "graciously submit" to their husband's authority.[13] On May 18, 2000, the Baptist Faith and Message Doctrinal Statement was revised. The Baptist Faith and Message Study Committee's proposed revisions

included an addendum to Article VI. It stated, "While both men and women are gifted and called to the ministry, the office of pastor is limited to men as qualified by Scripture."[14] According to Hankins, this solidified male authority and female subordination in the home and in the ministry within the conservative Southern Baptist denomination.[15]

The Southern Baptists have of late been well-financed and very articulate in their campaign to enforce women's subordination. Missionaries and teachers who refuse to sign a statement agreeing with the SBC's stance have been fired or forced to resign. The services of women leaders are no longer used and women are being suppressed in many of the American SBC churches.[16] Stan Hastey, a moderate Southern Baptist, surmises that the real issue is authority (over women), and it is the Southern Baptist's modern belief in inerrancy, not the Word of God, that is their ultimate spiritual authority. Hastey puts it this way:

> Here's the low-down dirty on fundamentalism...Despite its indefensible insistence that the Bible is an inerrant document, (in the) fundamentalist system, what one purports to believe about the Bible is deemed more important than believing what the Bible actually says. The flap over Ephesians 5 is but the latest example.[17]

Issues have arisen from different sources as to the oddity of today's conservative Southern Baptist and other traditionalists who now concede that slavery was contextual, but still refuse to see women's subordination that way. Hankins quotes several biblical scholars in his book, *Uneasy in Babylon*. He quotes Diana Butler Bass's argument that it was the early Christians who confronted the pagan's view of male

authority with a new liberation through Christ. She notes that the absurdity is that:

> When it comes to women...conservative Christians have drawn the line. In other words, they miss the cultural context of early Rome and enshrine wifely submission as biblical when it was actually cultural. The biblical family—now enshrined by Southern Baptists—is not biblical at all.... Pagans practiced male headship; early Christians rejected it. They experienced a God who lifts the oppressed.[18]

Wills, a Roman Catholic historian, emphasizes that the submission statement is closer to the pagan view of women, rather than a Christian reflection of women. It was Aristotle and Plato who taught the inferiority of women. The first-century church clearly viewed women with a more egalitarian spirit, as noted in Galatians 3:28. Wills, quoting biblical scholar Barth, notes that the Ephesians 5 verses were taken from the ancient hymnal language of Jewish weddings. In the marriage ceremonies, the groom pays for the bride. The price of Christ's bride (male and female) was the giving of his own life. The husband's position in a marriage suggests greater sacrifice on his part as he yields his life for his wife. The wife as his body is his own flesh.[19] Wills goes on to say that "the whole idea of one dominating the other or one submitting to the other is moot."[20]

Dobson, on the other hand, echoes the gender traditionalists' view of the inherent subordination of women and the "God-given right" of men to have authority over them. He states that there is a biological "pre-determination" for gender roles (this is not the same as biological differences). Dobson makes the generalization that family and friendships are

more important than opportunities and accomplishments for women. On the other hand, he asserts that pre-determined testosterone drives men to power and social dominance. The assumption is that power and social dominance driven by testosterone surges is the only kind of leadership that is sanctioned by God. Dobson also categorizes his description of a woman's temperament as "biologically pre-determined":

> The female temperament lends itself to nurturance, caring, sensitivity, tenderness, and compassion… Without the softness of femininity, the world would be a more cold, legalistic, and militaristic place. Men, on the other hand, have been designed for a different role. They value change, opportunity, risk, speculation, and adventure…Men are often (but not always) less emotional in a crisis and more confident when challenged…When these sex-linked temperaments operate as intended in a family, they balance and strengthen one another's shortcomings.[21]

Thus, biological determinism is Dobson's way of denoting that a woman's pre-determined role at Creation was to assist man in his dominion-taking. This biological determinism, Dobson notes, is the reason why there are only seven women chief executive officers in Fortune 500 companies; eleven women out of one hundred United States senators. Biological determinism is also, asserts Dobson, the reason why all forty-three presidents have been males.[22] This argument is false. While power and social dominance are indeed the reason women have been excluded from leadership, this power and dominance have nothing to do with the creation process and everything to do with the fallen nature of man in a patriarchal social system.

Seeking the truth about women cannot exist within a framework where the women themselves have no voice. In that environment, "deception and duplicity thrive when certain groups and individuals have the power to elevate their own truths by diminishing, silencing, even eradicating others."[23] Women are taught that their special roles as wives and mothers are the natural reason why even though they are half of the world's population, they still have no influence or clout in the economic, political, or even social arenas.[24]

God does give women dreams and aspirations beyond the family. The Word of God brings liberty; it does not place limitation on the dreams and aspirations of women. Neither society nor religion can any longer place restrictions on women and their gifts and talents. Restrictions that limit the voices of girls when they leave childhood make them and other women expendable. Research by Brown and Gilligan show that girls become disassociated with their own thoughts and feelings because they are pressured to conform to an image dictated to them by culture and tradition. By their teens, this becomes a crisis of giving up their own voice, sacrificing themselves to become "good" women. Thus, "to say what they are feeling and thinking often means to risk, in the words of many girls, losing their relationships and finding themselves powerless and all alone."[25] They lose their voice and become what others determine they should be.

Groothuis takes to task those who would try to prove that there is an innate characteristic that produces leadership traits in men and not in women:

> In recent years there has been a great deal of emphasis on "proving" the innate and therefore presumably God-ordained differences between men and women—differences that are said to entail a masculine aptitude

for leadership and a feminine capacity for receiving and affirming that leadership...as long as the definition of woman's difference entails the need for her to come under the protective guidance of a man and to gear her entire life around helping that man as he leads her...She is not "different" in any neutral sense. She is...not able to make her own decisions and control her own life—as is expected of any grown man. She is, quite simply, more child than adult.[26]

The sad thing is that those who disagree with traditionalists are attacked as sacrilegious for daring to question the traditionalists' doctrinal belief systems or their treatment of women, whether in the home or in the church. Attacking those who disagree with the belief in male authority and rule over women reflects a lack of civility toward those with differing viewpoints as to Christian male and female relationships. Martin speaks of the arrogance and disdain some traditionalists convey to those who disagree with them:

The sheer vehemence...(in) recent years attests that we are facing more than an occasional lapse of exegetical judgment. We are facing an ideology that is so certain of itself that in the hands of some, at least, the (biblical) text is not allowed to speak for itself.[27] They argue, wrongly, that those who oppose male authority do not differentiate between the roles of men and women beyond biology. Differences, for the traditionalists, are "the functional equivalent of two different species who are opposites in virtually every respect."[28]

The scripture, "There is neither Jew nor Greek, there is neither bond nor free, there is neither male nor female: for ye are all one in Christ Jesus" is not some pie in the sky equality

only to be realized in the hereafter (Gal. 3:28). Both Gentiles (Greeks) and bondsmen (slaves) are now free to lead in the church; however, this freedom has not been afforded women in many church settings. Groothuis states that "men and women are not just 'equally saved' (whatever that means). Rather men and women have equal status in the community into which their salvation has secured their membership."[29]

Hurley, a traditionalist, exhibits unusual candor in his book when he states that he sought answers to questions, such as whether men are superior to women. His is a refreshing exception to the usual traditional stance of piously never analyzing or examining their personal views. These views have often hinged upon a belief in male superiority and female inferiority. He goes on to say that he accepts the Word of God and he realizes that human authors—men, who lived in a given historical period—penned the Bible. It is, Hurley believes, the job of the church to critically examine the Bible translations in their historical context to comprehend them correctly. His examination began with his concern as to whether his wife should have to wear a veil and whether she should have to meekly accept every "crazy" thing the he decides to do. He surprisingly interjects that each succeeding generation must scrutinize biblical application as it relates to their life context.[30]

Hurley examines several biblical areas that he deemed irrelevant today. He first discusses veiling. The surrounding cultures mandated veils for women (Assyria, Muslim countries); however, the Old Testament did not refer to laws concerning veiling. It was because of this that Israel did not practice Islamic total veiling.[31] However, Keener in his research notes that there is evidence of veiling in the eastern Mediterranean, even in Paul's home, Tarsus.[32] The operative

phrase is *total veiling*, on which Hurley does not elaborate. Thus, Hurley discounts the use of wearing a veil even though there was evidence that it was practiced in ancient Jewish culture at that time. Secondly, he researched the comparison of the rich entering the kingdom of heaven to getting a camel through the eye of a needle. He found that the comparison had a cultural significance for that time. Hurley's research showed him that the needle's eye was a small door for entry by camels at night into Near Eastern cities. The travelers could not enter into the safety of the city until they had removed their valuables from the camels; the camels were then able to get through the small entry door. He says that the comparing of a camel getting through the eye of a needle with that of a rich person entering the kingdom of heaven was cultural and for that era only.[33]

Hurley seems to honestly wrestle with the issue of authority and subordination; nonetheless, he comes to a different interpretation of woman's subordination than he does with other cultural scriptures. He asserts that the Old Testament spoke of men's divine appointment and sociology or psychology does not influence that. Here, again, the same church mantra—the subordinate position of wives and daughters in no way equates with inferiority. His position is that the church has been in error when it has made the assumption of equating subordination with inequality. His inference here is that the Old Testament corroborates the New Testament in the case of hierarchical positions between men and women. Hurley does not use his vast resources to thoroughly check out his erroneous assumption of a divine mandate in the Old Testament that substantiates his interpretation of New Testament Scripture. For him the belief that the Old Testament corroborates the New Testament scriptures legitimizes subordination.

He perceives God's discourse with the couple after the Fall as a curse and eternal mandate and not a proclamation of the way things would be because of their disobedience. His perception of an eternal mandate on women's subordination, caused by the Fall, is not for him eradicated by Jesus' sacrificial death for all human beings. Thus, women, for him, do not receive the total atonement for their sins when accepting Jesus as Savior because subordination is an eternal mandate for them.[34]

Traditionalists limit the interpretation of Galatians 3:28 for women to a spiritual relationship with God. According to Massey, traditionalists who believe in male authority as ordained by God interpret the liberty that Paul talks about in Galatians 3:28 as spiritual, not legal, political, or social. Thus, social divisions and hierarchy have not been eliminated for women according to them. They believe that societal distinctions have nothing to do with salvation, service, dignity, and importance in the kingdom.[35] Yet, it was Peter, one of the apostles that gender traditionalists love to quote, who reiterated Joel's words in Acts 2:16–18:

> But this is that which was spoken by the prophet Joel; And it shall come to pass in the last days, saith God, I will pour out of my Spirit upon all *all flesh*: and your sons and your daughters shall prophesy, and your young men shall see visions, and your old men shall dream dreams: And on my servants and on my handmaidens I will pour out in those days of my Spirit; and they shall prophesy. (author's emphasis)

In the last days Joel prophesies that the Spirit of God would be poured out on all flesh, not just men! The prophecy is not dealing with eternity; it is dealing with life here on Earth.

For traditionalists, the normative scripture is 1 Timothy 2:12, which they interpret as mandating gender hierarchy. Traditionalists then limit the applicability of Galatians 3:28, which teaches equality of all believers. When using the traditionalists' proof texts regarding gender hierarchy, their view of Christianity has obvious commonalities with other religions or cults and their treatment of women. In most religions, women are relegated to spiritual equality in eternity. Hamilton views the teaching and treatment of women in the church as having more in common with the ancient Greek and Roman philosophers. He depicts the church as having:

> ...allowed our culture to shape us and even color how we read the Bible. We have erred, and our failing has debilitated our witness, making generations of women believe that the God of the Bible is against them."[36]

Groothuis maintains that the context in which scriptures such as 1 Timothy 2:12 are viewed were not intended to be universally normative, but rather applicable (in a practical sense) to the culture of the first century.[37]

Those opposing the traditional view believe that Christians, both men and women, are equal, not just in the spiritual realm, but in all aspects of social interaction.[34] These Christians believe that Galatians 3:28 is an affirmation of equality and dignity for everyone. The underlying principles of the New Testament are love, mercy, equality, and justice, and Christians are instructed to tolerate and submit to social situations that are less desirable. Thus, much of the treatment of women in the early church was the result of the cultural constraints; it was not a doctrine used to mandate subordination throughout the centuries.[34]

One theology professor who set out to study women's spirituality and their place in Christianity expressed the following as it relates to men and women and their religious and social interaction:

> As one of the ruling party, I am the possessor of power, one in control and in a position to dominate the culture. I have held this place in human history prepared for me over the millennia simply by virtue of my gender. I have not encountered the pain of marginalization or the loneliness of being the outsider.[35]

Evans stated that he had to guard against the temptation of using the study to "figure them (women) out" so that he could determine "what to do with them."[36] He could, he indicated, have formed neat categories to place things in perspective, a euphemism for "putting…people (women) in their place."[37]

In his findings, Evans comments that women's relationship to God has often paralleled their relationship to men. They see their value, not in terms of who they are, but in terms of their function (role). They, according to Evans, gauge their worth by their sins rather than their character—they admire, depend on, and defer to God and often consequently end up feeling dominated, undervalued, and, at times, fundamentally despised by God. They justify themselves by continual service and work and lowly self-effacement. He goes on to say that these women have never seen themselves as representatives of God. They view themselves in the role of "otherness."[38]

As a result of the study, Evans changed his perspective on women. Here is what he had to say at the end of the study:

When I make myself [as a man] the center of the universe, I see only what affects me and perceive things only as they have an effect on me. The result is pain, loneliness, and repeated disappointments. Occasionally, when I have entered into someone else's world or story, I have experienced freedom both from self-consciousness and from self-obstruction. I have experienced decentering.[39]

Traditionalists, in their attempt to neutralize the debate, assert that gender hierarchy is related to a woman's function. Therefore, women essentially are not inferior to men, but rather are "equal in being and unequal in function." Their arguments are couched in biblical-sounding euphemisms with coded, emotional-laden expressions and catchwords, such as *appropriate femininity and masculinity, differing responsibilities*, and *servanthood through male spiritual leadership*.[40] These nice, neat categories are used as Evans noted "to keep women in their place."[41]

When the issue of a "woman's place in Christendom" becomes a matter of mostly name-calling rather than a biblically and spiritually oriented debate, it ends up an earthly/fleshly conflict. Traditionalists fuel the debate by calling everyone who disagrees with them feminists (radical feminists is a more apt term) or even heretics. The truth is that many men and women on the opposite side of the debate are neither radicals nor feminists; they have just sought the truth by seeking God Almighty with their hearts, soul, and might.

Hove criticizes egalitarians in their interpretation of Galatians 3:28 by stating that they are in error when they include the eradication of social status (cultural roles that determine a woman's identity and essence), along with the

changes in the theological distinctions noted in the scriptures. Hove disagrees with the view that male authority is a result of the Fall; thus, for him, male authority is not nullified upon redemption, and Christ's redemption did not entail mutuality between men and women.[42] Hove notes that gender traditionalists (complementarians) view Paul's central message in Galatians 3:28 as primarily theological. He states that Paul meant that God included all people in the blessings of God. He goes on to say that Paul does not address the role relationships of men and women in the body of Christ. Galatians 3:28, he notes, addresses their initiation and inclusion into the body of Christ through faith and baptism. He uses Ronald Fung to validate his view that male and female distinctions are not social institutions but rather rooted in Creation, noting that there were social implications with slavery, which makes that subordination different from that of woman's subordination.[43]

Hove further emphasizes that gender traditionalists/ complementarians view unity in Christ as equality. Both men and women are equally part of the body of Christ and have equally inherited the blessings as children of God. The discrepancy arises as to what he means by unity in Christ and what he means by "through this unity in Christ both men and women are equal." Hove asserts that gender traditionalists, like him, do not believe that Galatians 3:28 means equality in all respects—men and women do not have the same roles. He goes on to say that Galatians 3:28 was never meant to imply that the oneness stated meant unqualified equality.[44] For Hove and other gender traditionalists, then, men and women have a qualified equality, but what does that mean?

Hove uses the faulty analogy of sugar and flour to make his point about men and women being different and yet equal. He compares men and women to sugar and flour by noting that one cannot put a cup of sugar in a recipe for a cup of flour even though they are both equals.[45] Hove errs in that flour and sugar are not equal, and they are made from different substances. Unlike flour and sugar, men and women are derived from the same substance! They were equally made in God's image; their DNA is derived from the same substance. Hove's mistake and that of many gender traditionalists is that they see men and women as more different than they see them as alike, and this is noted in his use of the analogy of sugar and flour to refer to them. This diminishes the common origin of men and women, both of whom are created in the image of God, and both of whom are co-image-bearers with a common mandate to take dominion on Earth. (See Genesis 1:26.)

When Adam recognized the woman Adam (he did not name her), he asserted that she was "bone of my bones, and flesh of my flesh" (Gen. 2:23). According to Fleming, Adam later usurped God's authority over woman![46] The danger for women in the assumption that women and men are more different than similar in substance has resulted in centuries of inequality and injustice for women, the ones whose "supposed" substance is not esteemed as highly as men's.

For Hove and others, oneness means sugar and flour and not "bone of my bone and flesh of my flesh." In essence, for him, men and women were not equally made in God's substance/ image and not equally made to be fruitful and take dominion on Earth. By qualifying equality and misrepresenting oneness, Hove and other (gender) traditionalists justify male authority

and reject it as originating with the Fall and ending with Christ's atoning death and resurrection.

If this inbred subordination was part of the creative design, God would have made woman after the animals and He would have made man the last. This would not negate man's naming the animals (and it might add credence to traditionalists' claim that Adam named the woman before the Fall). That would clearly be a more coherent scenario. If God had put man (the male) in total control, He would not have said:

> Let us make man in our image, after our likeness: and let *them* have dominion over the fish of the sea, and over the fowl of the air, and over the cattle, and over all the earth, and over every creeping thing that creepeth upon the earth.
>
> —Genesis 1:26

He would have said, "Let us make man in our image, after our likeness, and let *him* have dominion" [*them* would not have been used].

Some traditionalists err in their belief that only women, especially those in the modern feminist movement, write books on the subject of women being treated unjustly. Many men, as well as women, are speaking out on this subject today, and their viewpoints have been sought and are included in this book. In addition, it is the height of arrogance and contempt for others to reject another's viewpoint on the issues facing women in the church and home just because the person is a woman and not a man and then justify that view as biblical. Also, the assumption that women have no say in their own destinies and that it is God's will to place the total lives of one-half of His image-bearers—women—in the hands of their co-image-bearers—men—is fallacious. All belief systems must line up with the Word. "To do justice (to

the topic of gender and grace)...while subjecting both feminism and received theology to a fresh reading of Scripture is not an easy task."[47]

The fear of change and the idea of women invading their space has caused emotional resistance to equality for women. For some, the very act of placing the words *woman, gender,* and *equality* together incurs irrational responses. Nicholas Wolterstorff reveals the way his own denomination, the Christian Reformed, view change. He depicts the irrationality and fear that men face in conservative circles even when they know they are wrong. Many, in spite of the truth, hold fast to their dogma relating to women:

> Committee after committee appointed by Synod has always said in its majorities that the conservative interpretation of the passages was not compelling. But that didn't lead people to give up...In good measure it has been a struggle for males to hang on to power, a struggle partly generated by fear. And just not wanting women there!...In the face of a three-century-long process of reinterpreting the Bible under the influence of historical criticism, *people have been afraid that if they changed their mind at any point on what this or that passage meant, everything was going to slip and slide away. Never again would they find a place to dig in their heels...*Once upon a time men said, "They're too emotional, they can't think as well." And so forth. But conservatives writing synodical reports have usually not said that. In fact, they have said just the opposite, oddly, that women are just as good at it as men, but God said women shouldn't preach...I've noticed in some of these people a deep irrational revulsion at the very prospect of women preaching.[48] (emphasis added)

This emotional and irrational fear also causes traditionalists to want to return to a past-idealized era, where a woman knowing "her place" is all that seems to matter.

Bartchy delivered an ideal approach to the male and female relationship, particularly in marriage, based on his 1987 paper, "Consultation on a Theology of the Family." He espoused a balanced approach to a husband and wife's relationship, rather than one in which the husband is all-powerful and the wife is powerless.

1. A wife's natural response to a power-down structure in which the husband is given the role of authority just because he is male is manipulation. (This is often seen in many conservative marriages, as was discussed in the chapter "The Lure of Entanglement." It [manipulation] is called something positive and both husband and wife are equally involved and aware.)

2. The use of the military and government as comparative situations are invalid, for the basis for one person being in total charge of another is unsound and faulty.

3. No evidence exists that substantiates that God blesses any families because they are traditional. Christian homes where there are battered wives and abused children seem to suggest that the top-down authoritative household is open to problems because the men have a compelling need to assert their masculinity by dominating the members of their families.

4. The power paradigm used by traditionalists is the antithesis of the example of Christ-likeness, even though it is couched in pious and religious language.

5. This male authority model suppresses the natural gifts and talents of wives by keeping them in "their place."

6. The assumption that a "Christian marriage" with the male in charge and the female in subordination will produce the desired marriage is not true.

7. Even though the mutual submission model for a marriage is silently proving to be not just acceptable, but better than the traditional model, it is conspicuously ignored in Christian circles.[49]

Traditionalists tend to water down the mutual aspects in the Pauline verses on husband and wife relationships, and yet, focus on mutual love and consideration in other Bible verses.[50]

Sexism and Gender Hierarchy

Gender traditionalists tend to reject women when they relate to men on a level playing field, in the church, on the job, as well as in other social interactions. The position of a self-assured and confident woman is often ignored in meetings or social conversations. The snubs are sometimes conscious and sometimes subconscious. The tendency is to put the "uppity" woman in her place. They view all relationships with women as hierarchical or sexual. This hierarchical stance is not endorsed by Jesus, nor is it endorsed by Paul's example of relating to his

female colaborers in his letters. It is more closely related to that of the church fathers, as restrictions were placed on women when the church was institutionalized.

One example of sexism in the raw is depicted in John R. Kohlenberger's personal journey from male superiority. Kohlenberger notes that he is a product of the gender-stereotypical middle-class society of the fifties and sixties. He states that a woman's place was in the home and a man would not be caught dead doing "women's work." In social and athletic interaction, he learned not to do things "like a girl," for "boys did things better than girls and men were superior to women."[51]

Within his evangelical schooling and church affiliation, Kohlenberger was taught that Scripture sanctioned his secular view of male superiority:

> Eve was deceived and corrupted Adam. Sarah lacked Abraham's powerful faith.
> Jacob's scheming wives were nothing but trouble. Miriam criticized Moses. And don't forget Delilah and Jezebel! It seemed most of the women of the Old Testament were named only to be praised for their physical beauty or vilified for their treacherous dealings with men.[52]

He notes that he was taught that women had no authority in the church; they were to remain silent. In the home, women were to be "absolutely submitted" to their husbands. Bible colleges and seminaries provided little career guidance for women because the standing joke was that "women attended college only to find a husband, or to learn to teach children."[53]

It was only through the thoughtful and prodding inter-action of a patient wife and an insightful mentor that Kohlenberger's concept of male superiority was shattered. The fact that both male and female are created in the image of God reached his consciousness. (See Genesis 1:27.) Both men and women are co-heirs in the gift of life. (See 1 Peter 3:7.) There were no commandments in the Bible that consigned women exclusively to the home or limited their involvement in society. There were no commandments that limited men's involvement in the home. Kohlenberger acknowledged that he had heard many sermons on women submitting to their husbands, but none on Ephesians 5:21 where all—men too— are to submit to others, including their wives. He interjected that he had learned over twenty-three years of marriage that there was wisdom in his submission to his wife in her areas of expertise; however, he only recently realized that that kind of submission was a scriptural mandate. As for ministry, Kohlenberger states that it is only recently that he learned that Paul practiced what he preached. (See Galatians 3:28.) It was of extreme significance that Paul named women as his colaborers in ministry in Romans 16:3–15 and as partakers in his struggles in Philippians 4:3. It was of acute importance that Paul called Phoebe a "deacon" in Romans 16:1 and Junia an "apostle" in Romans 16:7.[54]

Timothy Vanderpool also dicusses what he calls his "journey toward egalitarianism." Vanderpool asserts that he was not raised in a Christian home; however, there were Christians on both sides of his family—his dad's family was Southern Baptist and his mom's family was mostly Pente-costal. The lessons he received from his family—that a woman should never be permitted to preach and that she should obey her husband because he is in charge—were indelibly

imprinted in his mind. Those lessons remained with him, he lamented, even as unbiblical as they were.[55]

Vanderpool stated that two months after receiving Christ, he heard that a woman was to preach the message in his old-school Pentecostal church. He vowed "If a woman starts to preach tonight, I'm going to get up and leave." Instead of leaving as he promised, that night Vanderpool witnessed the Word of God being preached by a woman, and, for the first time, he questioned what he had been taught.[56]

This experience led to a burning in his spirit and a long spiritual journey toward the truth. Vanderpool admits that he could not receive satisfactory answers from different leaders. He sought the truth concerning the problematic texts through prayer, searching his concordances, commentaries, articles, and discussions. According to Vanderpool, "My stomach often turned and cramped because I was haunted by the great depths of Scripture to unearth and the truth I was to discover." After eighteen months of painstaking research, he reached the conclusion that women were not subordinates or afterthoughts in God's creative plan. The truth, he discovered, was that women are equally created in God's image and equally capable of any task or office that men are capable of performing. "I realized that a man was not the 'king' of his house." Husband and wives are to submit mutually in a harmonious marriage.[57]

Various traditionalists have determined what is considered "a woman's place" as noted in the following vignettes. The very nature of God and His views on women and their purposes have been distorted by some of the very ones who profess Jesus as their Savior. This approach is unbalanced and un-Christlike. This argument, even within some conservative circles, is considered patronizing and tepid.[58] The following

quotes provide some insight into the beliefs of some traditionalists in the area of women and their destinies.

On Creation

There is an *"overall sense"* of *her being subordinate* to him in God's creation of the human race.[59] (emphasis added)
—Richard Clark, traditionalist

On Male Superiority and Man as God's Prime Creation

The first indication of the presence of subordination is that the man is the center of the narrative of the creation of woman. He is the first formed. Then God provides him with all that he needs for life: an occupation, land and wealth, and a wife...Woman is created to be a helper for the man...her life is oriented toward his in such a way that direction for her life comes through him....Secondly, it is the man who is called "Man" or "Human" and not the woman...*He is the embodiment of the race...she was not*...Thirdly, man is created first, before woman.[60]
—Richard Clark

On Man as God's Prime Creation

He is the "first-born" and hence would have a natural precedence by birth. He (God) allowed Adam to define the woman, in keeping with Adam's headship. Adam's sovereign act not only arose out of his own sense of headship, it also made his headship clear to Eve. *She found her own identity in relation to the*

man as his equal and helper by the man's definition.[61]
(emphasis added)

—Raymond C. Ortlund Jr., traditionalist

On the Creation
and Woman

Most commentators, both traditionally and at the present time, hold that *there is something in the author's mind concerning the woman's greater vulnerability.* The manner in which the narrative is presented would seem to point to something in this regard, *although such an opinion derives more from a feel for what is happening in the text than from anything explicitly stated therein.*[62] (emphasis added)

—Richard Clark

On Male Domination and Female
Subordination at Creation

"But God's naming of the race man *'whispers' male headship…*"[63] (emphasis added)

God did not name the human race "woman." If "woman" had been the more appropriate and illuminating designation, no doubt God would have used it. He does not even devise a neutral term like "persons"…*He called us "man," which anticipates the male headship brought out clearly in chapter 2* [of Piper and Grudem's book]…Male headship may be personally repugnant to feminists, but it does have the virtue of explaining the sacred text.[64] (emphasis added)

—Raymond C. Ortlund Jr.

A Joke?

"I think everybody should own at least one."[65]
—Paige Patterson, former president,
Southern Baptist Convention
(when asked his views on women
by a newspaper reporter)

On 1 Timothy and Women as Leaders

Regarding women as leaders, it is "...an affront to home and family" and "one of the raging, raging heresies and confusions of the day."

On the interpretation of 1 Timothy and women: "You [women] have a problem. I tell you what—you go home and raise a family and you may just see God."[66]
—Mark Coppenger, former president of
Midwestern Baptist Theological Seminary

First Timothy 2:14 teaches that women are more easily deceived than men.... Men's greater ability to resist deception makes them more capable of being a governor of the community. They are better able to achieve one of the main purposes of those with governing authority: to provide stability and to protect the community against alien spiritual influences and deception.[67]
—Richard Clark

On Women in Leadership

Redemption in Christ aims at removing the distortions introduced by the curse. In the family.... wives should

forsake resistance to their husbands' authority and grow in willing, joyful submission to their husbands' leadership. In the church, redemption in Christ gives men and women an equal share in the blessings of salvation; nevertheless, some governing and teaching roles within the church are restricted to men.[68]

—*The Danvers Statement*, by the Council on Biblical Manhood and Womanhood, December 1987

Chapter 17

A DIFFERENT SPIRIT

Women constitute more than half the
population of this country. Even so, their
contributions are often undervalued.[1]

—DEE JEPSON, CHAIRPERSON OF THE
BOARD OF REGENT UNIVERSITY

THERE ARE SEVERAL types of traditionalists. Firstly,
there are those who believe that men are called to be
in authority over women; they are ordained by God to do
this, and there are no exceptions to this rule. They believe
that women are basically secondary and those who do not
submit to their husbands are committing sin, even when
the husbands are wrong, or are in error. Then there are
those principled men and women who believe in what they
have been taught and that their interpretations of Scrip-
ture justify male authority and female subordination in the
church and home. The men believe that it is their duty to
take responsibility for everything, and it is the wife/woman's
responsibility to submit in everything, for it is what the Word

requires. They point to the fact that submissive women are often blessed with their prayers answered because of their obedience to their husbands, even when the husbands are in sin or may be even mistreating them. (They fail to note that anyone—male or female—who demonstrates a humble, submissive spirit will receive answers to their prayers and spiritual breakthroughs!) Thirdly, there are the theoretical traditionalists—male or female—who mouth their belief in marriage hierarchy. They profess a belief in top-down marriages, but in practice, they make decisions mutually and both husband and wife reverence, honor, and place the other's needs above his or her own. Lastly, there are those traditionalists who believe in strict, clearly drawn roles for women, and yet they are not antagonistic toward other Christians who believe in mutual submission and who do not share their top-down doctrine on male and female roles within the church and home.

The quote at the beginning of the chapter is from Dee Jepson, a traditionalist who offers hope for the body of Christ. God is calling His church to unite. If that is not possible doctrinally, the church can at least keep a unity spiritually. There is something refreshing about those who can present their beliefs without vilifying those who disagree. This is what Jepson writes in the article "Women in Society: The Challenge and the Call" in Piper and Grudem's book. It is an uplifting article in the midst of a book that takes aim at anyone who dares to defy the traditionalists' doctrines related to female subordination.

Jepson's article sounds a cord of unity for people who are on opposing sides, and it is this message that should be heeded by all who profess Jesus as their Lord and Savior, regardless of their position on men and women. Jepson writes of

speaking in love, not in self-righteousness, for she contends that no one but God knows the intent of another's heart. God has commanded His people to love, not judge each other.

Admittedly, there has probably been strident language on both sides, and Piper and Grudem's book is definitely an example of this. Jepson appears to be the only one in this book who does not lambaste those who differ with her traditional point of view as to the role of women in the church and the home. Neither does she set herself up as righteously indignant with a "holier than thou" attitude toward those who believe differently on this issue.

What Jepson does do is present a picture of women as multi-faceted beings. She does not major in the "so called limitations and boundaries" that God has supposedly placed on women, as many traditionalists infer in calling them the assistants of men. She extolls the family, and rightfully so. Jepson also decries the negative comments that disparage marriage, homemaking, and being a wife and mother, even by some Christians. Jepson recalls groans from an audience at a national committee of one denominational church when she mentioned the word "family." With a seeming purity of heart, she states:

> I wanted to weep, not because those present disagreed with me—that wasn't the point—but because it grieved me that the family, which is God's idea and which is the basic unit of government within a nation, could be viewed with disdain even in the church.[2]

She did not personally attack those people, even though they exhibited rudeness and a lack of civility.

What was more astounding is that Jepson presented a more expansive role for women in Christendom. She notes that

there are seasons in a woman's life—what maybe good for a woman at twenty-five may not be the thing that is good for her at forty-five. Jepson sees women as instruments of healing and peacemaking. Christian women are also needed to stop the slaughter of the unborn. She mentioned that women need not despair and consider themselves second-class citizens, as Jesus affirmed women and cut across barriers. She states that Jesus "is the liberator, the One who frees us from our own sin as well as from our circumstances and the distortions of our culture."[3]

Jepson reiterates several aspects of the women that were mentioned in the Bible. Christ was born of a peasant girl named Mary. It was this unlikely young girl that God chose to give birth to His son. In addition, she notes that Mary, not Martha, chose the better part—sitting at the Master's feet. Jepson also speaks of women being the first at the tomb, and that the first evangelist (Mary Magdalene) was a woman.[4]

There are others who also believe in male headship, leadership, and authority, and yet these particular traditionalists "emphasize women fulfilling their God-given destinies." They do not emphasize setting boundaries and limitations for women. They believe in women using their gifts within the church. Leaders in Charismatic and Pentecostal circles, such as T. D. Jakes and Myles Munroe, stand out. Jakes notes that men are not overtly discriminative, for they are far too sophisticated for that. He surmises that men's attitudes speak loudly when no words are uttered. He continues by noting that Christians fight to preserve the life of the unborn, and then mistreat them as they mature because of their gender, race, or denomination. In looking at Proverbs 31, Jakes notes that God's idea of a virtuous woman goes beyond the kitchen. The woman was

more than an assistant; she was a businesswoman, she owned property, and she had a family for which she cared.[5]

T. D. Jakes makes a profound statement about men and their myopic view of women, and it is echoed by others throughout this book. He talks about the staggering revelation of men being seen naked before a perfect and holy God with every substance, known and unknown, laid bare:

> While God sees us perfectly, we don't see Him fully. We have seen God only through our masculine eyes, tainted by our own biases. But today God is pulling scales off our eyes. As a result, we will soon discover a wall that has long blocked our view of His splendor: the sin of sexism. Will we allow God to diagnose this severe injustice in our land?[6]

Jakes exposes this severe injustice as the sexist attitude of some men as it relates to women.

Myles Munroe notes that women must begin to realize that they are created equal to men and that God sanctioned this at Creation. He emphasizes that women can take ownership of their God-given rights and equality because it has already been settled and no amount of postulating can change that. He notes that women should not seek their identity through men:

> If you ask somebody for something, you are admitting that they have it; if you have to demand something from someone, you are confessing that they own it. When you do that, you are devaluing yourself, because you are, in effect, relinquishing the possession of your rights to someone else."[7]

That is, women devalue themselves when they demand freedom from men, for no human can own another. Women, like men, are image-bearers of God, and to seek one's value from an earthly being devalues the seeker. Women who seek their God-given rights and values from men have relinquished their personhood to them.

Not all Christians view mutual submission and the sacrificial giving of one's life for their spouses as the doctrine espoused in Ephesians 5:21–33. However, some traditional men and women do believe that women should be allowed to fulfill their God-given destinies, and their gifts should not be quenched, wherever they may lead.

Chapter 18

COLABORERS IN THE KINGDOM

I surrender not our claim to equality. All I ask of
our brethren is, that they take their feet from off
our necks and permit us to stand upright on that
ground which God designed us to occupy.[1]

—SARAH M. GRIMKE, SUFFRAGETTE

THE CHURCH'S SUBORDINATION of women down through
the Middle Ages, the Reformation, and up to the modern
era has been discussed earlier. The doctrinal justification
today, rather than partly philosophical, has become solely
theological, and rather than institutional, is now based on
a creational teaching that supports female subordination. In
the past, the Blessed Virgin and cloistered virginal women
saints were the women who were praised. Today, the women
who remain within certain perceived roles and remain
obedient and submissive to male authority in the home and
church are praised. Woman's status has not changed.[2] In
other words, the institutionalized male authority has been
perpetuated within the church for centuries, and though

the rationale has changed, it continues to be done under the guise that it is God's divine order.

Another ploy used today (and mentioned earlier) is the flawed analogy between female subordination and functional subordination. Functional subordination, which occurs on a job or in the military, is derived from one's abilities or lack thereof for a particular time frame. It is limited—used until a person acquires other abilities, is promoted, or until a particular job is ended. Female subordination, on the other hand, has nothing to do with abilities; it is solely because of a woman's femaleness. Female subordination is lifelong and permeates a woman's total being, with her husband having total rule over her.[3]

Fearfully and Wonderfully Made

Just as in the Godhead, interdependence is predominant in the male and female dominion takers. Grenz explains that without the generation of the Son, there could be no Father God—the two are interdependent.[4] Also, *adam* was initially humankind (male and female), not male only: therefore, without the creation of the female, the male would not have fully manifested as man only. There lies the essence and beginning of the interdependence of male and female, "In the Lord, however, woman is not independent of man, nor is man independent of woman" (1 Cor. 11:11, niv).

Astonishingly, there are women who truly do not believe that they, too, are made in the image of God. Marilyn Hickey in *Women of the Word* states, "Many times women have said to me 'Marilyn, I have the feeling God thinks women are second-class citizens.'"[5] Here is what God would like for women to know: "You formed my inward parts; You covered me in my mother's womb. I will praise

You, for I am fearfully and wonderfully made; Marvelous are Your works" (Ps. 139:13–14, NKJV).

For traditionalists, sexuality saturates every aspect of a woman's life; a woman's femaleness becomes the determinant for everything that she does, rather than her being a dominion-taking child of God. This reflects shades of Freud's "Anatomy is Destiny." This belief asserts that one's destiny lies not in what God has ordained, but whether one is female or male; and if one is female, boundaries are placed on every facet of her life. For a woman in traditional circles, her anatomy/sex trumps her common destiny with man. The overriding emphasis on the differences are magnified to such an extent that men and women appear to be created altogether of a different substance, with no identifiable common destiny or essence. Piper, like other traditionalists, believe that femininity "is a freeing disposition to affirm, receive, and nurture strength and leadership from worthy men in ways appropriate to a woman's differing relationships."[6] This inference is that a woman is defined by how she relates to and affirms men. Piper lists what he considers positive feminine traits, taken from a book by Chervin. Chervin notes that women are:

> responsive, compassionate, empathetic, enduring, gentle, warm, tender, hospitable, receptive, diplomatic, considerate, polite, supportive, intuitive, wise, perceptive, sensitive, spiritual, sincere, vulnerable (in the sense of emotionally open), obedient, trusting, graceful, sweet, expressive, charming, delicate, quiet, sensually receptive (vs. prudish), faithful, pure.[7]

For traditionalists, it is the man's maleness that allows him to lead; there are no qualifications. For woman, it is

her femaleness that disqualifies her from leading, even when she is qualified to lead. Her femaleness is the reason that her role is designated assistant to the man as he walks out his destiny.

These prescribed traits limit individual differences as well as the use of a woman's unique talents within the church. Once assertions are made about what qualifies as feminine traits, these qualifications then become the generalized definition for womanhood. Hard and fast assertions cannot define human relationships or sexuality:

> What is repugnant to every human being is to be reckoned always as a member of a class and not as an individual person. A certain amount of classification is, of course, necessary for practical purposes: there is no harm in saying that women, as a class, have smaller bones than men, wear lighter clothing, have more hair on their heads and less on their faces.... a woman is just as much an ordinary human being as a man, with the same individual preferences, and with just as much right to the tastes and preferences of an individual.[8]

Sayers goes on to say that making unreasonable and irritating assumptions as to the tastes and preferences of a person solely based on the class in which that person belongs has been an error that has been predicated mainly upon women. She emphasizes that feminists also have an inclination to fall into this error of making sweeping generalizations about men.[9]

Many generalizations made by Westerners, in this case traditionalists, have their roots in the society and culture in which they live. Benedict debunks the generalized assumptions as to the personalities of both women and men. She

studied several different groups and she found that the traditional Western view of femaleness and maleness did not fit these groups that she studied. The Zuni Indians of the southwestern United States were all placid people. Even though physical punishment was not used, the children became well-behaved adults. Divorce was unusual, often resulting in the wife setting her husband's things outside of the house. He would then take his possessions and return to his mother's house. The Tchambuli's sexual roles were the reverse of what is perceived in Western cultures. Tchambuli men were preoccupied with their appearance and jewelry and their appeal to women. The men gossiped and catered to women's social tastes. The men were nurturing to their children. In essence, their lives revolved around their women and children. The women assumed the roles that are often reserved for men in Western tradition. They were practical and not interested in the latest clothes or jewelry. They were the primary providers, as well as the sexual aggressors.[10]

Margaret Mead found more differing temperaments between men and women than those in the typical Western society. The cross-cultural differences between the sexes in two of the New Guinea cultures studied by Mead were astounding. She, too, saw that traits in our culture are not always the same as traits in other cultures for each sex. The Arapesh tribe felt that both men and women should be cooperative, unaggressive, and sensitive to the needs of the opposite sex. These traits are considered feminine in our culture. In another tribe, the Mundugumors, she found that males and females were aggressive, tough, and nonresponsive. These traits are considered to be masculine in our culture.[11]

Dubois's research of the Alorese of Indonesia showed mothers who were anything but maternal. The women fed their children erratically, often ignoring their cries. Punishment was erratic, with mothers sometimes tricking or deserting their children as a means of discipline. The personality of Alorese adults tended to be deceitful, insecure, and suspicious.[12] These studies show that neither men nor women should be typecast without considering each person's individual characteristics.

It is up to every individual child of God to seek Him for him/herself, for one can never really know the truth or the extent of who he/she truly is without seeking the face of the Almighty through prayer, fasting, and "searching and examining the Scriptures" (Acts 17:11, AMP). The price of seeking God's heart is high. Jesus tells believers how they can know the truth. He says:

> If you abide in My word [hold fast to my teachings and live in accordance with them], you are truly My disciples. And you will know the Truth, and Truth will set you free.
>
> —John 8:31–32, AMP

It is God who reveals His truth concerning who men and women truly are and their relationship with each other, and this is worth the cost it takes.

> The Bible teaches that men and women are equal in terms of their worth and value to God, their shared spiritual inheritance and their shared role in governing creation. This does not mean that men and women are not uniquely designed. God created male and female with inherent physical and emotional distinctions, and the New Testament declaration that there is no (neither)

male or female in Christ is not a biblical endorsement
of androgyny.[13]

They, the male and female Adam, were also equipped to
individually walk out their destinies. Neither was incomplete
or less of an image-bearer, for at the end of the sixth day of
Creation, God deemed all things complete. Not only are both
man and woman equally accountable for sin (see Genesis
3:16–19), but also they are equally accountable for fulfilling
their God-given destinies. God fully equipped men to be
husbands and fathers and women to be wives and mothers,
but He also equipped both of them to be dominion-takers.
(See Genesis 1:26–27.)

Concerning Differences— Nature Versus Nurture

Women and men desire to know what makes them different
from the other sex; however, they must never lose sight of
what links them together in a common destiny. Both are
descendants of Adam (male and female), which makes both
image-bearers of God, called to take dominion on Earth. Both
nature and nurture play a role in male and female traits and
differences. There are aspects of masculinity and femininity
that are perceived to be innate or biological (of nature), and
there are aspects that are perceived to be cultural and social
(of nurture). For the sake of clarity, nature is any God-given
attribute, whether natural or spiritual. Nurture incorporates
attributes that are the result of social, cultural, and environ-
mental influences.

When traditionalists skew opposing views by accusing the
opposition of trying to establish that there are no differences
in the sexes, they are trying to dismiss anyone from ques-

tioning their view of female subordination. However, it is the imaging of God that should permeate the very depth of each person's being, not his or her sexuality. The differences in the sexes should not summarily relegate one sex to a lifetime of subordination and the other to a lifetime of authority over the other without qualifications and simply because they are of one particular sex. The differences should not cause one sex to be defined by fixed roles.

God-given talents should not be limited because of societal distinctions, for differences are not always the same from culture to culture; what one culture deems as masculine attributes, another may see as feminine. Johnson states that one cannot underestimate the power of some to eliminate or restrict another individual's God-given talents because of gender. Plus, socialization (environment) plays a significant role in the upbringing of males and females. Johnson emphasizes the startling results of Margaret Mead's research on males and females from different cultures.[14]

There are some differences beyond the biological differences between men and women; however, those differences may vary in different cultures. Psychological/social differences are not just the result of innate differences; they are the result of cultural and nurturing conditions. Differences beyond biological differences, although obvious, are not always easily defined as either innate/natural or socio-cultural.

As research continues, myths are being dispelled as to what makes a man and woman different and what makes them similar. The problems arise when sweeping generalizations are made about traits, behaviors, and characteristics that may or may not be innate (inherent), but may, instead, be the result of social and/or cultural conditioning and

training. One example of this has been the research on the brain, which continues to evolve.

Majoring in Differences Hinders Kingdom Purposes

This problem is compounded because gender traditionalists have a preoccupation with male and female differences, to the detriment of kingdom building. Their majoring in the differences of the sexes leaves little ground to emphasize the common ground of fulfilling the great commission and taking back the dominion of the earth. Little is said of the harvest field where people are dying for the lack of people to fulfill the Great Commission. For gender traditionalists, fulfillment of destiny is limited to males. It is men who are allowed to walk out their God-given destinies.

Because of the socialization process, men have usually been defined by what they do and women by who they know relationally, that is, their functions as wives and mothers. A woman's worth has been predicated upon this.

The Bible is replete with examples of women who felt that their lives were useless because they were barren (without a son). Oftentimes, other women who had children would taunt the barren women. Hagar ridiculed Sarah (Sarai) after she bore Ishmael and Sarah was still childless. (See Genesis 16:5.) Sarah had been the one who had asked her husband, Abraham, to take her handmaid, Hagar, and bear a child so that she, Sarah, would not be childless:

> Then Sarai said to Abram, May [the responsibility for] my wrong and deprivation of rights be upon you! I gave my maid into your bosom, and when she saw that she was with child, I was contemptible and despised in her eyes.
>
> —Genesis 16:5, AMP

Rachel, one of Jacob's wives, was obviously deeply depressed over her barrenness, even as her sister Leah (Jacob's other wife) bore many children. "When Rachel saw that she bare Jacob no children, she envied her sister [Leah]; and said unto Jacob, Give me children, or else I die!" (Gen. 30:1).

In the book of Samuel, Hannah is a barren woman. She is married to a man named Elkanah. Elkanah also had another wife, Peninnah, who had sons and daughters.

> Her rival provoked her greatly to vex her, because the Lord had left her childless. So it was year after year; whenever Hannah went up to the Lord's house, Peninnah provoked her, so she wept and did not eat.
> —1 Samuel 1:6–7, AMP

Not only have women been defined in the past (and even today) by their functions as wives and mothers, but they have not been allowed to utilize their individual talents and gifts. The socialization and cultural process can significantly influence generalizations about men and women that do a disservice to both sexes. Not acknowledging differences and unilaterally placing all women in one category can be just as harmful to women as it would be to men. Women's roles within the church are often restricted, leaving them with little or no freedom to exercise their gifts or callings. In essence, they have no voice in deciding their own destinies, or in fulfilling kingdom purposes.

Gender differences should not hinder or limit the work of the kingdom. There are differences in men and women, and Grenz states that the reasons for the differences are often debatable. He calls for "role flexibility," where generalities coincide with differences. It is this type of theory that helps

to move men and women toward godly relationships that are nurturing for both. Grenz explains this by noting:

> Such relationships come neither through static sex roles which view women as subservient to men nor through the denial of any sex-based distinctions between men and women. Instead, godly relationships emerge as men and women offer their unique perspectives as gifts to each other, so that together they might become the community of persons God intends humans to be.[15]

The work of the church is done through the facilitative ministry of all persons using their giftedness, as was depicted in the New Testament, where both sexes were used to serve the church. Facilitative leadership reflects Jesus' teaching on the subject. He taught that the way to the top is through humbly serving and reaching out to others. He noted that He came to serve, not to be served. (See Mark 10:42–45.) A servant leader facilitates others by empowering, enabling, and helping them to develop; a servant leader does not dominate, diminish, or restrict others. The traditional hierarchical structure of the church belies men's comprehension of church structure and undermines the declaration that they are servant leaders. Robert Greenleaf and other business leaders have grasped the biblical concept of servant leadership. They have empowered and esteemed those within their organizations. The results have transformed their businesses.[16] Yet, those within the church continue to limit the productivity of women in their ministries, choosing to bind them rather than to develop their gifts.

Women Are Not Clones or Robots

To treat women as a group with common (like) personalities, talents, and skills does a disservice to them and all of humankind. In doing this, women's roles have been designated for them at birth by those who have little temperament or patience for the operation of their talents and gifts beyond the roles that they have "designated" for them. Women are often placated by the notion that their gifts are to be utilized mainly in the home.

Women are expected to have like personalities, temperaments, and gifts. The argument that is given is that women were created to assist (serve) men in their purposes. Heaven forbid that a woman exhibits a talent that has not been designated as a feminine attribute, gift, or personality trait and that does not correspond to what has been deemed as feminine. It becomes an anathema if a woman believes that God has called her to an office that has been deemed as male. This type of man-made reasoning has been just as responsible for aberrant behavior in women (and men) as has Satan or other causes.

Those traditionalists who desire to limit the boundaries of women often idealize the past and mourn the present. The past, not truth or justice, is what is sought. A desire to return to an idealized era often blurs the warts and blemishes that were also part of that time. This idolization of the past often takes precedence over the will of God. God is about changing the hearts of people. He is about transcending culture. Tradition has sometimes caused people to miss God's visitation in their desire to return to or remain in the old wineskins that block their vision.

The Pharisees and the Sadducees wanted to keep their traditions, and because of that they missed the visitation

of Jesus. In their eyes, things were great before the upstart sect, known as The Way, came along. Things were great, even though there was a class system where some people had more rights than others. Things were great, even though women were treated like property. Things were great, even though those very Jewish leaders had to compromise their principles to incur the favor of a totalitarian Roman government that dominated them.

Hyatt characterizes the rationale of the traditional church in keeping women in their "place" rather than allowing them the full measure of their equal status as a theology of womanhood. Hyatt recounts the tragic incident of a woman, Evelyn, an honor student in a well-known Charismatic Christian seminary in 1995. Evelyn was receiving her master of divinity with honors that year. One day in a practice preaching class, one of the men in his practice sermon adroitly advocated the traditional view of women as subordinates. When a woman in the class praised the man for his excellent oration, but expressed some disagreement with his theology, the professor exploded—shaking his finger in her face. He disparagingly screamed at her, "Don't argue with the Bible! He's right, and you had better get it straight! As a woman, you must submit to man. God made him head over you."[17] As Evelyn listened to the tirade by the professor, she felt as if she had been stabbed with a knife. She was in agony for hours. In the wee hours of the night, she put her pain in writing. Here is an excerpt from what she wrote:

To a Man—From a Woman

I feel crushed, cast down, buried alive,
Burned on your funeral pyre while you yet live.
I am sad because you would sentence me to subservience;

Because you would have me smile always and never talk;
Because you would have me sit at your feet, obey your
 voice and call you my Lord:
Because you would control my world, my actions, my
 days, and say it is because you love me....

You would define my place,
Censor my words and consume my talents.

Most of all, you would deny me my calling,
My responsibility to answer to my God.[18]

This traditional theology of womanhood must be rejected in favor of a theology based on the foundation of Jesus' teachings and the accurate interpretation of the Bible, historically confirmed by the Holy Spirit. This cannot be accomplished by simply modifying traditional rationale.[19] The whole theology of womanhood must be overhauled.

Chapter 19

A TIME FOR RECONCILIATION

Racism in this country pales when held up to its
modern relative, sexism...The spirit of bigotry that
exists within religious circles is staggering....I was
shocked to hear the bleeding cry of my sisters who
were oppressed in every area, from the boardroom to
the bedroom....It is our job as Christ-centered men to
confront the hidden agenda that disfavors women...[1]

—T. D. JAKES, PASTOR AND AUTHOR

THERE ARE SOME tough questions that confront the church
today. Jesus says in John 16:12, "I have yet many things
to say unto you, but ye cannot bear them now." It is time
that the church sought the whole truth; truths that Jesus was
unable to reveal to His disciples while He was here on Earth.
The world sometimes sees the fallacy in some traditional
doctrines. It causes some to reject Jesus, who has nothing to
do with these man-made doctrines. This is especially true of
issues relating to women.

The church must revisit the woman's issue which is caused by the tendency of prideful human beings to err behaviorally, to have personal biases, and to adhere to faulty belief systems that have been handed down for generations. Gender traditionalists sanction the status quo in the church today and hold as sacrilege established religious, cultural, and social orders. They blame all the gender-related problems confronting the church on a radical feminist agenda that is sabotaging the church. There may be some problems that are feminist-related. However, traditionalists have yet to face the fact that many people see problems within the existing church structure and leadership, and these men and women are not radical feminists or advocates of the feminist movement. These men and women just want to see women and men fulfill their destinies unhindered. Many of these people have agonized about the issue of women in the church for years. There are those who have been reluctant to get into the fray, but who have been given a mandate by God to speak to this issue; and they must obey or risk being judged by God when they stand before Him.

Healing the Breach

Another problem that cannot be overlooked in the traditional church is that women have been wounded and offended by their treatment in some churches, simply because they desire to use their gifts and callings to carry out God's work here on Earth. There are many walking wounded in the body of Christ because of this. Jesus is calling the church to embrace the hurting, the wounded, and the disenfranchised. Women should not be afraid to accept Jesus or attend church due to bias within the church walls.

Male pride, Grady asserts, is at the root of men's sin against women. This patriarchal dominating spirit has precipitated sexual abuse, domestic violence, pornography, an increase in divorces, and adultery. This male pride, he states, has caused women to develop deep depression, addictions, eating disorders, and even lesbianism. He notes, "Many women who struggle with homosexuality admit they were molested by a male relative, and they say the shame of the experience caused them to hate men."[2]

Attacking Present-day Feminism,
Not the Cure-all for All that Ails the Church

American feminism started out on a positive note. Pre-feminists such as Sarah and Angelina Grimke, along with Theodore Weld, Henry Blackwell, and Lucy Stone, were advocates for the rights of slaves, the equalization of marriage and property laws, and the right of women to an education. Nineteenth-century feminists became outspoken supporters of the suffrage movement. Women such as evangelical ministers Frances Willard and Dr. Anna Shaw even enlisted churches to champion the cause of women's right to vote.[3]

Even then there were those who were against a woman's right to vote. The same scriptures that are used to keep women in subordinate roles within the church and home today were once used by Christian leaders to prevent women from exercising the right to vote. Women were granted the right to vote in 1920. Many of these Christian leaders gave up their effort to limit women from voting; however, they began to step up their efforts in the areas for which they still had control—the church and the home.[4]

Feminism took a radical turn in the sixties. Modern feminists were spawned from the sexist practices within

the culture, social discontent brought on by civil rights for African Americans, and leftist political leanings. By the seventies the movement took an ominous turn away from the early causes, such as the abolition of slavery, suffrage, and the denunciation of racism and sexism. Early feminists, particularly in the eighteenth and nineteenth centuries, even into the 1960s, worked to open channels that had been denied to marginal groups. These early activists sought God-given methods to improve the home, family, and society as a whole. Many modern-day secular and radical feminists tend to center their causes mainly on personal fulfillment and sexual liberation at all costs; to them the home and the family have become peripheral. Many modern-day feminists are no longer mainly Christian men and women who seek to free women to use their God-given talents for the betterment of all.[5]

Who are these women who have ignored God and sought to center their agenda on "beating men at their own game?"[6] Many of these women are people who have been wounded by life's circumstances, women who have then hardened their hearts to anything but their own agenda. They see anything less than equality as an affront to women. In seeking what they see as equality, they become militant and sometimes irrational in their strategies. Many refuse to see differences in the sexes because differences connote inferiority.

The most heart-wrenching thing about this is that many Christians, women included, want nothing to do with these feminists. They are the modern-day pariahs. However, these are also people for whom Jesus died on the cross. These are people who need to know that God loves them unconditionally. These are people who need to see the love of Jesus in Christians. Finally, these are people who need to know that

God is no respecter of persons; He loves all people, even those who have ignored His salvation.

Repentance Is in Order

Instead of the blame game—it's somebody else's fault—the church, especially the traditional church, should work to alleviate the discord between those who see designated/assigned roles for women and those who believe that women should be free to fulfill any gifts that God has bestowed upon them. Traditionalists have to recognize that there is a problem and desire to seek God's will about the situation. They must be willing to seek reconciliation by asking those who they have offended to forgive them and repent of the centuries-old (conscious or subconscious) view of women as inferior. This failure to see women as image-bearers placed here to fulfill kingdom purposes has robbed many women of the grace that was given to them through Jesus' atoning death and resurrection. It is up to the church, Jesus' body, to bring healing and restoration to God's people.

Women, in and out of the church, who have been hurt, rejected, and marginalized, must forgive those who have offended them, lest the pain and bitterness develop into a hardness of heart that will permeate their total existence. Jesus has already born the hurts and pains on the cross.

Gender reconciliation bridges the age-old breach that began after the Fall, a breach that relegates one sex to static roles, determined by the other sex. Multiple millions of women around the world are looking over the church's shoulder, longing to see the freedom Jesus purchased for them at Calvary. It is the church that is duty-bound to repair the breach of former generations. The world has tried with marginal success to help women in their quest

for destiny. By opening their hearts, those same traditional-
ists who have heretofore denied women their destinies can
begin to bring into the church the women's libbers, the cult
members, and others. They can do it by showing Jesus' love
instead of reviling them and subjecting them to a bunch
of man-made rules and limitations because of their sex,
beliefs, or practices.

If the church, particularly the traditional church, wants
to please God, it must do several things. Firstly, it must
acknowledge that the transgressions and sexual issues that
have put a wedge between men and women need reconciling.
Secondly, traditionalists need to repent and ask women who
have been offended to forgive them. Thirdly, those women
who have been hurt must let go of the hurt and forgive those
who have harmed them. Lastly, there must also be a new
resolve to have dialogue on this issue.

Various writers throughout this book have noted that men
must recognize that their prejudice, pride, and domination
have hindered the destinies of women down through the
centuries. Grady notes in *Ten Lies the Church Tells Women*
that husbands must repent to wives; pastors to female church
members; ministry leaders to female employees who have
been overlooked for opportunities; and denominations must
repent of gender bias.[8]

> Therefore, if any man be in Christ, he is a new crea-
> ture: old things are passed away; behold all things
> are become new. And all things are of God, who hath
> reconciled us to himself by Jesus Christ, and hath given
> to us the ministry of reconciliation.
> —2 Corinthians 5:17–18

Grady believes that the issue of women in ministry must be approached with a humble spirit, a heart for God, and a heart for people. Some women are coming to the Lord with brokenness, hurt, and shame that they have received from the church. As he speaks to women's groups, Grady acknowledges that he asks men in the audiences to kneel down with him and repent to the women in the audience for the way men have treated women. He identifies with the men who have hurt or abused women. As the women begin to cry and come forward for prayer, Grady speaks of a healing that happens. Healing is essential for the hurting because those who are healed can bring a message of equality to others without the bitterness or anger associated with secular feminism.[9]

Women should not have to be relegated to pre-determined roles. Little girls should have the freedom to grow up and dream dreams—dreams that should be encouraged and nurtured. Little girls should be allowed to develop every one of their God-given talents and not be waylaid before adulthood by the traditions of men. As Cunningham asserts:

> I see every little girl growing up knowing she is valued, knowing she is made in the image of God, and knowing that she can fulfill all the potential He has put within her. I see the body of Christ recognizing leaders whom the Holy Spirit indicates, the ones whom He has gifted, anointed, and empowered without regard to race, color, or gender.[10]

People in Christ's body, the church, must lay themselves bare before Almighty God. They must begin to repair the gender breach and set women free from the restrictive doctrines that have been inflicted upon them erroneously in the name of God.

CONCLUSION

...the debate between traditionalism and biblical equality is not—as some suggest—a titanic struggle between the orthodox and the heretical, or the biblical and the secular. It is, rather, a theological and hermeneutical disagreement over what the Bible teaches about gender roles.[1]

—REBECCA MERRILL GROOTHUIS,
WRITER AND EDITOR

I T IS THE fallen nature of man that summarily limits women in traditional marriages and within the church. This inequality has restricted women to relational associations within the family—wives, mothers, and daughters. They are prevented from becoming multidimensional beings because they are defined by their relationships to their fathers, husbands, and male-only church leaders. Women are not allowed to dream dreams. When one-half of God's image-bearers are prohibited by a ceiling above which they can never rise, and when men use the scriptures as justification for that ceiling, it is fallen nature, not spiritual destiny. It is that fallen nature that limits the potential that God has given women. It is that fallen nature that permits only men

241

to realize their dreams unencumbered by restrictions that limit them to their relational roles. Forcing one-half of God's created beings to look to the other half of His created beings as their authority in all things is to sanction idolatry, which is an abomination to God.

Jesus saw and nourished the potential of people, even in a repressive society. He never thought of Himself too highly or flaunted His power—He gave up His power to come to Earth as a mere human. He served others by washing His disciples' feet, not the other way around. He gave up His life so that all people would realize salvation.

The hidden conflict within the church is the wall that encompasses total male rule and authority and female subordination. Many traditional circles have incorporated the doctrine of Aristotle, which views women as a little higher than animals in the creative process, and not as high as man. Down through the ages, this philosophical view, though not spoken, has colored traditionalists' interpretation of certain Bible verses, much the same as it did with the church fathers, Thomas Aquinas and Martin Luther, among others. The rationale for male domination has changed, and today the predominant reason has become women's innate subordination, the belief that women were created to assist from the beginning. Gender traditionalists note in their arguments that women are not inferior, they are just created to assist man—equal in essence and unequal in function. When the scriptures have been interpreted to denote an innate assistant role for women, a chain has been instituted that casts women slightly higher than the animals and lower than men. Women's spiritual fulfillment is left for the bye and bye. In essence, although not stated verbally, this assumes that God made man (Adam) as the ultimate creation, and then as an

afterthought He created the woman to make things easy for the man while he tackled the task of taking dominion.

Traditionalists still maintain a subordinate role for women even as biological and scientific data related to capabilities beyond the prescribed roles of women are changing. God grants gifts to each individual, but it is the socialization process within both society and religion that determines whether any person fulfills his/her God-given talents. Individual traits for the different talents are incorporated in the gene pools of both men and women. In addition, God has provided that both men and women in Christ operate in spiritual gifts and that the Spirit in all believers should not be quenched.

It is grossly inaccurate to equate the honest critiquing of traditional roles as they have been designated as a desire to dismantle male and female differences. Any critique of the traditional view of a woman's place is seen as blurring the roles of men and women. Allowing women to have and fulfill God-given destinies, even if they go beyond the home, is not a blurring of the unique biological and sexual differences of males and females. It is not about eradicating God-given differences; it is, however, about eradicating man-made, enculturated limitations. It is not about making men and women the same, but rather about ending man-made social constraints that presume a hierarchical dominant status for men. It is not even about taking women out of so called "women's roles;" it is about women having the right to fulfill their destinies, even those outside of the inherent roles of daughters, wives, and mothers. It is about bringing gender reconciliation. Isn't this worth reexamining social, cultural, and yes, even religious constraints to see if they indeed line up with the Word of God and the Word made flesh—Jesus Christ?

When women come to Christ, they are supposed to become new creations, just as men are. (See 2 Corinthians 5:17.) Unfortunately, that is not the case; old baggage from the world is brought into the church. Many women are hampered with a double whammy—the outside force of male domination that has held them back and their own lack of a sense of who they are in Christ. Women themselves must grasp the mind of Christ. They must see themselves as codominion-takers, not assistants. Women must appropriate what Christ has already provided for them by His death, atonement, and resurrection. To do anything less is a travesty and minimizes Christ's sacrificial death.

Having a preconceived mindset has led gender traditionalists to view creation as God's mandate for male authority and the Pauline and Peter scriptures as an endorsement of it. To see any form of male supremacy, rule, or authority in the Genesis account of Creation would require a previous bias because it is not there. The devaluation of women is subtle because today's gender traditionalists cloak their beliefs in euphemistic terms. Christ taught a different message, and He taught it by sacrificing His life, not requiring all the sacrifice from someone else. Husbands who give their lives sacrificially are the ones who exhibit the true examples of servanthood. Instead of giving their lives sacrificially, some traditionalists have presumed to usurp God's authority over women, thereby nullifying God's Word through their own male pride and traditions.

> For laying aside the commandment of God, ye hold the tradition of men, as the washing of pots and cups: and many other such like things ye do. And he said unto them, Full well ye reject the commandment of God, that ye may keep your own tradition....Making

the word of God of none effect through your tradi-
tion, which ye have delivered: and many such like
things do ye.

—Mark 7:8–9, 13

The preaching, teaching, and healing ministries of promi-
nent women in Christendom are considered blasphemous by
gender traditionalists. It brings to memory what the Phari-
sees said about Jesus' ministry. The Pharisees did not believe
that Jesus was the Messiah and so they attributed what He
did through the Holy Spirit—His casting out demons in the
man—as coming from Beezlebub. Jesus had just healed a man
who was blind, mute, and demon-possessed. The people were
astonished at the miracles done by Jesus, but the Pharisees,
refusing to see the visitation of the Lord, said, "This fellow
doth not cast out devils, but by Beelzebub the prince of the
devils" (Matt. 12:24).

Jesus, knowing what the Pharisees were thinking, said:

Every kingdom divided against itself is brought to deso-
lation; and every city or house divided against itself shall
not stand: And if Satan casts out Satan, he is divided
against himself; how shall then his kingdom stand?

—Matthew 12:25–26

Why would Satan, the ruler of all demons, cast demons
out of the man and make him whole? Why would women,
who believe they are called by God to teach His Word,
preach of His goodness, and heal the lame, the sick, and the
oppressed, be doing anything but serving an Almighty God
who has commissioned them? How can anyone say that they
are preaching, teaching, and performing signs and wonders
through Satan?

WHAT'S NEXT?

I look at myself, and I say, "If God can use a wretch like me, who am I to say that He doesn't call women."[1]

—J. Alfred Smith, pastor

I kept meeting committed women who were sure that God had called them...I would have to be pretty sure of my position before I use it to judge another person's call, because if I made her stumble, it was none other than God to whom I would have to answer.[2]

—Craig Keener, professor and author

I am passionate about the issue of women in ministry because it is a concern on the heart of God. This is high on His agenda. The Father wants to release His daughters.[3]

—J. Lee Grady, author and editor of
Charisma magazine

WOMEN ARE ON the heart of God. There is still darkness in the church on this issue. It is light that overcomes the darkness. Christians in all circles have yet to tap into all that God has called His people to be, because of the church's darkness. This alone is enough to keep every believer prostrate before the Almighty God. This alone should keep every believer from presuming that he/she has all the answers. Change can be for good. The church must be discerning as to which changes are good and which are bad. Both men and women should be able to tap into God's best practices without the limitations and constraints of man-made restrictive categories—categories that have been justified by a particular group's interpretation of God's Word. Women are no more born to be robots, programmed for certain tasks and told what they can and cannot do, than are men. When this is done, one-half of the image-bearers of God are prevented from their God-given right to take dominion with men—and not merely assist them—on Earth:

> There is the unspoken threat that if a woman steps outside her sphere (homemaking, nursing, teaching, typing), she may lose her femininity. Women have been trained to hide their talents and consequently some of them have denied the Lord's call to action.[4]

The Sacred Cow

Sexism is the "ism" that remains veiled or couched in euphemistic terms. It is now acceptable to condemn racism in both the church and the secular realm. When it exists, it is renounced. Sexism is denounced in the workplace; however, no one dares speak of it in most of Christendom. For the most part, sexism in many Christian denominations is

hidden behind the Christian doctrine of male authority and female subordination. Sexism is not derived from the Bible. Here is what T. D. Jakes has to say about it:

> We have seen God only through our masculine eyes, tainted by our own biases. But today God is pulling scales off our eyes. As a result, we will soon discover a wall that has long blocked our view of His splendor: the sin of sexism.... Perhaps it is because we have an incessant need to be superior to others. We deny that we view women as less than men in many areas. The spirit of bigotry that exists within religious circles is staggering. We are generally not guilty of overt discrimination. We are far too civilized to be openly ignorant. It is subtle disrespect. It doesn't scream at women, it just ignores them.[5]

Sexist doctrines within the church have become sacred cows that no one dares to touch! It is reminiscent of Martin Luther's plight when he confronted the established religion, Catholicism. His concern was making the Bible people-friendly, so that all could read the Word for themselves and seek their own salvation. The Catholic priests who acted as mediators between humans and God were an example of another misguided use of church doctrine to legitimize a man-made agenda.

There are tough questions that confront the church today. It is time that the church sought the whole truth that Jesus was seeking to reveal to His disciples in John 16:12, and in order for them to do this, they must lay themselves bare before the Almighty God. The world sometimes sees the fallacy in traditional church doctrine. It causes some of them to reject Jesus, who has nothing to do with these doctrines and traditions of man. (See Mark 7:9.)

The church must reach out to not only those who are lost, but also to those who have been wounded by the church, whether they have remained in the church or whether they have left the church. The indignities and injustices suffered by women in the name of tradition must be rectified. Christ is not coming back to a church with blemishes. Just because something has always been done a particular way does not mean that it is the right way. The determinant is whether or not it is God's way. "There is a way which seemeth right unto a man, but the end thereof are the ways of death" (Prov. 14:12).

Reconciliation means repairing the breech that was caused by the Fall, for Christ is not coming back to an unreconciled church. This reconciliation does not just apply to bridging the gap between races and/or ethnic groups; it also means bridging the chasm between men and women. It means repentance from those who have restricted women in pursuing their talents. It also means women forgiving and releasing those who have hurt them, lest they become bitter and hardened. (Release comes for women when they grant forgiveness—asked or not asked.) God is then able to move on their behalf, for it is God's desire that the giftedness of all humanity is realized. He desires that all of His children reach their fullest potential, and that means encouraging both men and women to fulfill their God-given destinies.

Gender traditionalists' interpretation of the Word as it relates to women must not continue to resemble other religions (and cults). Women must no longer be forced to fit mandates that were written for cultural conditions that were prevalent in the repressive societies of the early church. This sexism is an attack on the character of God, states Loren Cunningham:

> When bias against women is perpetuated by Christians,
> the message it sends is that God is unjust....What if
> God calls you to do something that others say you
> cannot do?...You must obey God, not people. This
> isn't being rebellious; it's simply doing what Peter and
> John did. They recognized that a higher authority was
> telling them to do something contrary to the orders of
> earthly authorities. Whom will you obey, God or man?
> What if world changers like Martin Luther, William
> Carey, and William Wilberforce had done only what
> was agreeable to their culture and (church) traditions
> or to the leaders of their day?[6]

Women can no longer wait for others' affirmation. They
must take a stand, even in situations where they have been
restricted. "Today, there are not enough women who burn
with a desire to sit at the feet of Jesus in the tradition of
Mary."[7] Mary was willing to learn from the Master, rather
that seek identity within the traditional feminine role of
preparing food for others as her sister Martha did. (See
Luke 10:38–42.) Susan Hyatt asks, "Where are the Susannas
[Wesley]? Where are the Aimees [Semple McPherson]?"[8]

Going even further, one might ask: where are the Phoebe
Palmers, a Methodist evangelist and one of the prime partic-
ipants in the Third Great Awakening, which gave rise to
several turn of the century denominations? Where are the
Sarah and Angelina Grimkes, who, although they were raised
in the restrictive eighteenth century society of the South,
became prime movers in both the abolitionist and suffrage
movements? Where are the Amanda Smiths and Sojourner
Truths, both of whom were born slaves, and yet they moved
beyond the bondages to preach the message of Christ to
large crowds? Where are the Catherine Booths, who, along

with her husband, founded the Salvation Army, preached, and wrote a booklet called *Female Ministry*? Booth also sought to reduce the exploitation of women and children and historically became one of the most influential women in religious history.[9] Where are the Madame Guyons, willing to influence both Catholics and Protestants in France, Germany, Holland, England, and Switzerland with her writings and who encouraged hospices throughout Europe?[10] Where are the Kathryn Kuhlmans, who performed undisputed healing miracles through her ministry? "Through Kathryn Kuhlman, God poured out miracles without measure, and He simultaneously shattered men's pride and destroyed their 'theologies.'"[11] Where are the Harriet Tubmans, and the Corrie ten Booms?

God did not limit women's leadership to the church. Throughout the centuries, women became leaders in the secular realm. Women such as Catherine the Great, Queen Elizabeth I, Indira Gandhi, Golda Meir, Margaret Thatcher, and Corazon Aquino ruled with courage and greatness. These women proved to be as good as and sometimes better leaders than their male counterparts.

Many women have been forced to remain in the background. By doing this, the world may be missing out on a Queen Elizabeth I, who was perhaps the greatest British monarch. The world may be missing out on a Golda Meir, an Indira Gandhi, or a Margaret Thatcher. The church may be missing out on a Catherine Booth, a Harriet Tubman, or a Kathryn Kuhlman. This does not mean that women will cease to be homemakers; they will just no longer be limited to homemaking. They will be allowed the option of realizing their other God-given talents, whatever they are.

Women also have a part to play in their restoration; they must return to their first love—Jesus Christ. Each person, man or woman, must make Jesus the first in his/her life. No one must come before God, not even husbands and children. (See Luke 16:13.)

In conclusion, it may be the right time to extend an olive branch to one woman traditionalist, Elisabeth Elliot. Elliot, in viewing women as the assistants to men, referred to them as the responders to the needs of men. Women are so much more than that! There is a profundity beyond what Elliot intended when she penned the following:

> We are women, and my plea is *Let me be a woman,* holy through and through, asking for nothing but what God wants to give me, receiving with both hands and with all my heart whatever that is.[12]

The question to Elliot is, Are you willing to allow other women who humbly view their callings differently from yours to be women "holy through and through," rather than to dictate to them what their purpose in Christ should be?

The heart-cry of women for centuries has been to be holy, wanting nothing but God's will. Their cries have pierced beyond the surface, reverberating from the deep recesses of their hearts and souls. Yes, many women have cried out for centuries "Let me be the woman God created me to be" since the Fall of mankind. They have cried out (as Elliot has) from their hidden closets of intercession that as women they desire nothing but to please their God. They have cried out that they desire nothing but God's will and that they are willing to obey their Master, who has equipped them "in secret." These women also believe (as Elliot does) that true freedom lies in humble obedience; however, the difference

between them and Elliot is that their humble obedience is to the call of God on their lives, *wherever it may lead*! Women have for centuries sought to open the portals of heaven with their tear-drenched prayers, "asking for nothing but what God wants to give...receiving with both hands and with all (their) hearts whatever that is."

These women have also cried out to be able to prophesy as the Lord said they would do in Joel 2:28. And for this they have neither asked for nor sought personal glory. They have asked those who have placed them in bondage with their man-made traditions and doctrines to cease imprisoning and stifling the very essence of their being and allow them to fulfill their God-given destinies. If God gives someone (male or female) a mission to carry out, he/she must obey God, even if man refuses to acknowledge this destiny. Every man and woman will stand before God to answer as to why they did or did not fulfill the course that was set before him/her here on Earth.

Appendix

DOES ORDER OF CREATION AND REDEMPTION DEMAND FEMALE SUPREMACY?

A Satire on Male Authority by Alvera
Mickelsen, Freelance Writer and Editor

I N READING THIS satire, please note that using scripture verses in isolation can be dangerous. It can establish humanistic doctrines that do not reflect the Bible in its entirety.

The following is a farcical/mocked account of the way Scripture has been used to justify male authority. It pokes fun at this doctrine by using other isolated scriptures in such a way that they would justify the superiority of women over men (similarly to the way it has been done with male authority). It speaks to the absurdity of using scriptures in isolation rather than in the context of the whole Bible to further an agenda of male authority, a tactic used by traditionalists who emphasize a hierarchical structure between men and women.

In light of the persistent emphasis on the assumed "order of creation" in Genesis 2, Mickelsen presents the following tongue-in-cheek look at the "order of creation, redemption, and the climax" in which the subordination of men to women is established.[1] This nonsensical satire has as much validity as the historical approach that sees the subordination of women in the order of creation. The validity of both approaches is equally nonexistent.

> In studying the early chapters of Genesis, before sin entered the world, we get a clear picture of God's intention that females should be dominant over males. Let us first examine the order of creation that appears in chapter 1. The Creation begins with chaos, darkness, and void. But God moves in an orderly way to change that chaos into a beautiful world in which human beings stand at the pinnacle. First, the light is separated from the darkness—day and night (first day). Then the waters are separated from the dry land (second day). Then the earth brings forth vegetation and plants (third day). God next creates the sun, moon, and stars (fourth day). On the fifth day He makes birds and sea creatures, and finally, on the sixth day, God creates animals and human beings. The movement clearly is from chaos to harmony and order.
>
> Chapter 2 refines this further as it tells how God created man and finally woman—the pinnacle of his creation. This chapter indicates that God made the male as He made the animals and birds—from the dust of the ground; then He placed the male in the Garden and told Adam (the male) to give each of them names. In the process it was clear to both Adam and to God that the male was inadequate by himself for the responsibilities he had. So God said He would make for

Adam a strength and power equal and corresponding to him.

Unfortunately, male translators have refused to recognize the clear force of the Hebrew word *ezer* used here and usually translated "helper." This word appears twenty-one times in the Old Testament and is nearly always used of God as He supports humans with His superior strength or power. In this same sense, the woman "helps" the man with her superior strength and power and wisdom.

Adam clearly understood this subordinate relationship, as is seen in Genesis 2:24 (RSV), where the male says, "Therefore a man leaves his father and his mother and cleaves to his wife, and they become one flesh." This surely indicates that the male should be under the supervision of his father and mother until marriage, when he leaves them and "cleaves" (meaning "is glued to") to his wife. If God had intended the woman to be subordinate to the man, surely the Bible would say, "For this reason a *woman* leaves her mother and father and cleaves to her husband." If God had meant equality, the Bible would say, "The man and woman will each leave mother and father and cleave to each other."

The apostle Paul verifies this interpretation of the Creation account in 1 Corinthians 11:7 (RSV), where he writes, "woman is the glory of man" (meaning *mankind*). This concept is further emphasized in 1 Corinthians 11:9 (RSV), where Paul writes, "Neither was man created for woman, but woman for man." He is obviously saying that woman was created because the man couldn't get along without her. Paul then goes on in the next verse to say, "For this reason the woman ought to have a sign of authority on her head" (the man) (1 Cor. 11:10, NIV). However, Paul seems to realize that what he says may tend to make the woman

feel that she can lord it over the man, so he reminds women, "Nevertheless, in the Lord woman is not independent of man nor man of woman, for as woman was made from man [and is thus the pinnacle or glory of creation], so man is now born of woman. And all things are from God" (1 Cor. 11:11–12, RSV).

Satan clearly understood God's hierarchy in the Garden of Eden, for he approached Eve rather than Adam, knowing that she was the one in charge. When she handed the forbidden fruit to Adam, he ate some of it immediately, recognizing her God-given dominance over him. When God called to Adam and asked what had happened, Adam replied, "The woman whom thou gavest to be with me, she gave me fruit of the tree, and I ate" (Gen. 3:12, RSV).

This interpretation is verified in 1 Timothy 2:13–15, where Paul reminds his readers in Ephesus that Eve was created after Adam, thus she was the pinnacle of God's creation. He also reminds them that Satan, recognizing the primacy of Eve, went to her with his temptation—not Adam. In spite of this fact, Paul says, the woman is still the agent of salvation for all humanity (she will be saved by the birth of the child), and in that position she is expected to live in faith, love, and holiness, with modesty.

Of course, God held Adam just as responsible for the sin as Eve, since they each had the capacity to obey or disobey God.

When the punishment for sin was handed out, both Adam and Eve got a full share, but God still recognized the higher status of the woman. He told Eve that although she had so grievously sinned, she would be the instrument through which salvation would come to the world. "He [the seed of woman] shall bruise your head [Satan's], and you [Satan] shall bruise his heel"

(Gen. 3:15, RSV). The childbearing necessary to bring salvation to the world (in the person of a divine Savior) would be given to the woman as the dominant one in the pair, but great toil would accompany it. Worst of all, a terrible "role reversal" would occur. The divine order of creation (female domination) would be reversed, and the male would rule over the female. Even the most casual observer can easily see the havoc that this role reversal has wrought.

God's own preference in roles with men and women did not change—only the sinful acts of humans got mixed up. For example, we see that naming was the primary responsibility of women. The Bible does not say who named Cain or Abel, but it clearly says that Eve named the third child, Seth. (See Genesis 4:25.) Rachel and Leah named all the sons of Jacob (for whom the twelve tribes of Israel were named). The only exception was Benjamin, because Rachel died in his childbirth, and Jacob changed his name.

Significantly, the same thing happened in the New Testament, where the angel Gabriel appears first to Mary and announces the coming Savior. Gabriel tells Mary that she is to name the baby, Jesus. (See Luke 1:30–31.)

God's choice of Mary as the human parent of Jesus is another evidence that God still saw the primacy of the woman in the human race. Actually, no male played any part in the conception of our Redeemer, but God chose a woman to bear the Savior through apparently normal processes of growth within the womb. Since the birth of the Savior was miraculous anyway, God could just as easily have made Christ from the rib of Joseph, just as He made Eve from the rib of Adam. But He did not.

Instead, God fulfilled His original promise to Eve in the Garden of Eden. *Her* "seed" would bruise the head of Satan. Women were the exclusive human instruments of salvation for all humanity.

Women will continue in this role in the days ahead, as is evident in the book of Revelation. In Revelation 12, a woman is clothed with the sun, and on her head is a crown of twelve stars. She is pregnant, and she and her offspring represent the people of God, whom the dragon (Satan) has tried to destroy from the early church to the present day. But God prepares a special place for her in the wilderness, where she is nourished during persecution. Again, God's revelation to John shows the woman in her proper, God-ordained place of leadership—the position from which she was removed when sin entered the world. This is reinforced by the fact that when Satan was thrown out of heaven, after the Ascension of Jesus, he immediately went forth to make war on *the woman and her posterity.*

It is no accident that the New Testament always refers to the church as female. The church embodies the very power of God and is His instrument for the salvation of His people. The church is subject only to Christ, for through a woman the Savior came to this world. Throughout the Bible, the woman is God's instrument through which salvation comes.

Often we hear men refer to the Jewish system of preference for the first male in a family as some kind of "proof" that God ordained Adam to be dominant over Eve. The silliness of this interpretation becomes apparent when we note that God Himself usually chose the younger to be His chosen leaders. Jacob (the second-born twin) became the ancestor of the Hebrew people, rather than Esau, the first-born. When God sent Samuel to anoint a king to take the place of Saul, He did not

permit Samuel to anoint the oldest son of Jesse, as the Jewish custom would have it, but insisted on taking the youngest in the family. God chose Moses rather than Aaron, the older son. Jesus reinforced this principle when He said that to be great in His kingdom, a person had to become as "the youngest" (Luke 22:26, RSV). This again would point to the primacy of Eve in God's plan.

We also see the God-ordained dominance of women in God's choice of the ancestry of His chosen people. Who was the determining ancestor of the Hebrews? Was it Abraham? Not at all. Abraham had eight children, born by three different women. God's chosen instrument of ancestry was *Sarah*. Isaac, Sarah's only child, was the one through whom the Hebrews came. Ishmael, the son of Abraham by Hagar, did not count in God's plan, nor did the six children of Abraham and Ketura. Obviously, *Sarah* was God's chosen vessel for the ancestry of the Hebrews. Abraham was only the agent by whom she became pregnant.

Sarah's God-ordained leadership in the ancestry of the Hebrew nation is reinforced in Genesis 21:12. In this passage, a conflict has risen between Abraham and Sarah over what to do with Ishmael. In keeping with Sarah's ordained dominant role, God tells Abraham that he is to obey Sarah in the matter, "Whatever Sarah says to you, do as she tells you, for through Isaac shall your descendants be named" (RSV). We should also note that *nowhere* in the Old Testament is any wife told to obey her husband.

Some of the most crucial attributes of God are also represented as female—wisdom, for example, in Proverbs 8. Scripture often compares the love of God to the love of a mother for her child.

Simple observation of male and female traits indicates how the "role reversal" that occurred when sin entered

the world has damaged all humanity. Psychological tests and biblical data show that males tend to be more aggressive than females, more eager to show how "strong" they are, less skilled in building deep relationships, less able to communicate love and feelings. Women usually have greater skills, are better listeners, find nurturing easier than men find it, mature more rapidly, have greater endurance, are more willing to negotiate rather than fight. These very skills are needed in the world today, both in leadership of nations and of the church.

The basic purpose of the church involves nurturing and communicating the Gospel—both of which tend to fit the "female psyche" better than the male's. The failure of nations and of the church can perhaps be laid finally to the "role reversal" that changed God's ordained order of creation, involving female leadership, to the sad state we have today.

Since the biblical teachings on this subject are crystal clear, obviously the leadership of women over men as a divine mandate can only be denied by refusing the authority of Scripture. There is no middle ground. Either we accept the clear teachings of female leadership and male subordination, or we deny the authority of the very scriptures that are the foundation of our faith.

Selective, propositional exegesis can build whatever case the propositional logician wants to establish. Unfortunately, big lies repeated often enough seem to become accepted, regardless of how little foundation they have. Let's stop assuming the ancient myth that "female subordination" is found in the "order of creation" and substantiated in Paul's interpretation of Genesis. Let's rather stay with sound principles of interpretation, all textual passages, and a fresh look at the new order Christ came to establish.

NOTES

Introduction

1. Alan Padgett, "What is Biblical Equality?" *Priscilla Papers*, Summer 2002, 22.
2. Christy LaFrance-Williamson, "True Freedom in Christ" (Minneapolis, MN: Christians for Biblical Equality, 2005). This excerpt from LaFrance-Williamson's letter was retrieved from the CBE website, (www.cbeinternational.org). Christy had written to them, discussing the anger and heartbreak because of the limitations place on her by her Baptist church.
3. Ibid., 1–2.
4. Alvin John Schmidt, *Veiled and Silenced: How Culture Shaped Sexist Theology* (Macon, GA: Mercer University Press, 1989), 132.
5. Web site: www.anabaptists.org, accessed September 6, 2005, Harold S. Martin, "The Christian Woman's Veiling," 1–2.
6. John Piper and Wayne Grudem, *Recovering Biblical Manhood and Womanhood,* (Wheaton, IL: Crossway Books, 1991), 47.
7. Ibid., 51.
8. J. Lee Grady, *Ten Lies the Church Tells Women* (Lake Mary, FL: Creation House, 2000), 24–25.
9. Scott E. McClelland, *The New Reality in Christ: Perspectives from Biblical Studies* (Grand Rapids, MI: Academie Books, 1990).
10. Rick Joyner, *The Harvest* (Charlotte, NC: Morning Star Publication, 1989), 4.

Chapter 1
What They Didn't Say About Creation

1. Patricia Gundry, *Woman Be Free* (Grand Rapids, MI: Zondervan Publishing House, 1977), 12–13.
2. Funmi Josephine Para-Mallam, "Why? Oh Why Am I a Woman?" *Priscilla Papers*, Fall, 2001.

3. Faith Martin, "A Response to Recovering Biblical Manhood and Womanhood by John Piper and Wayne Grudem" From the *Conference for Women* (Beaver Falls, PA: College Hill Reformed Presbyterian Church, 1993), 15.

4. Joy Elasky Fleming, *Man and Woman in Biblical Unity: Theology from Genesis* (Minneapolis, MN: Christians for Biblical Equality, 1993), 5.

5. Susan Hyatt, *Some Basics Thoughts on Biblical Womanhood* (Dallas, TX: Susan Hyatt, 2002).

6. Martin, "A Response to Recovering Biblical Manhood and Womanhood," 15.

7. Aida Besancon Spencer, *Beyond the Curse* (New York: Thomas Nelson Publishers, 1985), 23.

8. Raymond C. Ortlund, Jr., "Male-Female Equality and Male Headship: Genesis 1–3" in Piper and Grudem (eds.), *Recovering Biblical Manhood and Womanhood: A Response to Evangelical Feminism* (Wheaton, IL: Crossway Books), 103.

9. Fleming, *Man and Woman in Biblical Unity: Theology from Genesis*, 12–16.

10. Rebecca Merrill Groothuis, *Good News for Women* (Grand Rapids, MI: Baker Books, 1997), 124.

11. Ortlund, "Male-Female Equality and Male Headship: Genesis 1–3," 100.

12. Fleming, *Man and Woman in Biblical Unity: Theology from Genesis*, 6.

13. Loren Cunningham and David Joel Hamilton, *Why Not Women?* (Seattle, WA: YWAM Publishing, 2000), 95.

14. L. Scanzoni and N. Hardesty, *All We're Meant to Be: A Biblical Approach to Women's Liberation,* (Waco, TX: Word, 1974), 28, in Massey, *Women in the Church*, 66.

15. Groothuis, *Good News for Women*, 219–221.

16. Ibid., 124.

17. Ortlund, "Male-Female Equality and Male Headship: Genesis 1–3," 100.

18. Ibid., 100–101.

19. Mary J. Evans, *The Place of Women in the New Testament* (Master of Philosophy Thesis, London Bible College, December, 1977, 8–9) quoted in Fleming, *Man and Woman in Biblical Unity: Theology from Genesis*, 12.

20. Ortlund, "Male-Female Equality and Male Headship: Genesis 1–3," 101.

21. Phyllis Bird, *Images of Women in the Old Testament* (New York: Simon and Schuster, 1974) 73–74, in Ruether, *Religion and Sexism*.

22. Evans, *The Place of Women in the New Testament,* quoted in Fleming, *Man and Woman in Biblical Unity: Theology from Genesis*, 12.

23. Christiane Carlson-Theis, "Man and Woman at Creation: A Critique of Complementarian Interpretations," *Priscilla Papers*, Fall, 2004, 5.

Chapter 2
What They Didn't Say About the Fall

1. Bilezikian, *Beyond Sex Roles* (Grand Rapids, MI: Baker Book House, 1985), 58.

2. Stephen Clark, *Man and Woman in Christ* (Ann Arbor, MI: Servant Books, 1980), 26.

3. Scott McClelland, "The New Reality in Christ: Perspective from Biblical Studies," in June Steffensen Hagen (ed.), *Gender Matters* (Grand Rapids, MI: Academie Books, 1990), 57.

4. Ibid.

5. Ibid.

6. Fleming, *Man and Woman in Biblical Unity: Theology from Genesis*, 20.

7. Hamilton in Cunning and Hamilton, *Why Not Women?* 98.

8. Fleming, *Man and Woman in Biblical Unity: Theology from Genesis*, 22.

9. Clark, *Man and Women*, 30. In a footnote, Clark interprets 1 Timothy as stating that woman stepped our from under the man's authority; thus, usurping his rule.

10. Ibid.

11. Bilezikian, *Beyond Sex Roles*, 42.

12. Ibid.
13. Clark, *Man and Woman in Christ*, 30.
14. Bilezikian, *Beyond Sex Roles*, 42.
15. Clark, *Man and Woman in Christ*, 29.
16. Ibid., 31.
17. Belezikian, *Beyond Sex Roles*, 50.
18. Ibid., 42.
19. Fleming, *Man and Woman in Biblical Unity: Theology from Genesis*, 38.
20. Alvin John Schmidt, *Veiled and Silenced: How Culture Shaped Sexist Theology* (Macon, GA: Mercer University Press, 1989) 87–88.
21. Walter C. Kaiser, Jr., *Hard Sayings of the Old Testament* (Downers Grove, IL: InterVarsity Press, 1988), 35.
22. Ibid.
23. Ibid., 34.
24. Ibid.
25. Fleming, *Man and Woman in Biblical Unity: Theology from Genesis*, 32–33.
26. Belizikian, *Beyond Sex Roles*, 57.
27. Fleming, *Man and Woman in Biblical Unity: Theology from Genesis*, 40–41.
28. Ibid., 40.
29. Ibid.
30. Bilezikian, *Beyond Sex Roles*, 54.
31. Clark, *Man and Woman in Christ*, 25.
32. Appendix A contains a satire written by Alvera Mickelsen. Mickelsen pokes fun at those who promote male superiority by using isolated scriptures to justify their stance. She takes isolated scriptures out of context to promote female superiority. She does this to show the absurdity of placing one sex above another. Clark's discourse on male superiority and men as the "embodiment of the race" provided the impetus for this satire.
33. Fleming, *Man and Woman in Biblical Unity: Theology from Genesis*, 35.
34. Mary Steward Van Leeuwen, *Gender and Grace* (Downers Grove, IL: InterVarsity Press, 1990), 47.

35. Fleming, *Man and Woman in Biblical Unity: Theology from Genesis*, 40.

36. Ibid.

37. Ibid., 40-41.

38. Clark, *Man and Woman in Christ*, 28.

39. Ibid.

40. Susan Hyatt, *Why Bother to Get It Right About the Woman Issue* (Dallas, TX: Hyatt, International Ministries, Inc., 2000), 31.

41. Ibid.

42. Ibid.

43. Craig Keener, *Paul, Women and Wives* (Peabody, MA: Hendrickson Publishers, 1992), 119.

Chapter 3
The Deadliest Enemy of All

1. Cunningham in Cunningham and Hamilton, *Why Not Women?* (Seattle, WA: YWAM Publishing, 2000), 22.

2. Ibid., 15.

3. Ibid., 15.

4. Ibid., 16.

5. Bureau of Justice Statistics, (Rpts. 98–100), 1996, www.ojp.usdoj.gov/bjs (accessed June 1, 2007), quoted in Cunningham and Hamilton, *Why Not Women?* 17–18.

6. Sheryl Watkins, "Women: Five Barriers Facing Women in the Developing World," *Today* (Federal Way, WA: World Vision, April–May 1997), 4–7, quoted in Cunningham and Hamilton, *Why Not Women?* 18.

7. Cunningham in Cunningham and Hamilton, *Why Not Women?* 16.

8. Elizabeth Farrell, "Women in the Danger Zone," *Charisma*, June 1999, 57–64.

9. Watkins quoted in Cunningham and Hamilton, *Why Not Women?* 19.

10. Farrell, "Women in the Danger Zone," 57–64.

11. Watkins quoted in Cunningham and Hamilton, *Why Not Women?* 19.

12. Cunningham in Cunningham and Hamilton, *Why Not Women?* 22–23.

13. Catherine Booth, *Aggressive Christianity* (Wheaton, IL: World Wide Publications, 1993), 1–32.

Chapter 4
Captive Souls

1. Hamilton in Cunningham and Hamilton, *Why Not Women?* 233.

2. Kristina Dumbeck, *Leaders of Women's Suffrage* (San Diego, CA: Lucent Books, 2001), 8.

3. James Alsdurf and Phyllis Alsdurf, *Battered into Submission* (Downers Grove, IL: InterVarsity Press, 1989), 32–35.

4. Constance F. Parvey, "The Theology and Leadership of Women in the New Testament," in Rosemary Radford Ruether (ed.), *Religion and Sexism: Images of Women in the Jewish and Christian Traditions* (New York: Simon Schuster, 1974), 117–149.

5. Hamilton in Cunningham and Hamilton, *Why Not Women?* 80.

6. Spencer, *Beyond the Curse*, 64.

7. Hamilton in Cunningham and Hamilton, *Why Not Women?* 80.

8. Ibid., 107.

9. Ibid., 108.

10. Ibid., 107.

11. Ibid., 102–103.

12. Ibid., 103.

13. Roger M. Evans, "Encounter with Women's Spirituality" in June Steffensen Hagen (ed.), *Gender Matters* (Grand Rapids, MI: Academie Books, 1990), 274.

14. Ibid., 274.

15. Sandra Lipsitz Bem, *The Lenses of Gender: Transforming the Debate on Sexual Inequality* (New Haven, CT: Yale University Press, 1993), 42.

16. Ibid., 42.

17. Gary Hubbard and Joseph Hubbard, Ph.D., "Psychological Resistance to Egalitarianism" in Journal of Biblical Equality," 1990, 26–52, from Hyatt, *In the Spirit We're Equal*, 292–294.

18. Ibid.

19. S.R. and Linda McDill, *Dangerous Marriage*, (Grand Rapids, MI: Baker Books, 1999), 32–34.

20. Gavin de Becker, *Protecting the Gift* (New York: The Dial Press, Random House, 1999), 15, quoted in Cunningham and Hamilton, *Why Not Women?* 17.

21. McDill and McDill, *Dangerous Marriage*, 18.

22. Bureau of Statistics, quoted in Cunningham and Hamilton, *Why Not Women?* 18.

23. McDill and McDill, *Dangerous Marriage*, 19.

24. Alsdurf and Alsdurf, *Battered into Submission*, 125.

25. Ibid., 126.

26. Ibid., 126.

27. Faith Martin, "A Response to Recovering Biblical Manhood and Womanhood," by John John and Wayne Grudem, presented at the Conference for Women, College Hill Reformed Presbyterian Church, Beaver Falls, PA, February 27, 1993, 5.

28. Alsdurf and Alsdurf, *Battered into Submission*, 115.

29. Ibid., 115–119.

30. Ibid., 150.

31. Ibid., 151.

32. Ibid., 151.

33. Ibid., 74.

34. Ibid., 73.

35. Ibid., 76–77.

36. Ibid., 128.

37. Ibid., 123–131.

38. McDill and McDill, *Dangerous Marriage*, 19.

39. Alsdurf and Alsdurf, *Battered into Submission*, 21.

40. Ibid., 23.

41. Ibid., 140.

42. Ibid., 135.

43. Myles Munroe, *Understanding the Purpose and Power of Woman: A Book for Women and Men Who Love Them* (New Kensington, PA: Whitaker House, 2001), 16.

44. Ibid., 16–17.

45. J. Lee Grady, *Ten Lies the Church Tells Women*, 21.

46. Lesly F. Massey, *Women in the Church* (Jefferson, NC: McFarland & Company, Inc., 2002), 38.

47. Michelle Rosaldo and Louise Lamphere (eds.), *Woman, Culture, and Society* (Stanford, CA: Stanford University Press, 2001), 28–29.

48. Ibid., 22–23.

49. Ibid.

50. Sherry B. Otter, "Is Female to Male as Nature Is to Culture?" (Stanford, CA: Stanford University Press, 2001) in Rosaldo and Lamphere (eds.), *Women, Culture, and Society*, 67–87.

51. Ibid., 74-76.

52. Ibid., 76.

53. Rosaldo and Lamphere, *Women, Culture, and Society*, 35–41.

54. Ibid., 41–42.

55. Karen McCarthy Brown, "Fundamentalism and the Control of Women" (New York: Oxford University Press, 1994) in Hawley, *Fundamentalism and Gender*, 188–189.

56. Fleming, *Man and Woman in Biblical Unity: Theology from Genesis*, 43.

57. Bonnie Thurston, *Women in the New Testament* (New York: Crossroads Publishing Company, 1998), 15.

58. Erub. 18a-b is a quote from the early Jewish rabbinic tradition, noted in the Mishnah, quoted in Spencer, *Beyond the Curse*, 52. In ancient Jewish culture, a woman and the home were synonymous. Women were built for homemaking according to Rabbi Hisda.

59. Alvin Schmidt, *Veiled and Silenced: How Culture Shaped Sexist Theology*, 78.

60. Ibid., 78.

61. Thurston, *Women in the New Testament*, 15.

62. Spencer, *Beyond the Curse*, 64.

63. M. Rafiqul-Haqq and P. Newton, "The Place of Women in Pure Islam," *The Berean Call* http://debate.domini.org/newton/ wp,emg.html (accessed June 1, 2007).

64. Diana R. Garland, *Family Matters* (Downers Grove, IL: InterVarsity Press, 1999), 200–201, quoted in Preato, "A Fresh Perspective on Submission and Authority in Marriage," *Priscilla Papers* (19), 2005, 23. Garland in her book cites various studies that maintain that egalitarian couples are more satisfied than traditional couples with their marriages. She revealed other negatives in traditional marriages, such as higher depression in wives, as well as higher rates of wife abuse.

65. Dennis J. Preato, "A Fresh Perspective on Submission and Authority in Marriage," *Priscilla Papers* (19) 1, 29.

66. Barna Research Group, quoted in Preato, "A Fresh Perspective on Submission and Authority in Marriage," *Priscilla Papers* (19) 1, 20. Preato uses a 2001 Barna study to show the divorce rate among various Christian groups.

67. Preato, "A Fresh Perspective on Submission and Authority in Marriage," 22.

68. Alver Mickelsen, "An Egalitarian Response," in Bonnidell Clouse and Robert G. Clouse (eds.), *Women in Ministry* (Downers Grove, IL: InterVarsity Press, 1989), 120.

Chapter 5
Letting God Be God

1. Ortlund, "Male Female Equality and Male Headship: Genesis 1–3" in Piper and Grudem (eds.), *Recovering Biblical Manhood and Womanhood: A Response to Evangelical Feminism*, 103.

2. Stanley Grenz, "Nurturing Godly Relationships Between Men and Women," presented at Carey Regent College, Vancouver BC Northern Seminary, Lombard, IL, 6.

3. Ibid., 8.

4. Scott McClelland, "The New Reality in Christ: Perspective from Biblical Studies," in June Steffensen Hagen (ed.), *Gender Matters: Women Studies for the Christian Community* (Grand Rapids, MI: Academie Books, 1990), 56.

5. Rebecca Merrill, *Good News for Women* (Grand Rapids, MI: Baker Books, 1997), 104.

6. Hamilton in Cunningham and Hamilton, *Why Not Women?* 117–118.
7. Ibid., 117.

Chapter 6
The Lure of Entanglement

1. Sandra M. Schneiders, "The Effects of Women's Experience on their Spirituality: Resources for Christian Development," Joann W. in Conn (ed.), *Women's Spirituality: Resources for Christian Development* (New York: Paulist Press, 1986), 36.
2. Myles Munroe, *Understanding the Purpose and Power of Woman: A Book for Women Who Love Them*, 12–14.
3. Schmidt, *Veiled and Silenced: How Culture Shaped Sexist Theology*, 88.
4. Ibid., 88.
5. J. Fowler Willing, "Women and the Pentecost," *Guide to Holiness* (September, 1898), 87, quoted in Hyatt, *Why Bother to Get It Right About the Woman Issue?* 22–23.
6. Hyatt, *Why Bother to Get It Right About the Woman Issue?* 23.
7. S. Scott Bartchy, "Issues of Power and a Theology of the Family," *Mission* (July–August, 1987) 3–15, quoted in Massey, *Women in the Church*, 52.
8. Mary Stewart Van Leeuwen, *Gender and Grace* (Downers Grove, IL: InterVarsity Press,1990), 46.
9. Schneiders, "The Effects of Women's Experience on their Spirituality: Resources for Christian Development," in Conn (ed.), *Women's Spirituality: Resources for Christian Development*, 36.
10. Van Leeuwen, *Gender and Grace*, 46.
11. Ibid., 120.
12. Carol Gilligan, *In a Different Voice: Psychological Theory and Women's Development* (Cambridge, MA: Harvard University Press, 1982), 67.
13. Van Leeuwen, *Gender and Grace*, 47.
14. P. B. Wilson, *Liberated Through Submission* (Eugene, Oregon: Harvest House Publishers, 1990), 57–58.
15. Ibid., 58.

16. Ibid., 59.

17. Bilezikian, *Beyond Sex Roles*, 42.

18. Hamilton in Cunningham and Hamilton, *Why Not Women?* 108.

19. Harriet Goldhor Lerner, *The Feminist Thought of Sarah Grimke* (New York: Oxford University Press, 1998), 85.

20. Michelle Zimbalist Rosaldo & Louise Lamphere (eds.), *Women, Culture, and Society*, 8–10.

21. Ibid., 34.

22. Ibid., 10.

23. Grady, *Ten Lies the Church Tells Women*, 100.

24. Ibid., 142.

25. Ibid., 142.

26. Blum, *Sex on the Brain*, (New York: Viking, 1997), 191–192.

27. Ibid., 189–194.

28. Ibid., 190.

29. Ibid., 162.

30. Ibid., 166.

31. Ibid., 200, 162, 164.

32. Van Leeuwen, *Gender and Grace*, 65.

33. Ibid., 66.

34. Ibid., 67.

35. Blum, *Sex on the Brain*, 190.

36. Leslie C. Johnson, "Women: Too Fragile for the Frontline," *E-quality*, Winter 2006 http://org/new/E-Journal/2006/06winter/06winterjohnson.html (accessed June 1, 2007).

37. Ibid.

38. Ibid.

39. Ibid.

40. Grady, *Ten Lies the Church Tells Women*, IX.

41. Alsdurf and Alsdurf, *Battered into Submission*, 139.

42. Piper and Grudem, *Recovering Biblical Manhood and Womanhood*, 46.

43. "Girl Recalls Dad's Lesson: Fight," *St. Petersburg Times* http://www.freerepublic.com/focus/f-news/1099771posts (accessed March 17, 2004).

Chapter 7
Jesus, the Liberator

1. Dorothy L. Sayers, *Are Women Human?* (Grand Rapids, MI: William B. Eerdmans Publishing Company, 1971), 47.

2. Ross Shepard Kraemer, "Jewish Women and Women's Judaism at the Beginning of Christianity," in Kraemer and D'Angelo (eds.), *Women and Christian Origins* (New York: Oxford University Press, 1999), 51–61.

3. Judith P. Hallett, "Women's Lives in the Ancient Mediterranean," in Kraemer and D'Angelo (eds.), *Women and Christian Origins* (New York: Oxford University Press, 1999), 30.

4. Sayers, *Are Women Human?* 46–47.

5. Bishop S. Terri Smith Little is Pastor of Love Ministries Family Church.

6. Catherine Kroeger and Richard Kroeger, "Why Were There No Women Apostles?" *Equity*, nd., 11–12.

7. Ibid., 10.

8. Ibid., 10.

9. Hamilton in Cunningham and Hamilton, *Why Not Women?* 54.

10. Kroeger and Kroeger, "Why Were There No Women Apostles?" *Equity*, 10.

11. Walter L. Liefeld and Ruth A. Tucker, *Daughters of the Church: Women and Ministry from the New Testament Times to the Present* (Grand Rapids, MI: Academie Books, 1987), 46.

Chapter 8
Paul and Peter—Clandestine Operatives?

1. Lesly F. Massey, *Women and the New Testament* (Jefferson, NC: McFarland and Company, Inc., 1989), 129.

2. Lesly F. Massey, *Women in the Church*, 35–38.

3. Rosemary Radford Ruether, (ed.), *Religion and Sexism: Images of Women in the Jewish and Christian Traditions* (New York: Simon and Schuster, 1974), 122–123.

4. Constance F. Parvey, "The Theology and Leadership of Women in the New Testament," in Ruether (ed.), *Religion and Sexism: Images of Women in the Jewish and Christian Traditions*, 122.

5. Ben Witherington, *Women in the Earliest Churches* (New York: Cambridge University Press, 1988), 3–4.

6. Thurston, *Women in the New Testament*, 31.

7. Ibid., 32.

8. J. L. Sheler, "Reassessing an Apostle," *U.S. News and World Report*, April 5, 1999, 52.

9. Keener, *Paul, Women and Wives*, 5.

10. Ibid.

11. Source obtained from the Internet: Alvera Mickelsen, "Did Paul Practice What We're Told He Preached?" July 22, 2003. cbeinternational.org.

12. Elsie Thomas Culver, *Women in the World of Religion* (Garden City, NY: Doubleday and Company, Inc., 1967), 5.

13. Keener, *Paul, Women and Wives*, 37, 133–134.

14. Groothuis, *Good News for Women*, 19–39.

15. Scott McClelland, "The New Reality in Christ: Perspective from Biblical Studies," in Hagen (ed.), *Gender Matters*, 65.

16. Groothuis, *Good News for Women*, 34.

17. Spencer, *Beyond the Curse*, 64.

18. Gretchen Gaebelien Hull, *Equal to Serve*, (Grand Rapids, MI: Baker Books, 1991), 75.

19. Ibid., 126–127.

20. Keener, *Paul, Women and Wives*, 146–147.

21. Grady, *Ten Lies the Church Tells Women*, 73.

22. Keener, *Paul, Women and Wives*, 146.

23. Ibid., 169.

24. Preato, "A Fresh Perspective on Submission and Authority in Marriage," 21.

25. Keener, *Paul, Women, and Wives*, 148.

26. Preato, "A Fresh Perspective on Submission and Authority in Marriage," 21.

27. Ibid., 21.

28. Keener, *Paul, Women, and Wives*, 169.

29. Cunningham and Hamilton, *Why Not Women?* 170.
30. Susan C. Hyatt, *In the Spirit We're Equal* (Dallas, TX: Hyatt International Ministries, Inc., 1998), 247.
31. Hull, *Equal to Serve*, 196–198.
32. Groothuis, *Good News for Women*, 154.
33. Ibid.,152.
34. Hull, *Equal to Serve*, 198.
35. Keener, *Paul, Women, and Wives*, 52.
36. Mickelsen, "Did Paul Practice What We're Told He Preached?"
37. Ibid.
38. Susan C. Hyatt, "Some Basic Thoughts on Biblical Womanhood" (Dallas, TX: Susan Hyatt, September 2, 2002). This excerpt is taken from Hyatt's paper.
39. Hamilton in Cunningham and Hamilton, *Why Not Women?* 166.
40. Ibid., 166–168.
41. Ibid., 168.
42. Ibid., 170.
43. Kaiser, *Hard Sayings of the Old Testament*, 36.
44. Mickelsen, "Did Paul Practice What We're Told He Preached?"
45. Ibid.
46. Keener, *Paul, Women and Wives*, 107–108.
47. Grady, *Ten Lies the Church Tells Women*, 57.
48. Groothuis, *Good News for Women*, 219.
49. John Temple Bristow, *What Paul Really Said About Women* (San Francisco: Harper Collins Publishers, 1991), 114.
50. Groothuis, *Good News for Women*, 227.
51. Leland Edward Wilshire, "The TLG computer and Further Reference to *authentein* in Timothy 2:12," *New Testament Studies*, 34, 1988, 120–134 in Hyatt, *In the Spirit We're Equal*, 261–263.
52. Groothuis, *Good News for Women*, 227.
53. Hull, *Equal to Serve*, 74–75.
54. Bartchy, "Issues of Power and a Theology of the Family," 3–15 in Alsdurf and Alsdurf, *Battered into Submission*, 90.

55. In Appendix A, Alvera Mickelsen satirizes the use of the Bible to assert male superiority.

Chapter 9
Quashing the Revolution After the First Century

1. Massey, *Women in the Church*, 4.
2. Kraemer, "Jewish Women and Women's Judaism at the Beginning of Christianity," in Kraemer and D'Angelo, *Women and Christian Origins*, 54–66.
3. Hyatt, *In the Spirit We're Equal*, 21–23.
4. Kraemer in Kraemer and D'Angelo, 42.
5. Hyatt, *In the Spirit We're Equal*, 22, 29.
6. Keener, *Paul, Women, and Wives*, 240–241.
7. Thurston, *Women in the New Testament*, 57–58.
8. Ibid., 57–58.
9. Kraemer, "Jewish Women and Women's Judaism(s) at the Beginning of Christianity," in Kraemer and D'Angelo, *Women and Christian Origins*, 53.
10. Thurston, *Women in the New Testament*, 154–155.

Chapter 10
Idolatry in the Church

1. Grady, *Ten Lies the Church Tells Women*, 21.
2. Parvey, "The Theology and Leadership of Women in the New Testament" in Ruether (ed,), *Religion and Sexism: Images of Women in the Jewish and Christian Traditions*, 146.
3. Ibid., 146–147.
4. Wendy Fletcher-Marsh, "Toward a Single Anthropology: Developments in Modern Protestantism," in Martos and Hegy, *Equal at the Creation: Sexism, Society, and Christian Thought* (Toronto: University of Toronto Press, 1998), 131.
5. Ibid., 131.
6. Ibid., 130–132.
7. Ruether, *Religion and Sexism: Images of Women in the Jewish and Christian Traditions*, 157.
8. Ibid., 160.

9. Ibid., 150–179.

10. Bristow, *What Paul Really Said About Women*, 3–9.

11. Hyatt, *In the Spirit We're Equal*, 50.

12. Bristow, *What Paul Really Said About Women*, 5–6.

13. Hyatt, *In the Spirit We're Equal*, 52.

14. Ibid., 54.

15. Hyatt, *Why Bother to Get It Right About the Woman Issue?* 14.

16. Joyce E. Salisbury, *Church Fathers, Independent Virgins*, (London: Verso, 1991), 12.

17. Ibid., 13.

18. Ibid., 22.

19. Ibid., 23.

20. Ibid., 22.

21. Ibid., 49.

22. Ibid., 50.

23. Witherington, *Women in the Earliest Churches*, 205.

24. Ruether, *Religion and Sexism: Images of Women in the Jewish and Christian Traditions*, 166.

25. Ibid., 170.

26. Hyatt, *In the Spirit We're Equal*, 49–50.

27. Bristow, *What Paul Really Said About Women*, 110–119.

Chapter 11
A Form of Godliness Without the Power

1. Helen Ellerbe, *The Dark Side of Christian History* (San Rafael, CA: Morningstar Books, 1995), 29.

2. Ibid., 14.

3. Ibid., 14–29.

4. Hyatt, *In the Spirit We're Equal*, 39–40.

5. Williston Walker, *The Great Men of the Christian Church* (Freeport, NY: Books for Libraries Press, 1968), 24–45.

6. Ibid., 44–45.

7. Ellerbe, *The Dark Side of Christian History*, 15–17.

8. Hyatt, *In the Spirit We're Equal*, 42.

9. Ellerbe, *The Dark Side of Christian History*, 17.

10. Ibid., 17.
11. Ibid., 14–29.

Chapter 12
The Darkest Time of All

1. Hyatt, *In the Spirit We're Equal*, 58.
2. Bristow, *What Paul Really Said About Women*, 29.
3. Hyatt, *In the Spirit We're Equal*, 56.
4. Eleanor Commo McLaughlin, "Equality of Souls, Inequality of Sexes: Woman in Medieval Theology," in Ruether (ed.), *Religion and Sexism* (New York: Simon and Schuster, 1974), 226.
5. Susan C. Hyatt, *Why Bother to Get It Right About the Woman Issue?* 24.
6. McLaughlin, "Equality of Souls, Inequality of Sexes: Woman in Medieval Theology" in Ruether (ed.), *Religion and Sexism*, 213–266.
7. Ibid.
8. Ibid., 229.
9. Ibid.
10. Ibid.

Chapter 13
Reformation for Some; Status Quo for Others

1. Alsdurf and Alsdurf, *Battered into Submission*, 148.
2. Stephen P. Thompson, *The Reformation*, (San Diego, CA: Greenhaven Press, 1999), 12–16.
3. Ibid., 166–176.
4. Karant-Nunn and Weisner-Hanks, *Luther on Women: A Sourcebook*, 1–14.
5. Merry E. Weisner-Hanks, "Protestant Attitudes About Women," in Thompson (ed.), *The Reformation* (San Diego, CA: Greenhaven Press, Inc., 1999), 169.
6. Susan Karant-Nunn and Merry E. Weisner-Hanks, *Luther on Women: A Sourcebook* (Cambridge: Cambridge University Press, 2003) 1–14.
7. Hyatt, *In the Spirit We're Equal*, 66.

8. Ibid., 65.
9. Thompson, *The Reformation*, 12–25.
10. Hyatt, *In the Spirit We're Equal*, 65.
11. Ibid., 66.
12. Karant-Nunn and Wiesner-Hanks, *Luther on Women: A Sourcebook*, 62.
13. Ibid.
14. Ibid.
15. Ibid., 88–136.
16. Ibid., 93, 95.
17. Ibid., 188.
18. Ibid., 188–189.
19. Ibid., 15–31.
20. Wiesner-Hanks, "Protestant Attitudes About Women," in Thompson (ed.), *The Reformation*, 168.
21. Hyatt, *In the Spirit We're Equal*, 68.
22. Ibid., 67.
23. Wiesner-Hanks, "Protestant Attitudes About Women," in Thompson (ed.), *The Reformation*, 168.
24. Ibid., 167–176.

Chapter 14
What About Mary?

1. Hull, *Equal to Serve*, 132.
2. Ibid., 142.
3. Witherington, *Women in the Earliest Churches*, 207.
4. Ruether (ed.), *Religion and Sexism: Images of Women in the Jewish and Christian Traditions*, 224.
5. Ellerbe, *The Dark Side of Christian History*, 24–27.
6. Karant-Nunn and Wiesner-Hanks (eds.), *Luther on Women: A Sourcebook*, 32–57.
7. Ibid.
8. Ibid., 56.
9. Ibid.
10. Ibid.

Chapter 15
The Church in Flux

1. Alsdurf and Alsdurf, *Battered into Submission*, 137.

2. Fletcher-Marsh, "Toward a Single Anthropology: Developments in Modern Protestantism," in Margos and Hegy (eds.), *Equal at the Creation: Sexism, Society, and Christian Thought*, 129.

3. Ibid., 136.

4. Susan Hyatt, *Spirit Led Women* (Dallas, TX: International Christian Women's History Project, nd.).

5. Fletcher-Marsh, "Toward a single Anthropology: Developments in Modern Protestanism" in Margos and Hegy (eds.), *Equal at the Creation: Sexism, Society, and Christian Thought*, 136.

6. Ibid.

7. Grady, *Ten Lies the Church Tells Women*, 22.

8. Martos and Hegy (eds.), *Equal at Creation: Sexism, Society, and Christian Thought*, 15.

9. Schmidt, *Veiled and Silenced: How Culture Shaped Sexist Theology*, 29.

10. Ibid. Schmidt notes a comment once made by Benjamin Rush, who noted that some people could justify any idea, even absurd ones, with some isolated biblical passages using the example of slavery.

11. Rebecca Merrill Groothuis, *Women Caught in the Conflict* (New York: Wipf and Stock Publishers, 1994), 37.

12. Schmidt, *Veiled and Silenced: How Culture Shaped Sexist Theology*, 30.

13. Ibid., 30–31.

14. Ibid., 32.

15. Groothuis, *Women Caught in the Conflict*, 35.

16. Ibid., 31–33.

17. Ibid., 36.

18. Robert Clouse, "Introduction," in Clouse & Clouse (eds.), *Women in Ministry* (Downers Grove, IL: InterVarsity Press, 1989), 14–15.

19. Hyatt, *Spirit Led Women*, 3.

20. Robert Clouse, "Introduction," in Clouse & Clouse (eds.), *Women in Ministry*, 15–16.

21. Ibid., 14–17.

Chapter 16
Defenders of the Status Quo

1. Hyatt, *In Spirit We're Equal*, 301.

2. Groothuis, *Good News for Women*, 58.

3. Faith Martin, *Call Me Blessed*, (Grand Rapids, MI: Eerdmans, 1978), 51–55, as quoted in Johnson, "Gender, Society, and Church" in Hagen (ed.), *Gender Matters: Women Studies for the Christian Community*, 241–242.

4. Winston A. Johnson, "Gender, Society, and Church" in Hagen (ed.), *Gender Matters: Women Studies for the Christian Community*, 242.

5. Piper, *Recovering Biblical Manhood and Womanhood*, 52.

6. Ibid.

7. Ibid., 51.

8. Ibid., 50.

9. Ibid., 51.

10. Ibid., 50.

11. Barry Hankins, *Uneasy in Babylon: Southern Baptist Conservatives and American Culture* (Tuscaloosa, AL: The University of Alabama Press, 2002), 200–239.

12. Web site: www.cbeinternational.org, (nd.), Joe Trull, "A CBE Member Responds to the Proposed SBC Revision of the 1963 Baptist Faith and Message."

13. Hankins, *Uneasy in Babylon: Southern Baptist Conservatives and American Culture*, 200–239.

14. Trull, "A CBE Member Responds to the Proposed SBC Revision," 2.

15. Hankins, *Uneasy in Babylon: Southern Baptist Conservatives and American Culture*, 200–239.

16. Jane Lampman, "All Equal Under God, but Submission for Women?" in *The Christian Science Monitor*, 2003.

17. Hankins, *Uneasy in Babylon: Southern Baptist Conservatives and American Culture*, 221.

18. Dianna Butler Bass, evangelical historian and columnist, quoted in Hankins, *Uneasy in Babylon: Southern Baptist Conservatives and American Culture*, 218–219.

19. Gary Wills quoted in Hankins, *Uneasy in Babylon: Southern Baptist Conservatives and American Culture*, 219–220.

20. Ibid., 220.

21. Dobson, *Bringing Up Boys*, 27–28.

22. Ibid., 23.

23. Harriet Goldhor Lerner, *The Dance of Deception* (New York: Harper-Collins Publishers, 1993), 219.

24. Ibid.

25. Lyn Mikel Brown & Carol Gilligan, *Meeting at the Crossroads: Women's Psychology and Girl's Development* (Cambridge, MA: Harvard University Press, 1992), 217.

26. Groothuis, *Women Caught in the Conflict*, 26–27.

27. Martin, "A Response to Recovering Biblical Manhood and Womanhood" by John Piper and Wayne Grudem," 6.

28. Groothuis, *Women Caught in the Conflict*, 143.

29. Groothuis, *Good News for Women*, 35.

30. Hurley, *Man and Woman in Biblical Perspective*, 13–19.

31. Ibid., 45–47.

32. Keener, *Paul, Women, and Wives*, 27.

33. Hurley, *Man and Woman in Biblical Perspective*, 17–18, 45–47.

34. Ibid., 44–57.

35. Massey, *Women and the New Testament*, 127–137.

36. Hamilton in Cunningham and Hamilton, *Why Not Women?* 233.

37. Evans, "Encounter with Women's Spirituality" in Hagen (ed.) *Gender Matters: Women Studies for the Christian Community*, 267.

38. Ibid., 283–286.

39. Ibid., 279.

40. Groothuis, "Strange Bedfellows: Strategies Shared by Darwinist and Gender Traditionalists," *Christian Ethics Today*, February, 1998, 54.

41. Evans, "Encounter with Women's Spirituality" in Hagen (ed.), *Gender Matters*, 274.

42. Richard Hove, *Equality in Christ? Galatians 3:28 and the Gender Dispute* (Wheaton, IL: Crossway Books, 1999), 97–104.

43. Ibid., 103.

44. Ibid., 102–103.

45. Ibid., 111.

46. Fleming, *Man and Woman in Biblical Unity: Theology from Genesis 2–3*, 43.

47. Van Leeuwen, *Gender and Grace*, 10.

48. Nicholas Wolterstorff, "Between the Times," *Reformed Journal*, December 1990, 18, quoted in Rebecca Merrill Groothuis, *Women Caught in the Conflict*, 17, 161–162.

49. S. Scott Bartchy, in Massey, *Women in the Church*, 52–53.

50. Massey, *Women in the Church*, 53.

51. John R. Kohlenberger, III, "A Personal Journey from Male Superiority to Mutual Submission," *Christian Management Report*, March/April, 2000, 15.

52. Ibid.

53. Ibid.

54. Ibid.

55. Timothy L. Vanderpool, "My Journey Toward Egalitarianism," www.cbeinternational.org (accessed August 20, 2005).

56. Ibid.

57. Ibid

58. Massey, *Women in the Church*, 52–53.

59. Clark, *Man and Woman in Christ*, 24.

60. Ibid., 24–25.

61. Ortlund, "Male Female Equality and Male Headship: Genesis 1-3," in Piper and Grudem (eds.), *Recovering Biblical Manhood and Womanhood: A Response to Evangelical Feminism*, 103.

62. Clark, *Man and Woman in Christ*, 30.

63. Ortlund, "Male Female Equality and Male Headship: Genesis 1-3," in Piper and Grudem (eds.), *Recovering Biblical Manhood and Womanhood: A Response to Evangelical Feminism*, 98.

64. Ibid.

65. Paige Patterson, quoted in Hankins, *Uneasy in Babylon*, 237.

66. Mark Coppenger, quoted in Hankins, *Uneasy in Babylon*, 236.

67. Clark, *Man and Woman in Christ*, 203.
68. The Council on Biblical Manhood and Womanhood, *The Danvers Statement* (Wheaton, IL: Council on Biblical Manhood and Womanhood, 1988).
69. Clark, *Man and Woman in Christ*, 24–25.

Chapter 17
A Different Spirit

1. Dee Jepson, "Women in Society: The Challenge and the Call," in Piper and Grudem (eds.), *Recovering Biblical Manhood and Womanhood: A Response to Evangelical Feminism* (Wheaton, IL: Crossway Books, 1991), 389.
2. Ibid.
3. Ibid.
4. Ibid., 388-399.
5. Jakes, "Exposing the Wall," *New Man*, November/December, 1997, 45.
6. Ibid.
7. Munroe, *Understanding the Purpose and Power of Women*, 19.

Chapter 18
Colaborers in the Kingdom

1. Sarah M. Grimke, "Letters on the Equality of the Sexes and the Condition of Woman," 1838, in Placher, *Readings in the History of Christian Theology*, Volume 2 (Philadelphia: Westminster Press, 1988), 120.
2. Martos and Hegy, *Equal at the Creation: Sexism, Society, and Christian Thought*, 14.
3. Groothuis, 1997, *Good News for Women*, 44.
4. Stanley J. Grenz, "Nurturing Godly Relationships Between Men and Women," presented at Carey/Regent College, Vancouver, BC and North Seminary, Lombard, IL, n.d., 7.
5. Marilyn Hickey, *Women of the Word* (Tulsa, OK: Harrison House, 1981), 9.
6. Piper and Grudem, *Recovering Biblical Manhood and Womanhood*, 45–46.
7. Ibid., 46.

8. Sayers, *Are Women Human?* 17–18.

9. Ibid., 20.

10. Schmidt, *Veiled and Silenced: How Culture Shaped Sexist Theology*, 8–9.

11. Winston A. Johnson, "Gender, Society, and Church," in Hagen (ed.), *Gender Matters: Women's Studies for the Christian Community*, 228.

12. Schmidt, *Veiled and Silenced: How Culture Shaped Sexist Theology*, 10.

13. Grady, *Ten Lies the Church Tells Women*, 14.

14. Johnson, "Gender, Society, and Church," in Hagen (ed.), *Gender Matters: Women's Studies for the Christian Community*, 228.

15. Grenz, "Nurturing Godly Relationships Between Men and Women," 25.

16. Stanley J. Grenz and Denise Muir Kjesbo, *Women in the Church*, (Downers Grove, IL: Intervarsity Press, 1995), 215–219.

17. Hyatt, *Why Bother to Get It Right About the Woman Issue?* 21.

18. Ibid.

19. Ibid., 33.

Chapter 19
A Time for Reconciliation

1. Jakes, "Exposing the Wall," 45.

2. Grady, *Ten Lies the Church Tells Women*, 194.

3. Groothuis, *Women Caught in the Conflict*, 31–47.

4. Ibid.

5. Ibid.

6. Ibid., 45.

7. Cunningham, *Why Not Women?* 235.

8. Grady, *Ten Lies the Church Tells Women*, 193.

9. J. Lee Grady, "Author Lee Grady Tells Truth About '10 Lies'," Christians for Biblical Equality, www.cbeinternational.org/news/about/Lee_Grady.shtml (accessed March 28, 2007).

10. Cunningham, *Why Not Women?* 13–14.

Conclusion

1. Groothuis, *Good News for Women*, 15.

What's Next?

1. Alfred Smith, "Foreword," in Minnie Claiborne, *How to Be a Winner: Women in the Ministry* (Shippensburg, PA: Companion Press, 1991), IX.
2. Keener, *Paul, Women and Wives*, 3-4.
3. Grady, *Ten Lies the Church Tells Women*, 195.
4. Kari Torjesen Malcolm, *Women at the Crossroads: A Path Beyond Feminism and Traditionalism* (Downers Grove, IL: InterVarsity Press, 1982), 189.
5. Jakes, "Exposing the Wall," 45.
6. Cunningham in Cunningham and Hamilton, *Why Not Women?* 48-49.
7. Malcolm, *Women at the Crossroads: A Path Beyond Feminism and Traditionalism*, 40.
8. Susan Hyatt, *Where Are My Susannas?* (Dallas, TX: Hyatt International Ministries, Inc., 1997).
9. Robert Clouse, "Introduction," in Clouse and Clouse (eds.), *Women in Ministry* (Downers Grove, IL: InterVarsity Press, 1989), 18.
10. Malcolm, *Women at the Crossroads: A Path Beyond Feminism and Traditionalism*, 37-39.
11. James Buckingham, *Daughter of Destiny: Kathryn Kuhlman...Her Story* (Plainfield, NJ: Logos International, 1976), IX.
12. Elliot, "The Essence of Femininity: A Personal Perspective," in Piper and Grudem (eds.), *Recovering Biblical Manhood and Womanhood*, 398.

Appendix A: Does Order of Creation and Redemption Demand Female Supremacy?

A Satire by Alvera Mickelsen

1. Mrs. Mickelsen is a writer, editor, and former professor of journalism. Reprinted with permission of the author.